W9-AGM-489

proceeds go to

Bush Clinton Coastal Recovery Fund

www.bushclintoncoastalfund.org

The purpose of the Bush Clinton Coastal Recovery Fund is to help cities, towns, counties, schools and other entities address critical infrastructure needs so they can rebuild. This fund will help citizens along the Gulf Coast reclaim their lives and restore the beauty and culture of the place they call home.

Houston Hurricane Recovery

www.houstonhurricanerecovery.org

Mayor Bill White established this relief fund to help fill unmet human needs for victims of Hurricane Ike in the city of Houston, Harris and Galveston counties and other affected areas. The mayor's fund is providing money to small organizations that provide shelter and housing, food and household supplies, transportation and child care. It is also helping to make whole some damaged child care and social service organizations that cannot operate without assistance before insurance claims are paid.

The United Way of Greater Houston Hurricane Recovery Fund

www.unitedwayhouston.org

The United Way of Greater Houston Hurricane Recovery Fund supports the human services response for long-term recovery after the storm, helping address the needs of our community's most vulnerable – seniors, individuals with disabilities and families with lower incomes. The focus will be on assessing storm-related needs, helping people in their own efforts to develop and implement plans for recovery through case management, providing mental health services, assisting with minor home repair and supporting individuals and families with basic needs.

Copyright© 2008 Houston Chronicle • ISBN: 978-1-59725-191-4

Published by Pediment Publishing, a division of The Pediment Group, Inc. www.pediment.com Printed in Canada. Designed and composed in the U.S.A.

contents

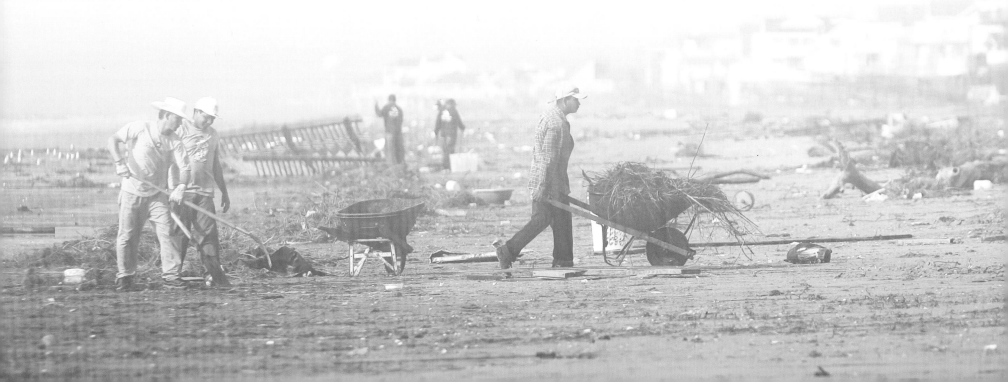

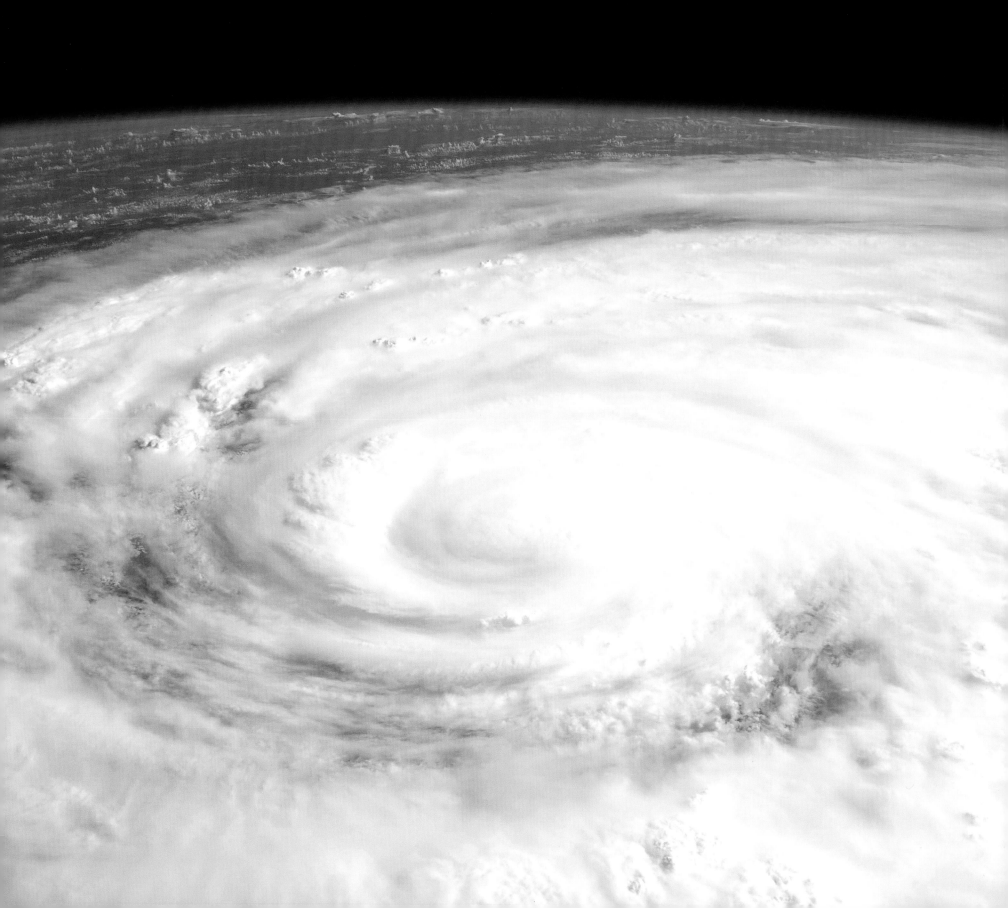

foreword

Hurricanes are familiar business for those living along the coast. But as Ike zeroed in on Southeast Texas, a feeling grew that this could be the big one. First projected to strike land near Freeport, Ike had only to move slightly to the east to put one of the nation's most populous metropolitan areas squarely in its path. It moved. Suddenly more than a million people were called on to evacuate, including those living on Galveston Island, which 108 years earlier had been the scene of the worst natural disaster on American soil. And suddenly, Chronicle journalists had their hands full.

More than 100 Chronicle reporters, photographers, editors, artists and videographers were mobilized for the biggest story to confront Greater Houston since a hurricane named Alicia hit in 1983. After spending the week documenting every angle of the preparation for Ike's landfall, they hunkered down along with millions of remaining residents as the storm pummeled the area in the early morning hours of September 13. Some were on the front lines in Galveston. Others were scattered across the region in shelters and hotels. A core team of two dozen reporters and editors remained at the Chronicle building in downtown Houston. The venerable and sturdy structure took a pounding of its own as Ike's winds roared down urban canyons — smashing windows, ripping up signs and trees and tearing off awnings.

As dawn broke and Ike pushed inland, another phase of the story began. The Chronicle looked to every corner of our community to describe the ravages: from the portions of the Bolivar Peninsula laid bare by a brutal storm surge to the city of Galveston made temporarily unlivable by flood and wind damage and the loss of all municipal services to the countless neighborhoods covered in broken trees and assorted debris. Virtually the whole area, some 2.6 million people, was without power. The economic cost will make it one of the most expensive storms on record. Ike claimed at least 40 local deaths, with many still missing.

The awesome damage — some of it severely felt by Chronicle journalists who nevertheless remained on the job — was surpassed only by the determination to overcome it. Ike was hardly gone before the cleanup began, and the work has continued unabated since. This book, through a remarkable collection of photographs, represents a sampling of our work. It bears witness not only to the destructive power of nature but to the will to persevere.

Disasters happen. We build anew.

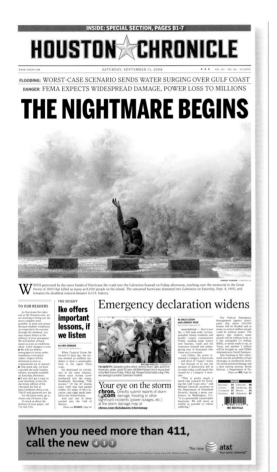

SEPTEMBER 13, 2008

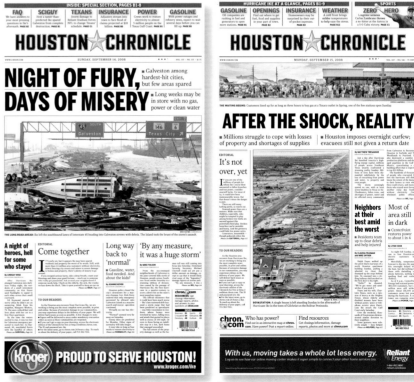

SEPTEMBER 14, 2008 SEPTEMBER 15, 2008

eye on the storm with SciGuy

"SciGuy" Eric Berger was a voice of calm and reason before and during the storm, posting updates to chron.com all day and night to let Houston-area readers know where the storm was going and what damage could be expected. His daily online chats drew thousands as Houston turned to him for the most accurate information available.

By ERIC BERGER
HOUSTON CHRONICLE

The swirl of clouds that spun into Hurricane Ike seemed an unlikely candidate to threaten the upper Texas coast.

Ike formed deep in the Atlantic Ocean, far enough north of the equator where most storms curve northward into the ocean, harmlessly becoming "fish storms."

Since 1900, more than five dozen storms had passed within 170 miles of where Ike formed, and only eight of those eventually struck the United States. Just one storm tracked into the Gulf of Mexico.

That storm, alas, was the powerful 1915 hurricane that blew ashore just southwest of Galveston. The island survived only because its leaders had built a seawall following the Great Storm of 1900.

Long before Ike's final landfall along Galveston Island, its 135-mph winds matched the 1915 storm's. But after its encounter with Cuba's mountains, Ike never again reached Category 3 on the Saffir-Simpson scale, or major hurricane status.

It mattered not for the Texas coast.

Upon entering the Gulf of Mexico, the storm's central pressure dropped and Ike grew into an immense hurricane. But for reasons scientists do not fully understand, Ike's winds would never again exceed 110 mph, making it "just" a Category 2 hurricane.

As Ike so strikingly demonstrated, however, maximum winds actually have very little to do with the size of a hurricane's storm surge — that is, the amount of water it pushes onshore.

Far more important is the size of a storm's area of highest winds, and Ike had a tremendous wind field. Scientists who sum up the total energy of a storm's winds say that although Ike's winds were considerably weaker than Hurricane Katrina's, at times its total energy exceeded that of the hurricane that dealt New Orleans a stunning blow.

Such was the size of Ike, then, that it pushed up to 10 feet of water across the West End of Galveston Island, and more than 16 feet onto Bolivar Peninsula.

It was a surge the likes of which Houston and its environs have seen but a few times in history, most recently during Hurricane Carla in 1961. Many homes built along the coast since then, which stand at or just above ground level, were destroyed this time around by Ike's towering waves.

When the next storm comes, next year or perhaps decades hence, will history repeat itself?

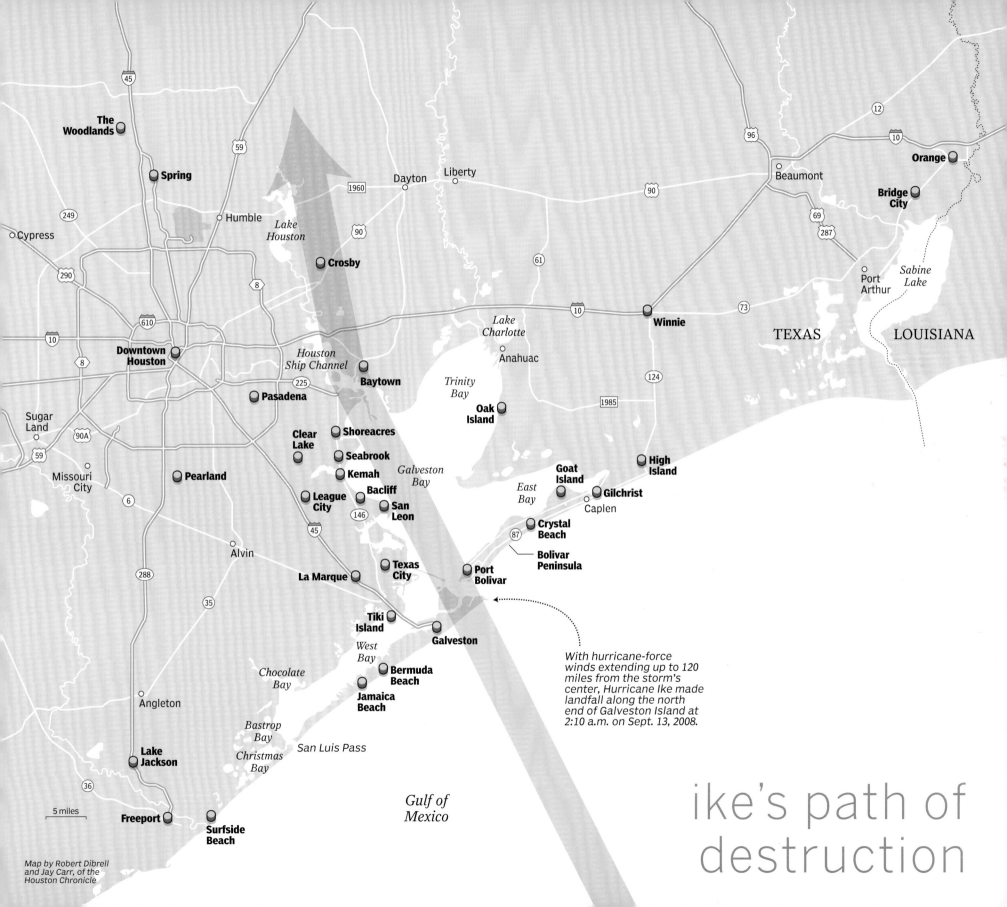

ike's path of
destruction

With hurricane-force
winds extending up to 120
miles from the storm's
center, Hurricane Ike made
landfall along the north
end of Galveston Island at
2:10 a.m. on Sept. 13, 2008.

Map by Robert Dibrell
and Jay Carr, of the
Houston Chronicle

TEXAS LOUISIANA

Gulf of
Mexico

5 miles

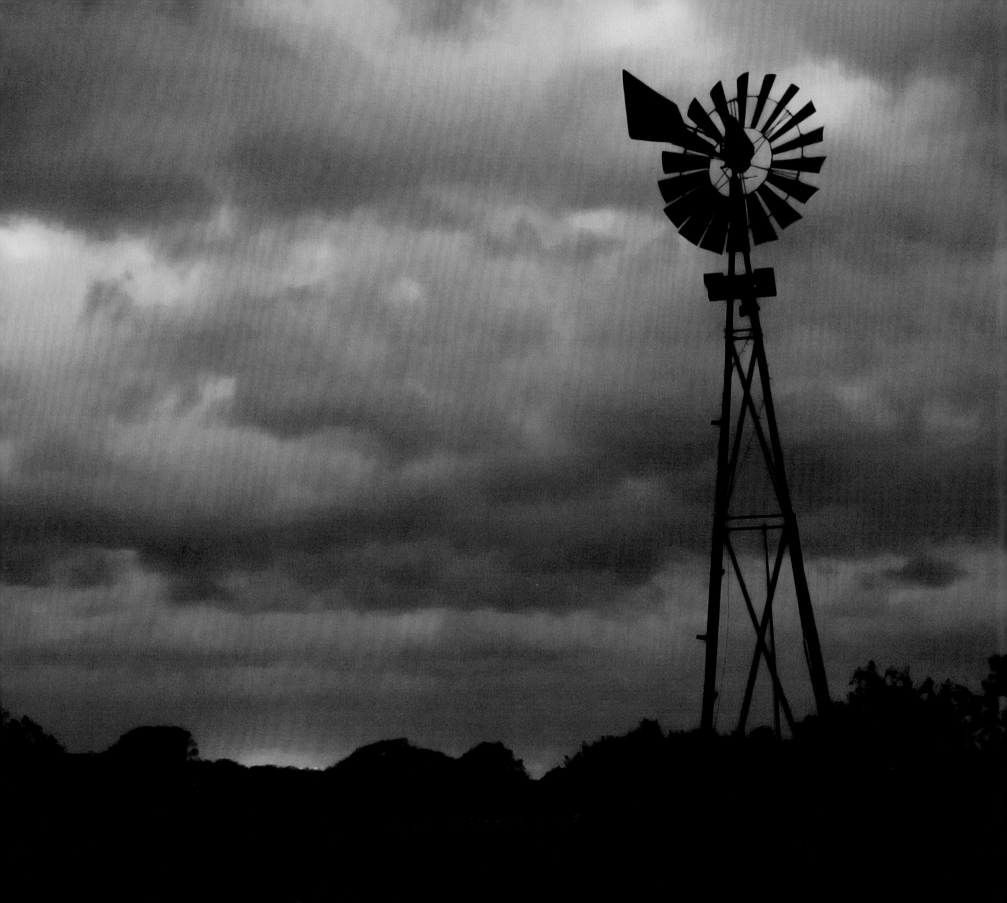

CHAPTER *One*

hunkering down

Coastal residents knew the drill: Board up the windows, load up on supplies, fill up the car, wait and watch. With Hurricane Ike still churning far out in the Gulf of Mexico, people from Freeport to the Louisiana border were told to get ready. But it was hard to know what to make of this latest storm, which had strengthened and weakened several times. As it moved steadily toward us, the winds were not so high by hurricane standards. Its ghostly radar image revealed a large storm pinwheeling toward the state, but not one as impressive as storms past that fizzled near the end. Some people thought Ike would prove more nuisance than menace. Forecasters knew better. Its wide "wind field" meant Ike was pushing a lot of water in front of it. As it got closer, their warnings became increasingly dire for those living close to the shore and not protected by a seawall: Evacuate or die. Most of the million or so people in the evacuation zones did leave, finally accepting the fact that the Greater Houston area was in for a direct hit.

HAUNTING SIGNS | OPPOSITE | Ominous skies frame a windmill as Hurricane Ike approaches. | SEPT. 12 | LAKE JACKSON | **JULIO CORTEZ**

IN THE DARK | TOP | The Longorias — sisters Ingrid and Lisa and their mother, Lorena — watch a battery-operated TV after the power goes out at their home. | SEPT. 12 | PEARLAND | **MAYRA BELTRÁN**

JOINT EFFORT | TOP | Sgt. Ignacio Rodriguez of Magnolia helps coordinate bus traffic and fueling at the west side's Tully Stadium to support joint operations with the Department of Public Safety and other agencies. | SEPT. 10 | HOUSTON | **ERIC KAYNE**

ROPED IN | BOTTOM | Rey Villarreal loads one of his horses into a trailer as he prepares to drive them north out of harm's way. "This area floods, so we've got to get them out," he said. | SEPT. 10 | GALVESTON | **JOHNNY HANSON**

PREPARATION | OPPOSITE | Robert Sawyer cuts plywood to board up a home. | SEPT. 10 | JAMAICA BEACH | **JOHNNY HANSON**

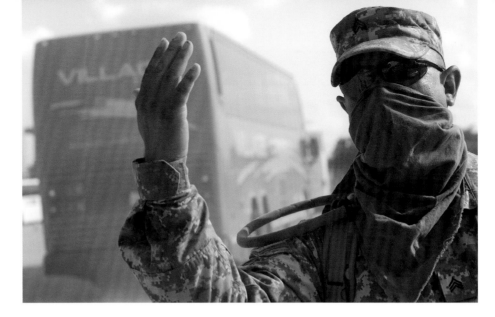

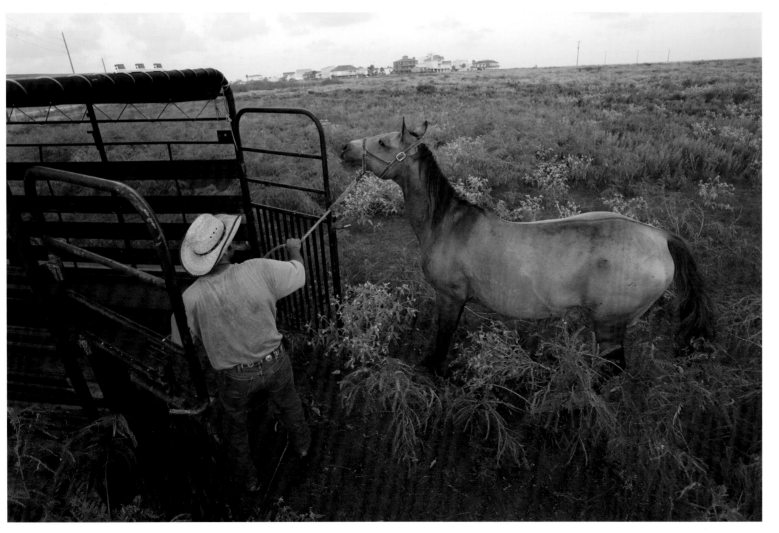

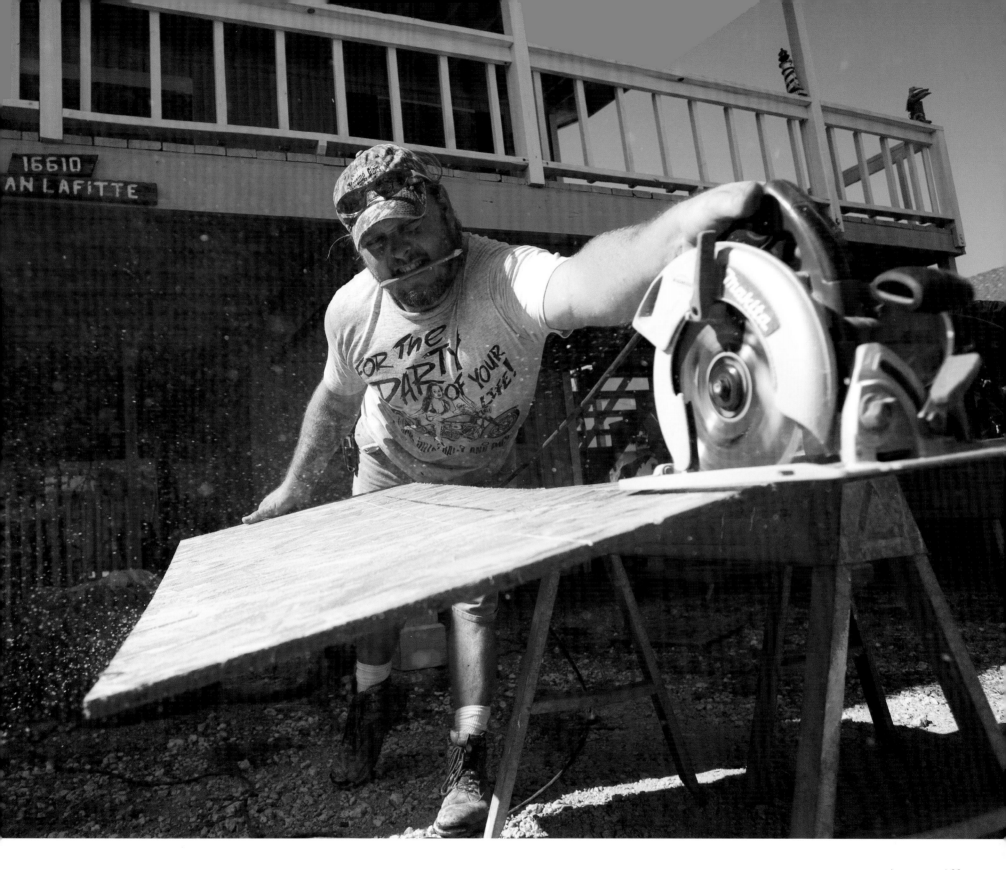

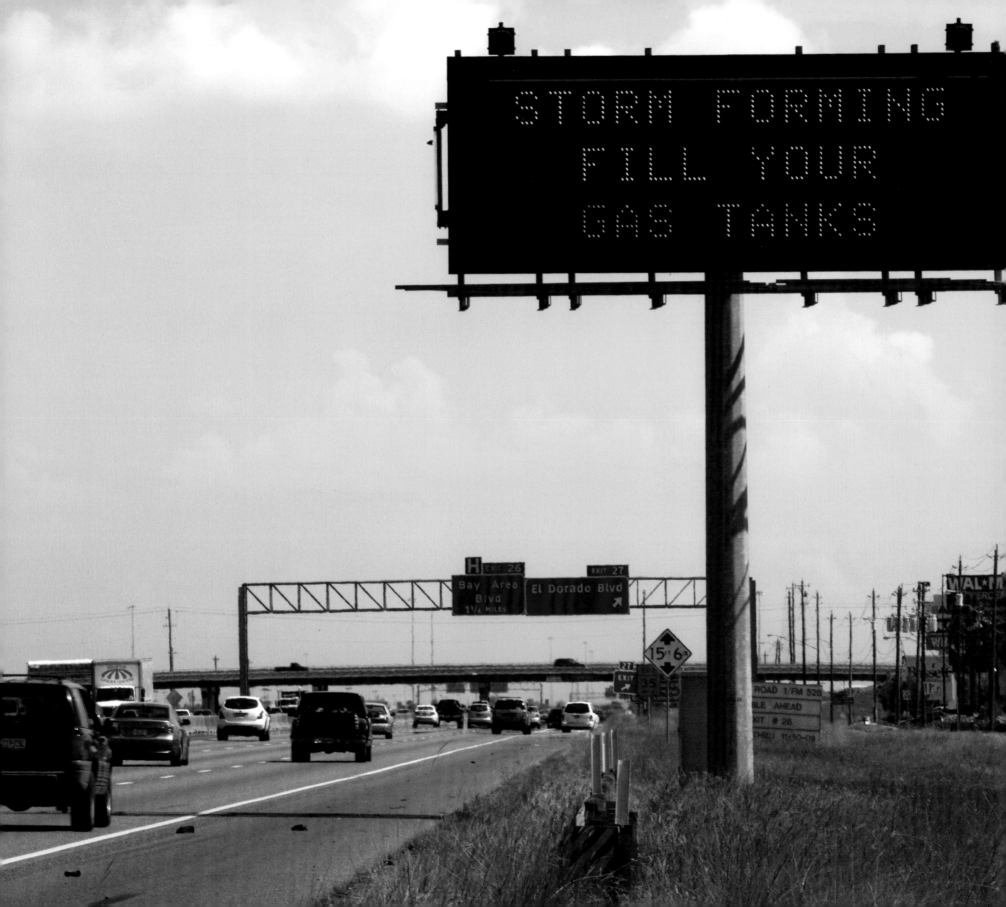

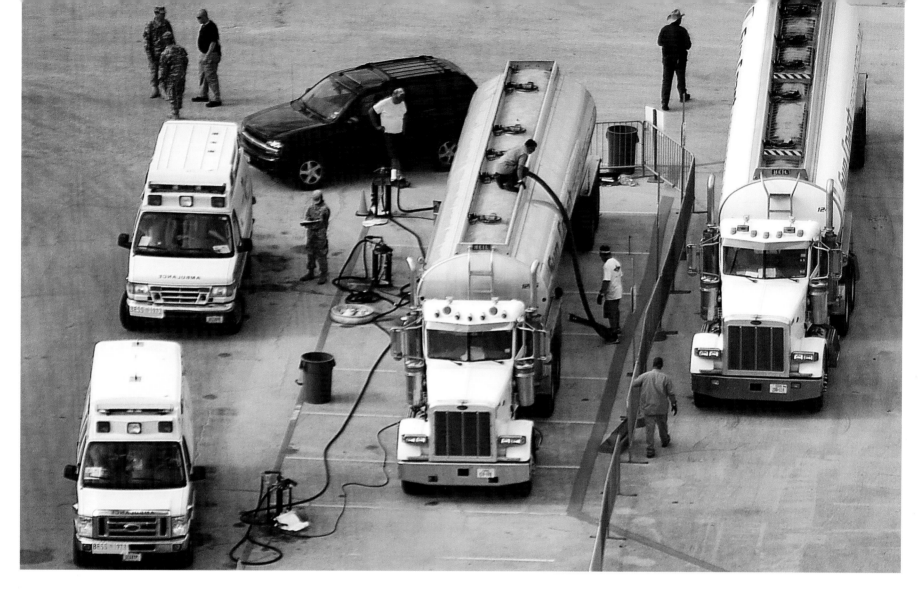

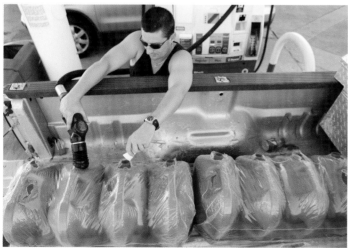

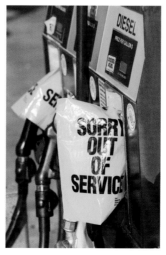

FILLING UP | TOP | Emergency vehicles are fueled at a staging area at Tully Stadium. | SEPT. 11 | HOUSTON | **SMILEY N. POOL**

ONE BY ONE | BOTTOM LEFT | Scott Brown fills eight 5-gallon gas cans at a station on Texas 249 and Louetta. He purchased the cans at Home Depot to fill with fuel for his generator. | SEPT. 11 | HOUSTON | **MELISSA PHILLIP**

EMPTY | BOTTOM RIGHT | A gas station runs dry. | SEPT. 11 | LEAGUE CITY | **MELISSA PHILLIP**

GOOD ADVICE | OPPOSITE | A sign on the Gulf Freeway warns motorists to fill up. | SEPT. 10 | CLEAR LAKE | **JOHNNY HANSON**

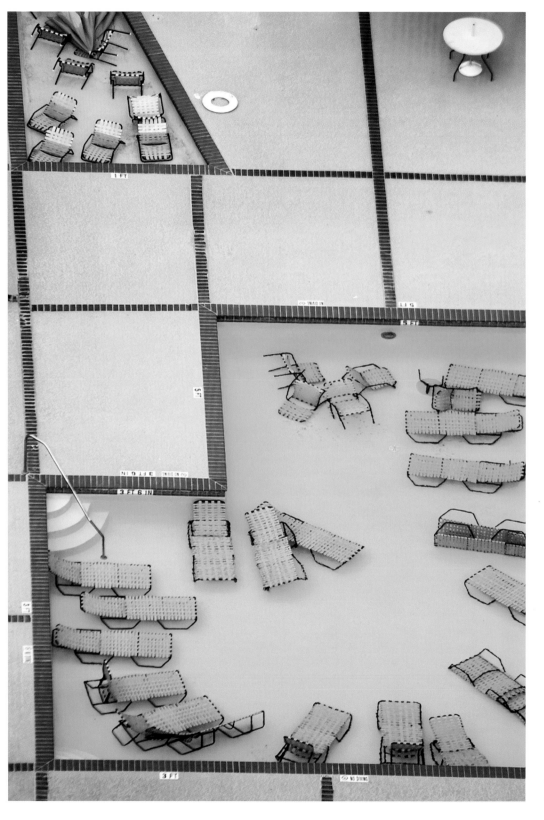

CLOSING EARLY | TOP LEFT | H-E-B employees tell Victor Arthur, right, that the store already closed. "What am I supposed to do about food?" Arthur asked. "I guess I'll try the corner store." | SEPT. 11 | GALVESTON | **JOHNNY HANSON**

INGENUITY | RIGHT | Patio furniture is submerged for protection in the swimming pool of a westside apartment complex. | SEPT. 11 | HOUSTON | **SMILEY N. POOL**

STOCKING UP | BOTTOM LEFT | Employees at the Home Depot at Interstate 10 near Wirt wheel a cart of supplies to a customer's car. | SEPT. 11 | HOUSTON | **JAMES NIELSEN**

VANISHING | OPPOSITE | Higher than average surf encroaches on the beach. | SEPT. 11 | SURFSIDE BEACH | **SMILEY N. POOL**

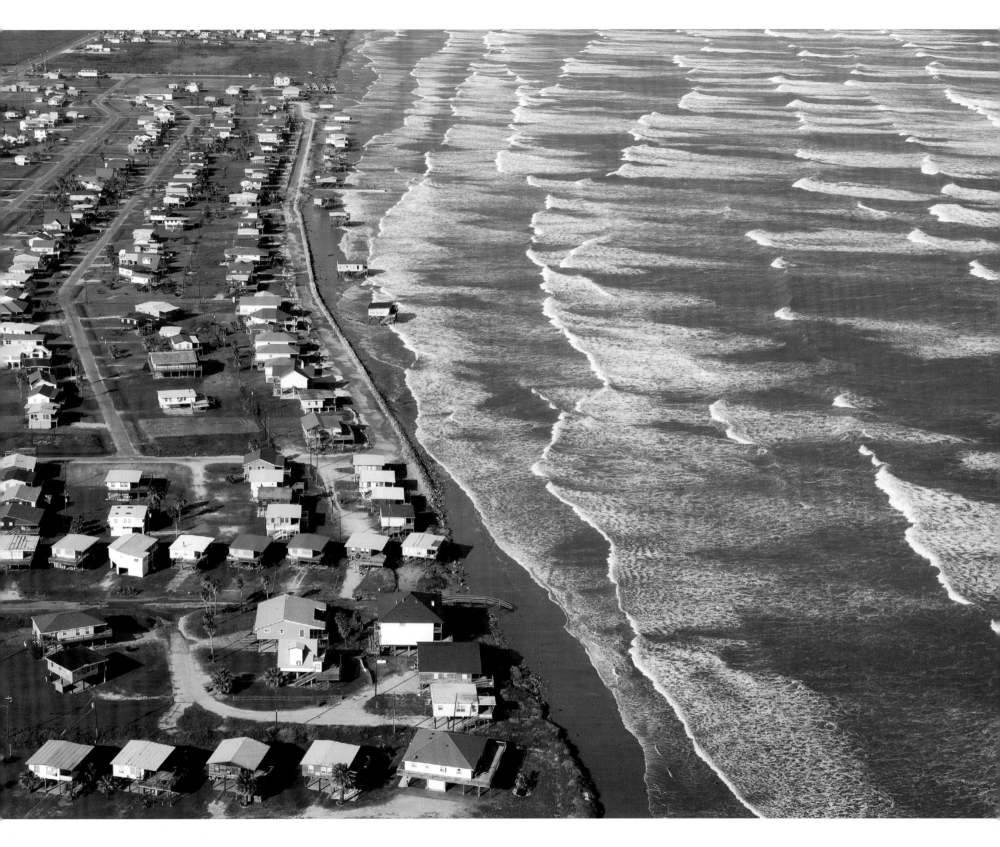

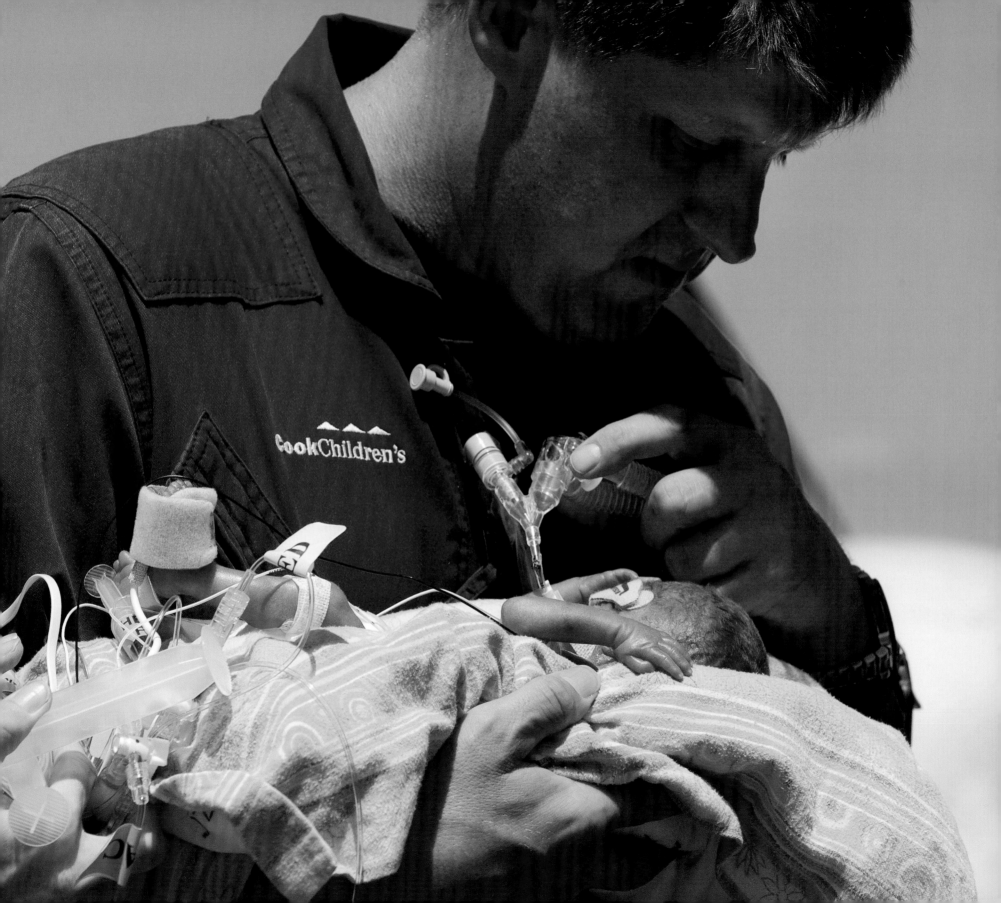

TINY EVACUEE | OPPOSITE | An emergency worker carries one of 27 infants who were flown from the University of Texas Medical Branch to other Texas cities. Many of the infants were in incubators or attached to equipment. | SEPT. 11 | GALVESTON | **JAMES NIELSEN**

OUT OF HARM'S WAY | TOP | Buses from the Alvin Independent School District drive north on Texas 288. | SEPT. 11 | HOUSTON | **JULIO CORTEZ**

MERCURY RISING | BOTTOM | The heat begins to take its toll on elderly residents waiting in line for a bus to take them to a shelter. Elizabeth Schadt suffered a minor scrape on her hand after falling, and was transported to a hospital. | SEPT. 11 | GALVESTON | **JOHNNY HANSON**

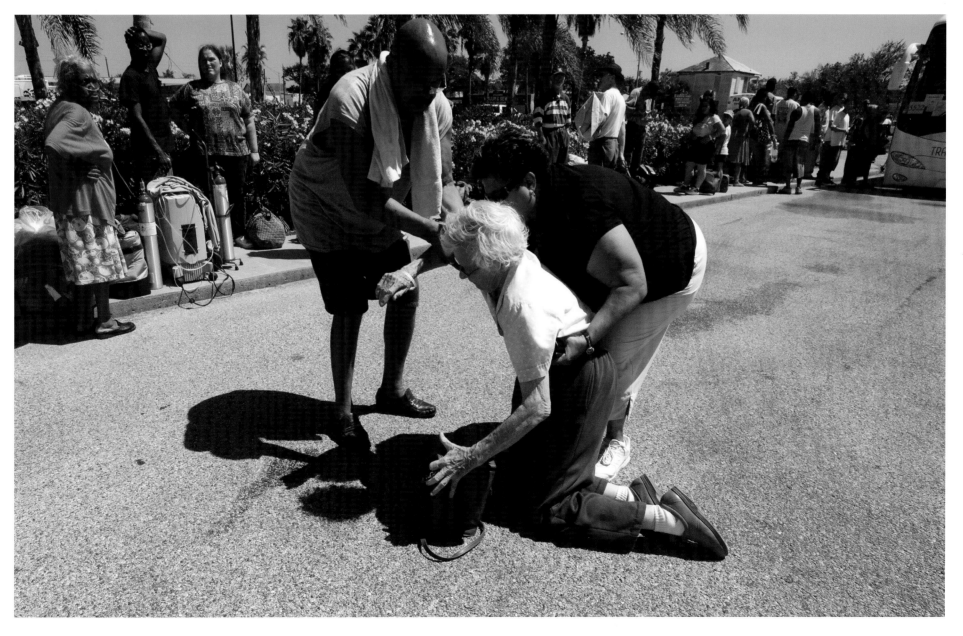

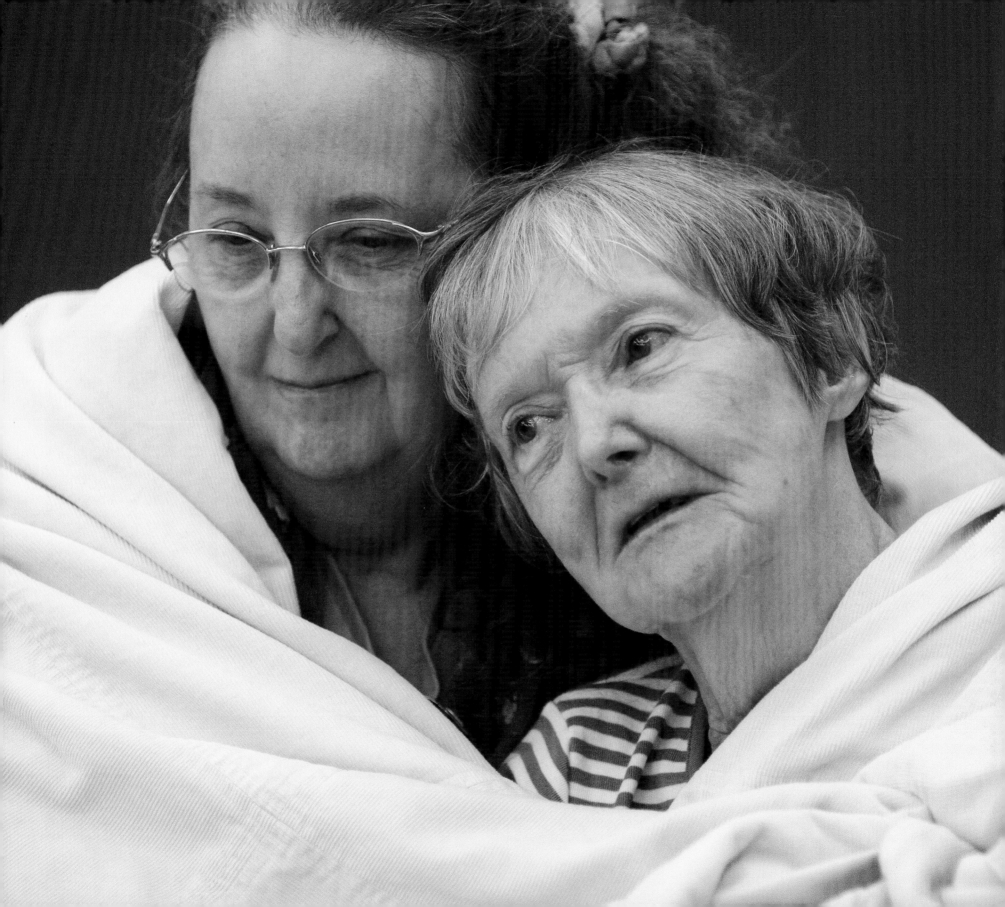

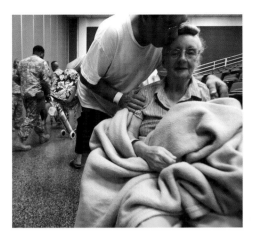

FAMILY TIES | OPPOSITE | Carole McFadden, left, and her mother, Freda Evans, try to stay warm as they wait to be evacuated by bus from a staging site at Charles T. Doyle Convention Center. | SEPT. 11 | TEXAS CITY | **MELISSA PHILLIP**

A KISS FOR THE ROAD | TOP LEFT | Pearl Newman, 79, gets a kiss from her son-in-law, Phil Walters, while waiting to be evacuated by the National Guard at the Pasadena Convention Center. | SEPT. 11 | PASADENA | **SHARÓN STEINMANN**

LONG WAIT | TOP RIGHT | Evacuees from coastal cities gather at the George R. Brown Convention Center to wait for buses. | SEPT. 11 | HOUSTON | **MAYRA BELTRÁN**

BOUND FOR THE CAPITAL | BOTTOM | Hundreds wait at the Island Community Center for buses to take them to a shelter in Austin. | SEPT. 11 | GALVESTON | **JOHNNY HANSON**

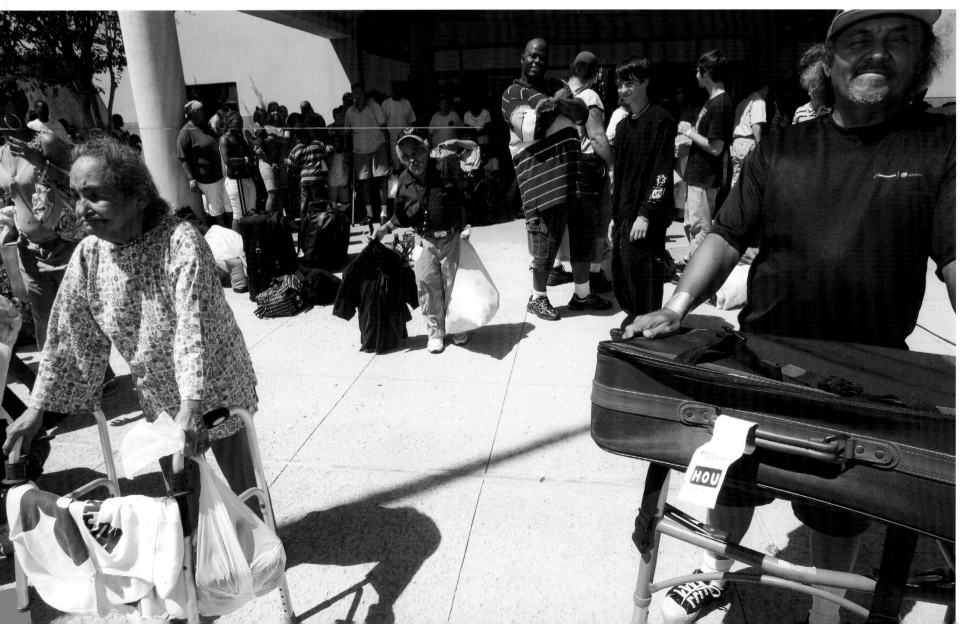

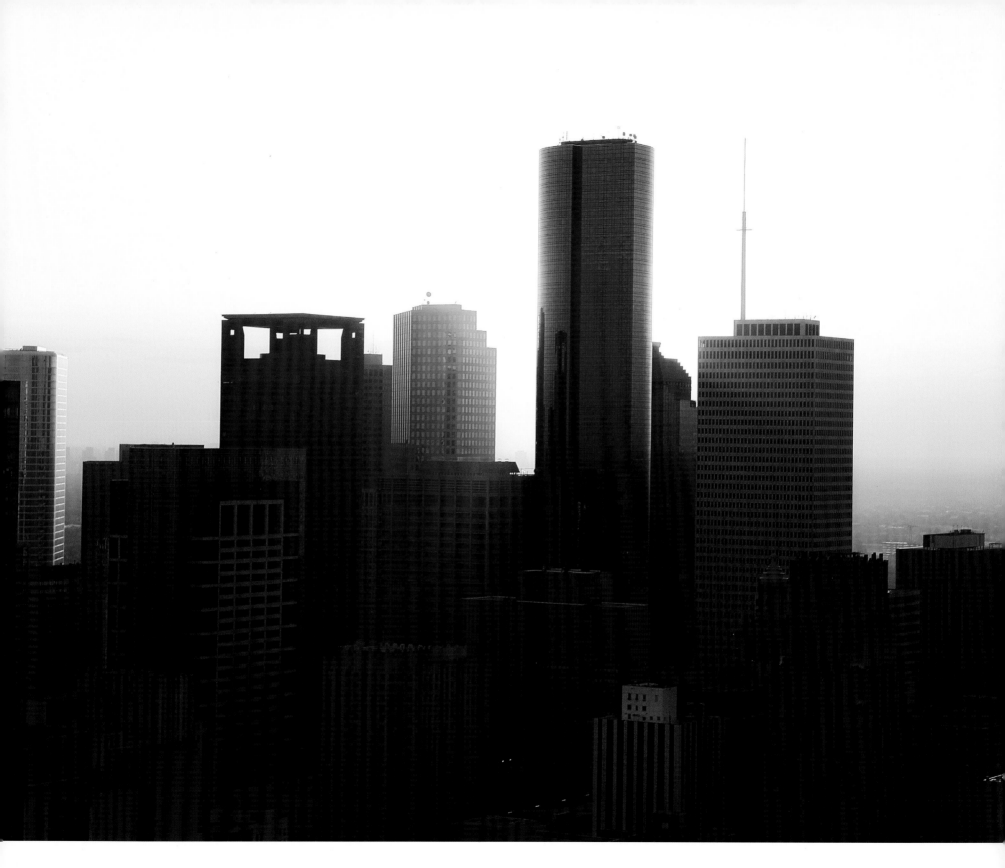

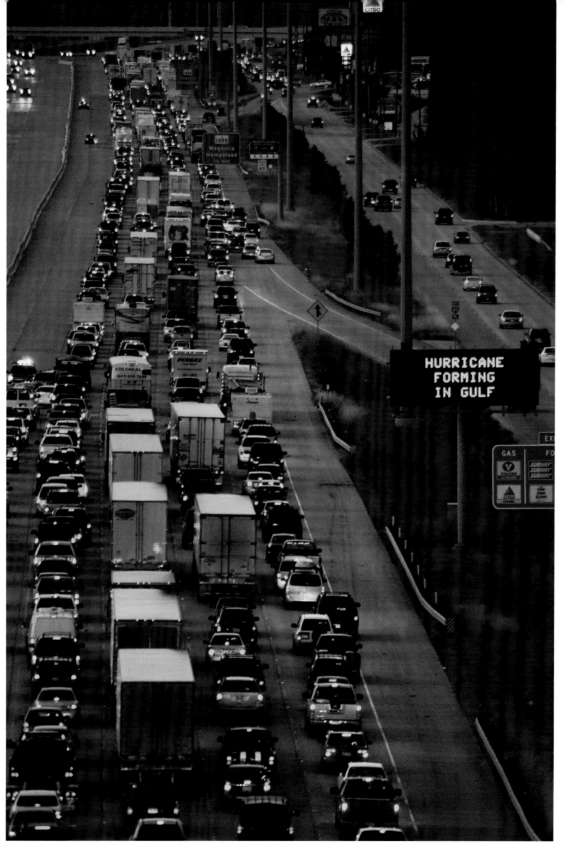

SKYLIGHTS | OPPOSITE | As the sun sets on the city, the National Weather Service sternly warns coastal residents to evacuate. | SEPT. 11 | HOUSTON | **SMILEY N. POOL**

SLOW GOING | RIGHT | Traffic backs up on Interstate 45 northbound as residents evacuate the Greater Houston area. | SEPT. 11 | THE WOODLANDS | **SMILEY N. POOL**

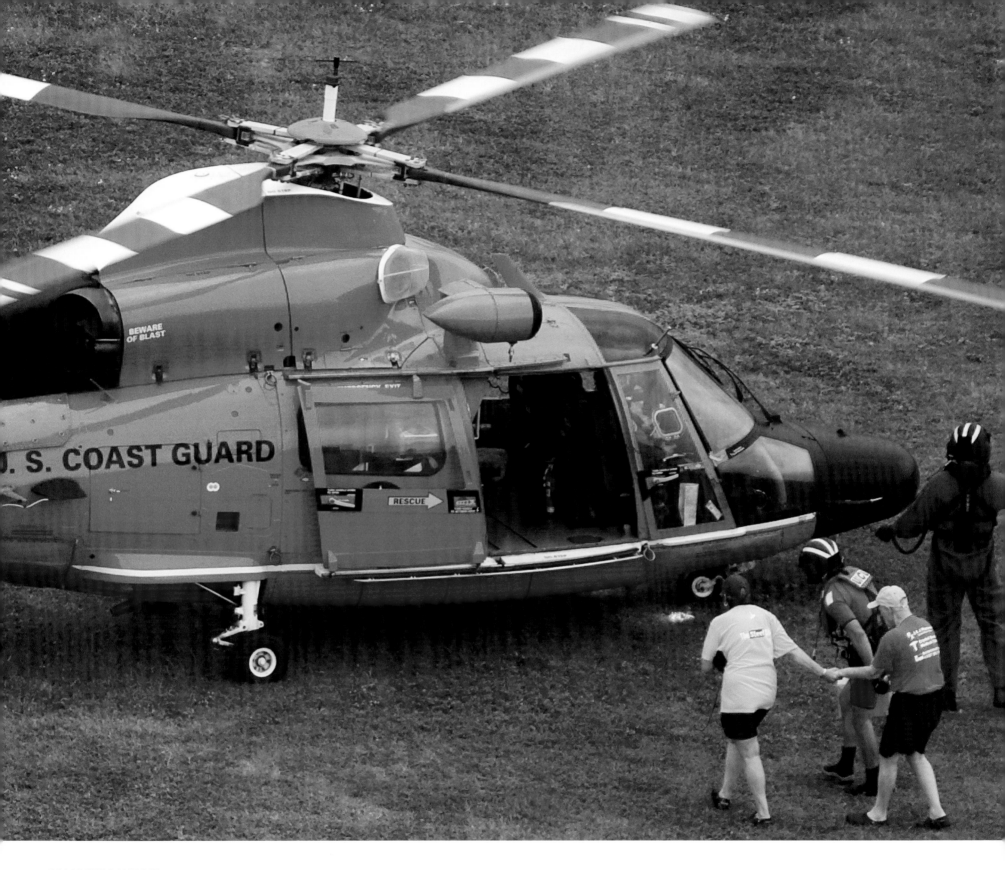

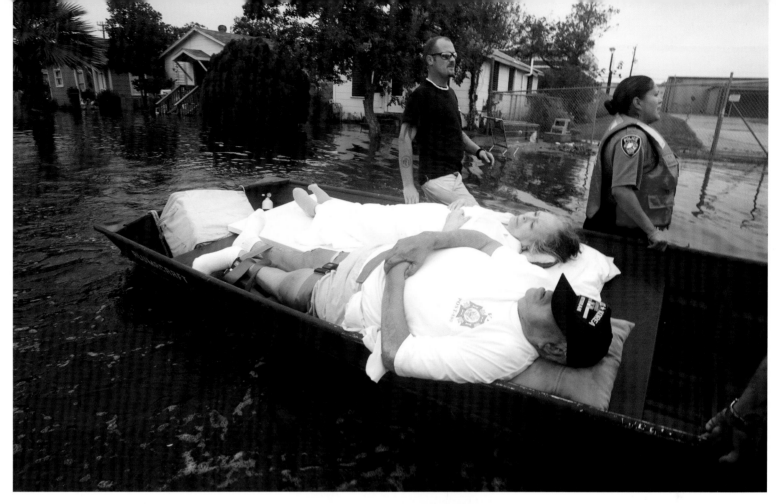

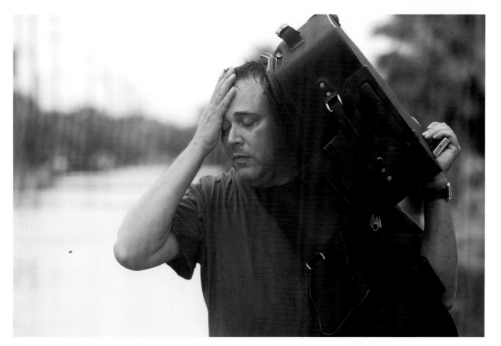

AIRLIFT | OPPOSITE | Evacuees are helped aboard a U.S. Coast Guard helicopter as water quickly rises on the coast. | SEPT. 12 | BOLIVAR PENINSULA | **SMILEY N. POOL**

HELPING HANDS | TOP | Rescue workers help a bedridden couple evacuate after their street was flooded. | SEPT. 12 | GALVESTON | **JOHNNY HANSON**

FRUSTRATION | BOTTOM | Frank Urbina shows his exasperation after he is denied permission to ride in an ambulance with his bedridden parents, shown at top. Urbina was eventually allowed to join his parents as they evacuated to Austin. | SEPT. 12 | GALVESTON | **JOHNNY HANSON**

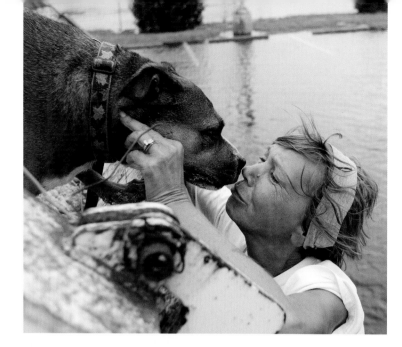

NOSE TO NOSE | TOP | Angie Fleener kisses her dog, Hally, after they were rescued from high water by a dump truck and taken to a shelter. Hally rode in the back of the truck to the shelter, while Fleener rode in the cab. | SEPT. 12 | GALVESTON | **MELISSA PHILLIP**

STORM SHELTER | BOTTOM | Several city employees sleep on the floor as they take shelter in the San Luis Hotel. | SEPT. 12 | GALVESTON | **BRETT COOMER**

TO SAFETY | OPPOSITE | Galveston police officer Jeremy Smart, right, and Chris Hendricks, center, assist 93-year-old Belle Kenney from a rescue boat. Police Sgt. Renaye Ochoa holds a dog, Pete, who belongs to another resident. | SEPT. 12 | GALVESTON | **MELISSA PHILLIP**

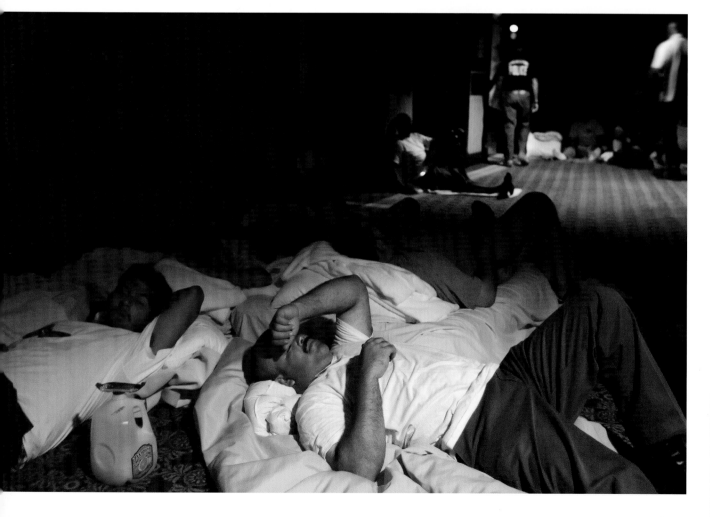

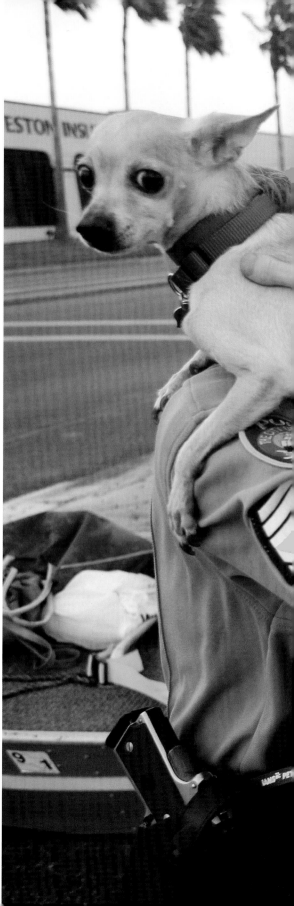

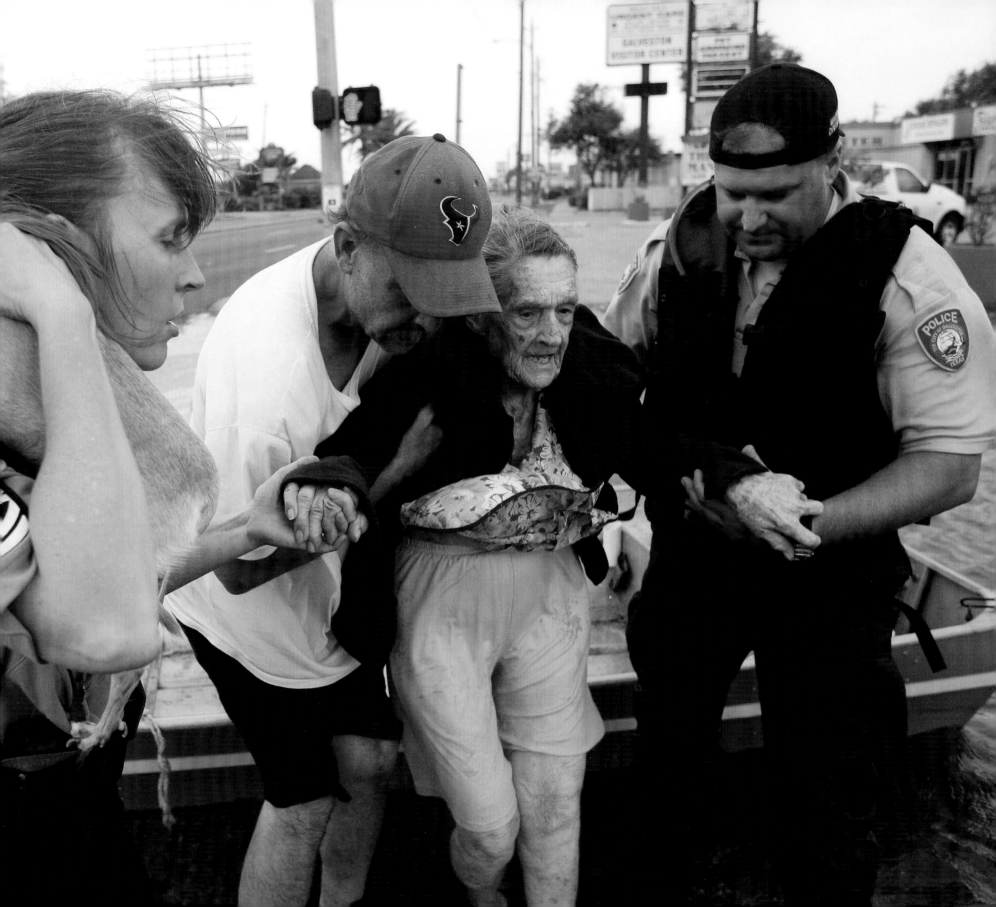

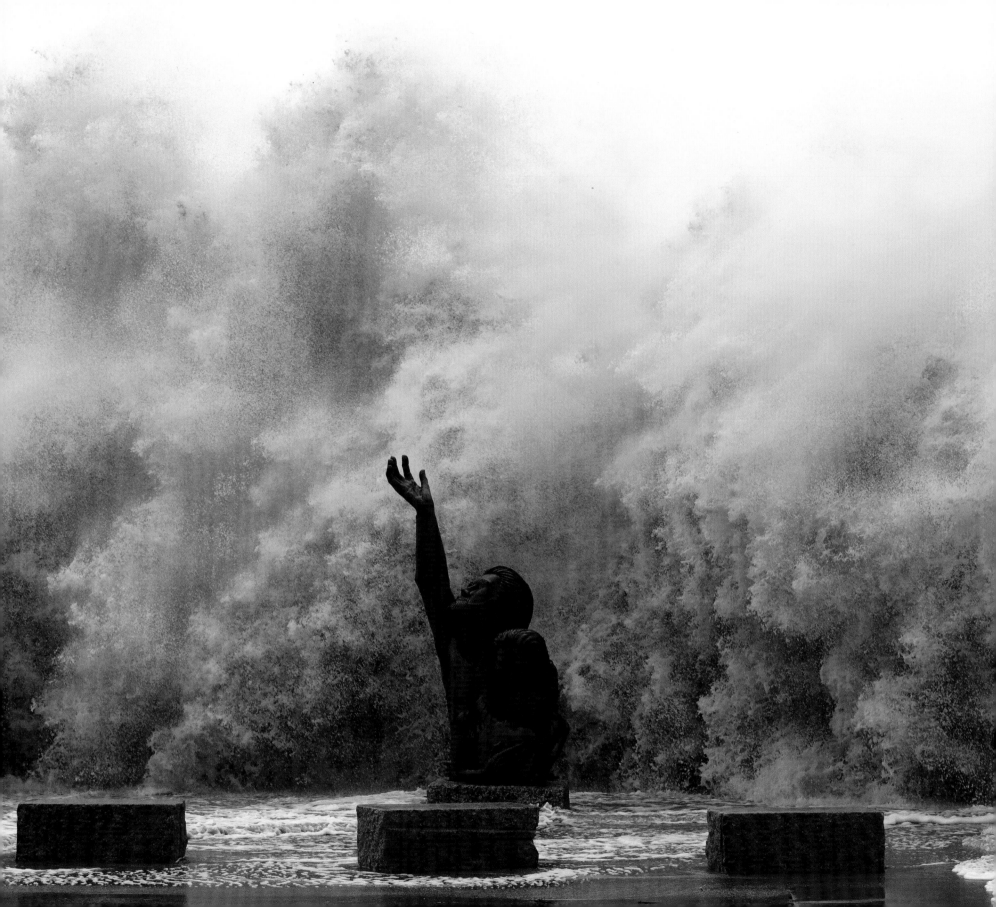

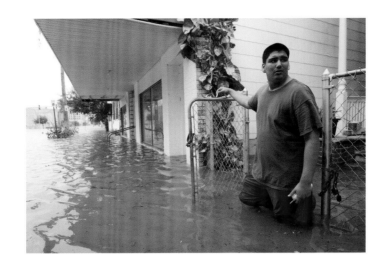

CHAPTER *Two*

the nightmare begins

First came the water. Ike was still well offshore, but the tidal surge accompanying it began to swamp low-lying coastal areas early on Friday, September 12. Even the portion of Galveston protected by a seawall erected after the Great Storm of 1900 was inundated. It had been 25 years since Houston and its outlying communities had faced the full-on fury of a hurricane, but that storm, Alicia, did not bring water like this. As Ike moved ashore in the middle of the night, the storm surge pounded the unprotected Bolivar Peninsula the hardest, wiping away entire communities. Technically, Ike never reached major hurricane status. But its surge proved devastating and its sustained winds of 110 mph were enough to take down thousands of trees and power poles. As millions of people in Southeast Texas hunkered down in darkened homes, praying that their trees would remain standing and their roofs attached, the winds raged on and on through a very long night.

WALL OF WATER | OPPOSITE | Fierce waves threaten the memorial to the Great Storm of 1900, which remains the deadliest natural disaster in U.S. history. | SEPT. 12 | GALVESTON | **JOHNNY HANSON**

WATER AT THE DOOR | TOP | Sean Rumgay, 15, wades into floodwaters outside his house. | SEPT. 12 | GALVESTON | **BRETT COOMER**

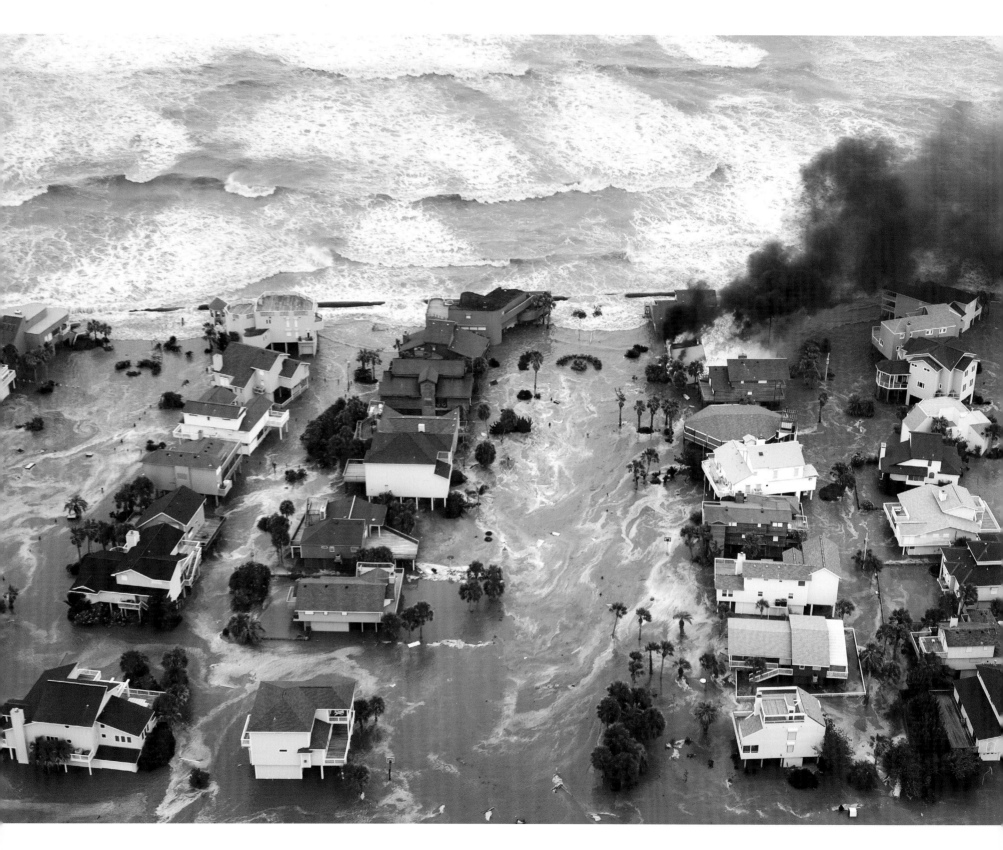

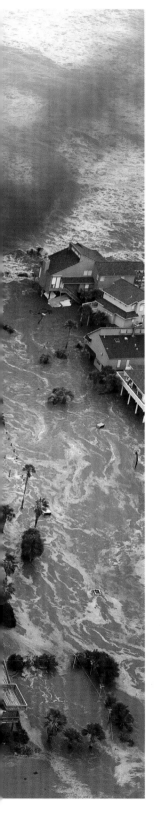

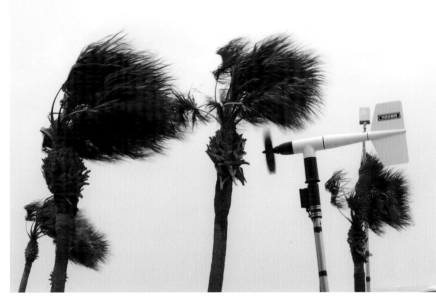

FIRE AND SEA | OPPOSITE | A house is engulfed in flames as floodwaters and crashing waves inundate beach homes. | SEPT. 12 | GALVESTON | **SMILEY N. POOL**

GUSTS | TOP | A wind gauge measures wind speeds of more than 60 mph. | SEPT. 12 | GALVESTON | **JOHNNY HANSON**

MEMORIES | BOTTOM | Waves crash over the Seawall as two men walk near a memorial to the Great Storm of 1900, which killed as many as 8,000 people. | SEPT. 12 | GALVESTON | **SMILEY N. POOL**

HAZARDOUS DRIVING | FOLLOWING LEFT | A truck ventures out as waves crash over the Seawall. | SEPT. 12 | GALVESTON | **SMILEY N. POOL**

DOUBLE TAKE | FOLLOWING TOP RIGHT | Travis Postany hangs on to a sign post as he clowns around while a wave crashes into the Seawall. | SEPT. 12 | GALVESTON | **BRETT COOMER**

RISING | FOLLOWING BOTTOM RIGHT | Floodwaters threaten dozens of homes. | SEPT. 12 | SURFSIDE BEACH | **BRETT COOMER**

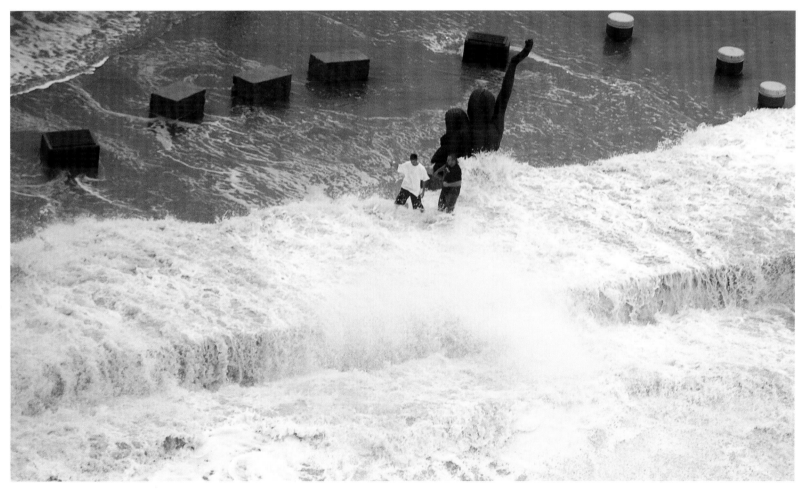

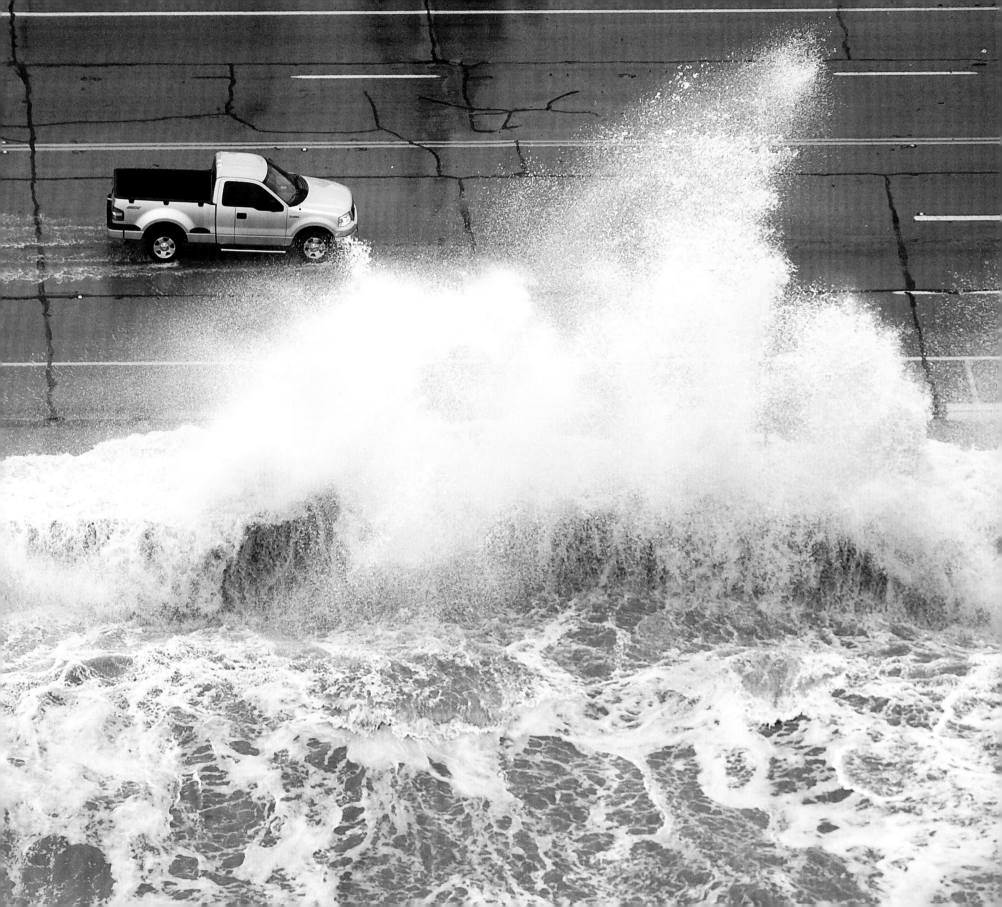

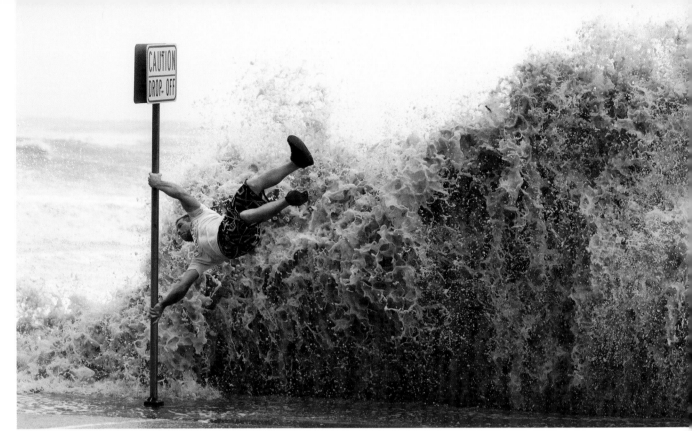
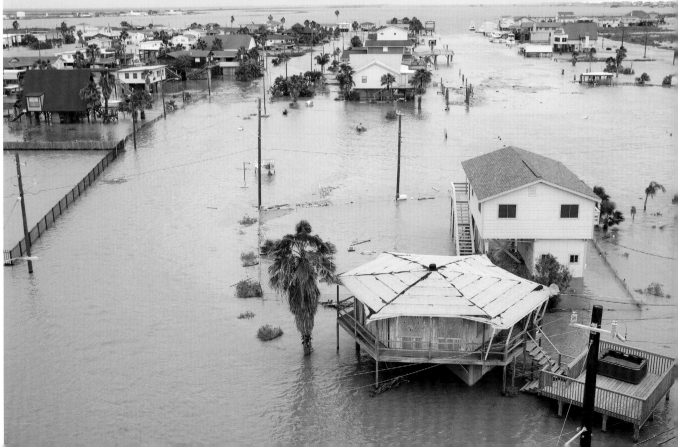

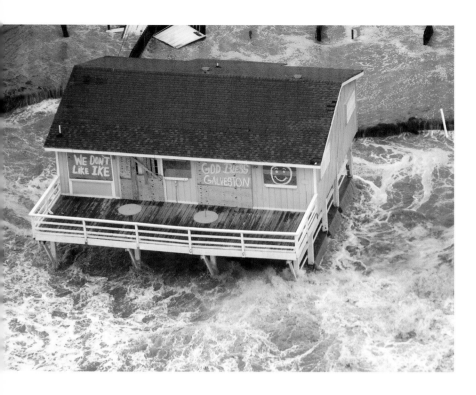

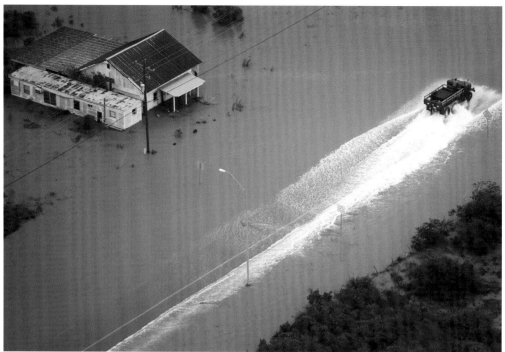

COMMON SENTIMENTS | TOP LEFT | The messages "We don't like Ike" and "God bless Galveston" are scrawled on plywood covering the windows of a beach house. | SEPT. 12 | GALVESTON | **SMILEY N. POOL**

LEAVING A WAKE | TOP RIGHT | A truck maneuvers through floodwaters. | SEPT. 12 | BOLIVAR PENINSULA | **SMILEY N. POOL**

WAIST-DEEP | BOTTOM | Kevin Little, 12, left, and Melonie Villa, 18, both from Deer Park, wade into the rising waters. | SEPT. 12 | KEMAH | **ERIC KAYNE**

FLAMES | OPPOSITE | Chase Griffin trudges through floodwaters after checking on a boat storage facility that caught fire. | SEPT. 12 | GALVESTON | **BRETT COOMER**

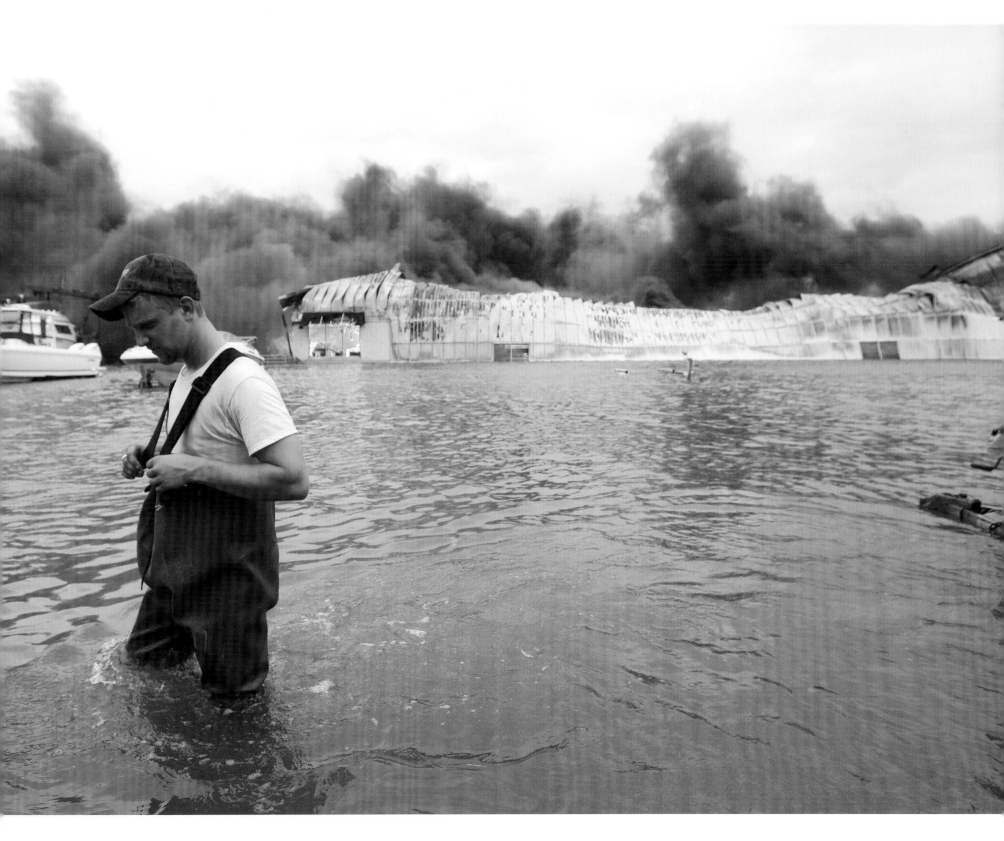

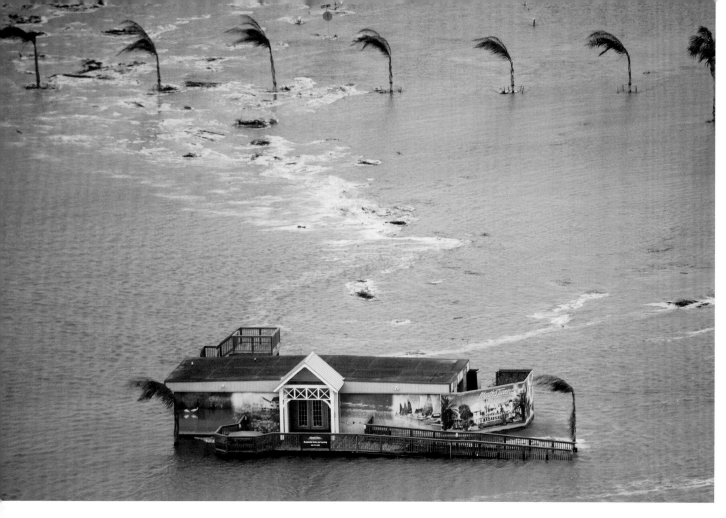

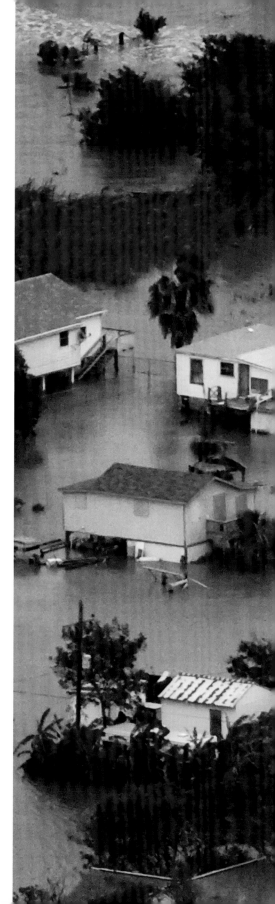

SURROUNDED | TOP | Floodwaters breach a real estate office. | SEPT. 12 | GALVESTON | **SMILEY N. POOL**

DEEP-WATER DELIVERY | BOTTOM | A truck plows on, trying to navigate a road that already has been swallowed by floodwaters. | SEPT. 12 | GALVESTON | **SMILEY N. POOL**

FLYOVER | OPPOSITE | A Coast Guard helicopter passes above homes threatened by rising waters. | SEPT. 12 | BOLIVAR PENINSULA | **SMILEY N. POOL**

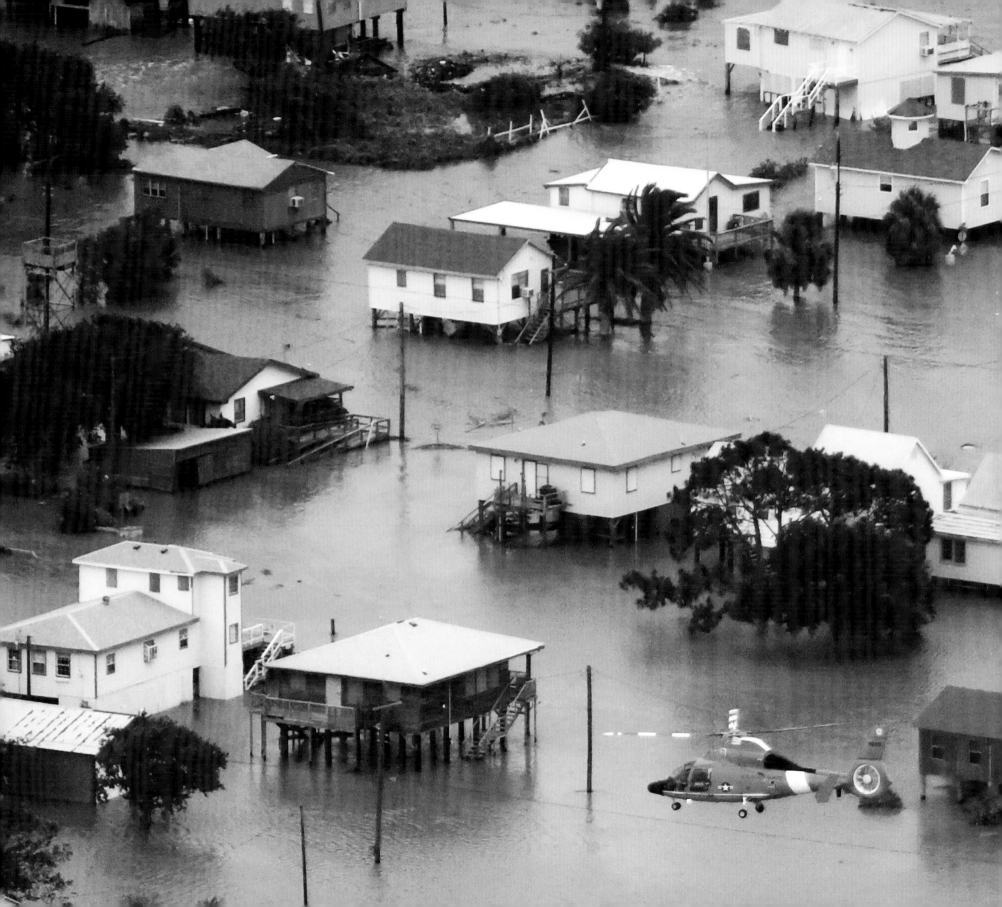

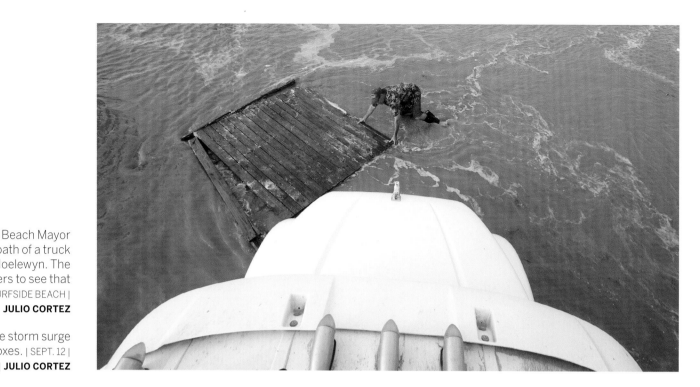

NOT IN THE JOB DESCRIPTION | TOP | Surfside Beach Mayor Larry Davison clears debris from the path of a truck driven by Freeport city employee David Hoelewyn. The two were part of a team navigating high waters to see that families left before Ike's landfall. | SEPT. 12 | SURFSIDE BEACH | **JULIO CORTEZ**

OCEAN EVERYWHERE | BOTTOM | Water from the storm surge continues to rise, nearly topping mailboxes. | SEPT. 12 | SURFSIDE BEACH | **JULIO CORTEZ**

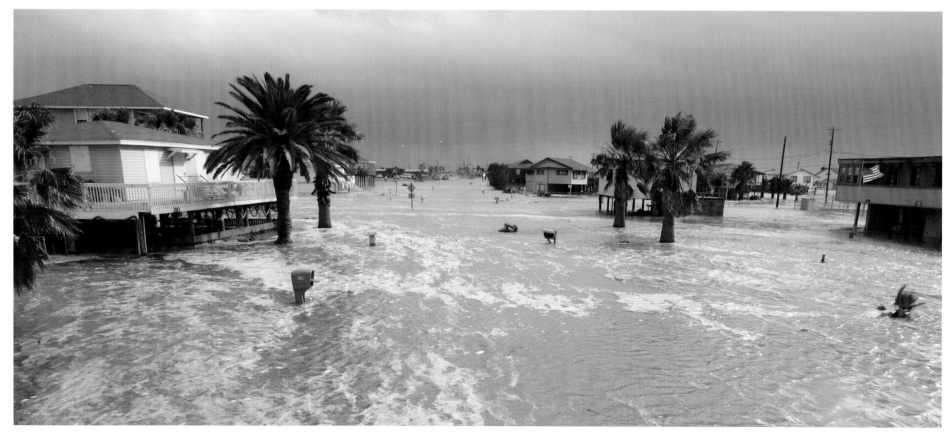

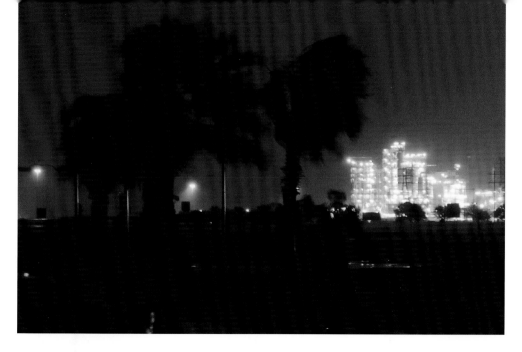

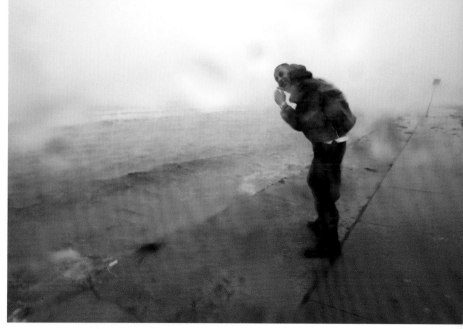

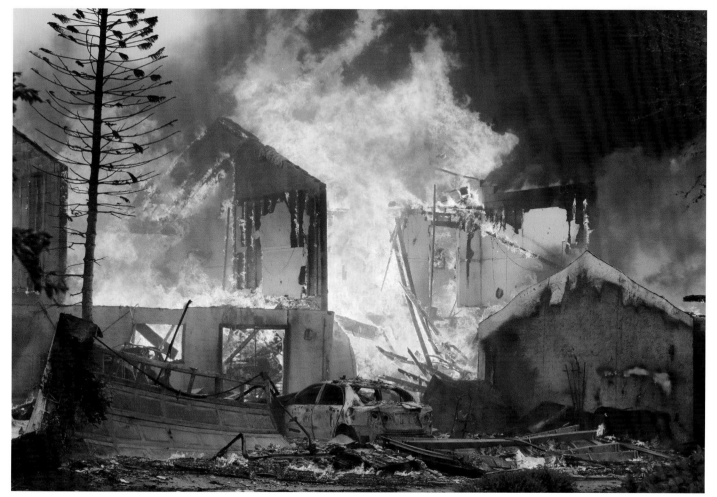

BEACON | TOP LEFT | The Dow Chemical Plant is seen in the background as palm trees sway in the gusty winds along Texas 332. While most of the area was dark due to power outages, generators kept the plant powered. | SEPT. 12 | LAKE JACKSON | **JULIO CORTEZ**

BRAVING THE ELEMENTS | TOP RIGHT | Stuart Robinson with Cyclone Research Group gets battered by winds and rain as he tries to get a look at the Seawall. | SEPT. 13 | GALVESTON | **JOHNNY HANSON**

CLOSE CALL | BOTTOM | Six townhomes burn on Beaudelaire Circle. Frederika Kotin, the owner of one of the townhomes, escaped with the clothes on her back, one shoe and her dog. | SEPT. 13 | GALVESTON | **MELISSA PHILLIP**

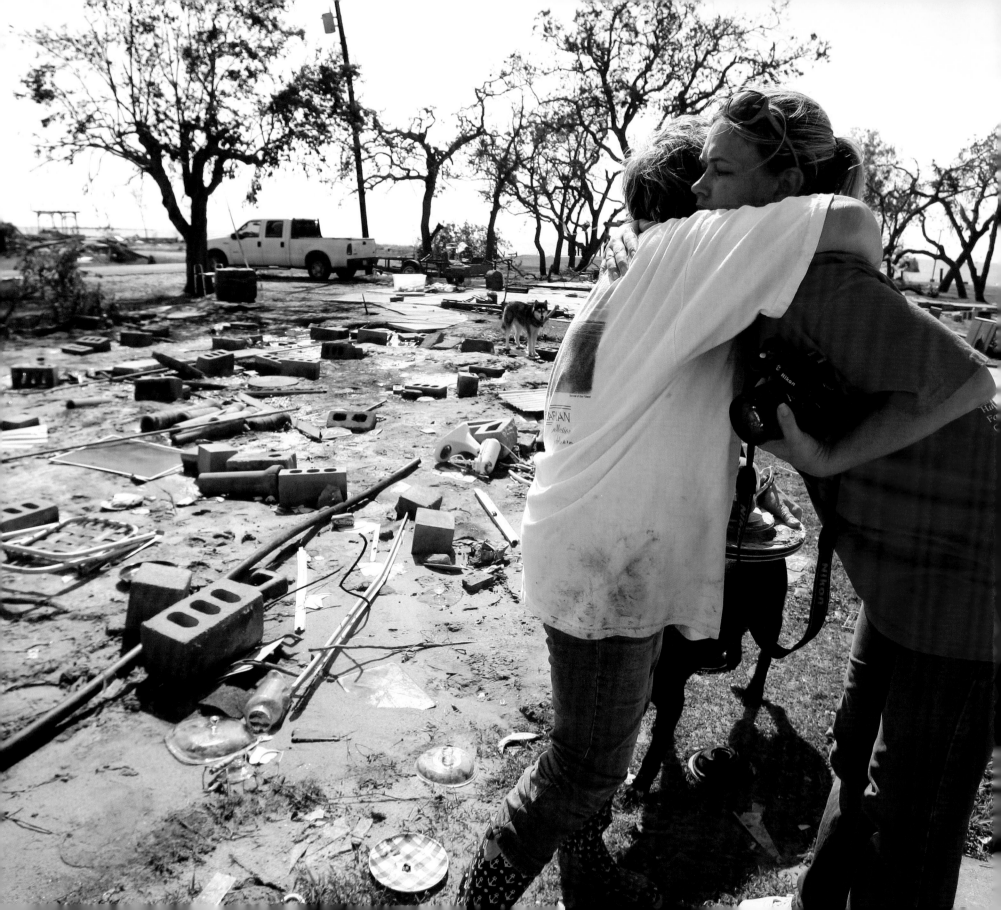

CHAPTER *Three*

days of misery

Saturday came and Ike left, and those who lay behind its wide swath opened their doors to a
tableau of destruction rarely seen outside of war zones. Trees and portions of trees lay everywhere
akimbo, leading to power outages that would take weeks to fully repair. Signs were down, roofs were
off, cars were flooded and things were generally tossed about in the manner of a child's tantrum.
But true heartbreak was headquartered in Galveston and points immediately east, where Ike's
surge had swept through thousands of homes and businesses and flattened hundreds of them
completely. Some of those washed-away homes — nobody knows precisely how many — had
people still in them when the water arrived. Rescue crews spent long hours finding those stranded
by the storm, and search teams spent weeks looking through debris fields and marshes for bodies.
At least 40 perished. Galveston city officials pleaded with residents to stay away until services could
be restored, finally relenting in the face of pressure. The residents, like their counterparts in nearby
towns and communities, returned to find a city irrevocably changed.

PAINFUL TASK | OPPOSITE | Vicky Dearman, left, gets a hug from her friend, Sandra Ysassi, as Dearman sifts through the rubble of her father's home for her family's heirlooms.
| SEPT. 15 | OAK ISLAND | **SHARÓN STEINMANN**

HISTORIC LOSSES | TOP | Mold damaged books on the lower floors of the Rosenberg Library, home of the Galveston and Texas History Center. | SEPT. 20 | GALVESTON | **JOHNNY HANSON**

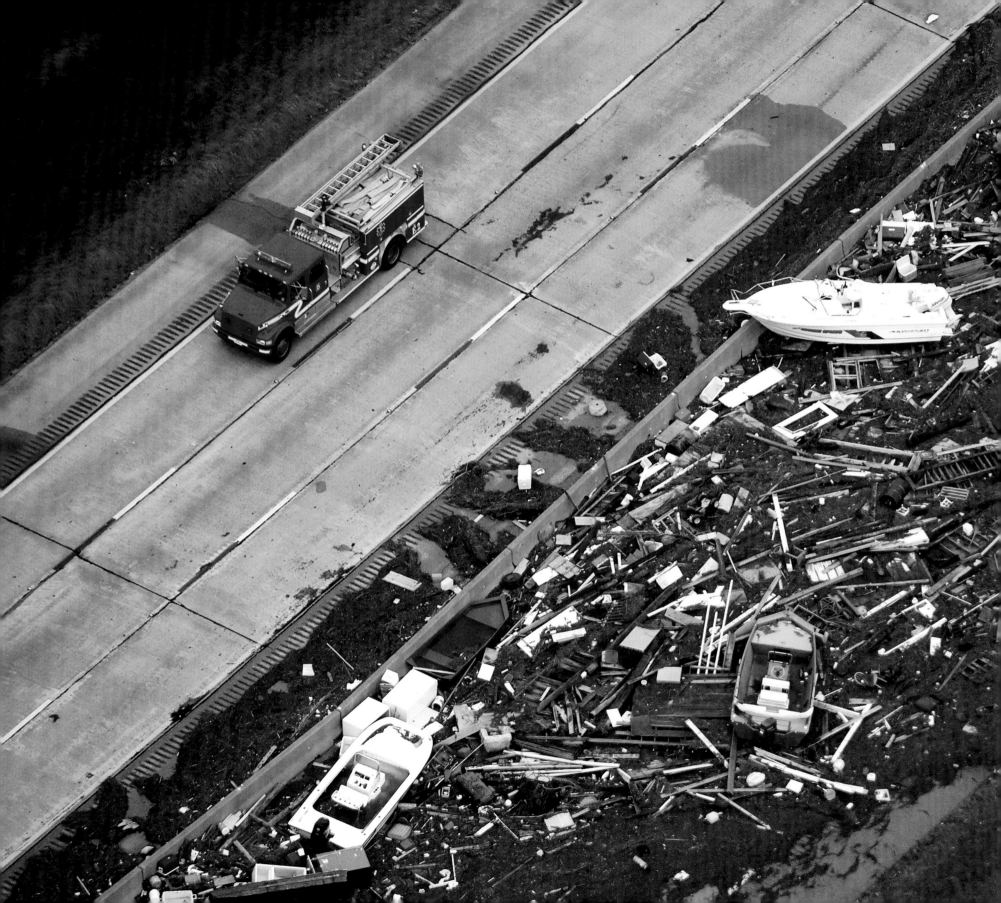

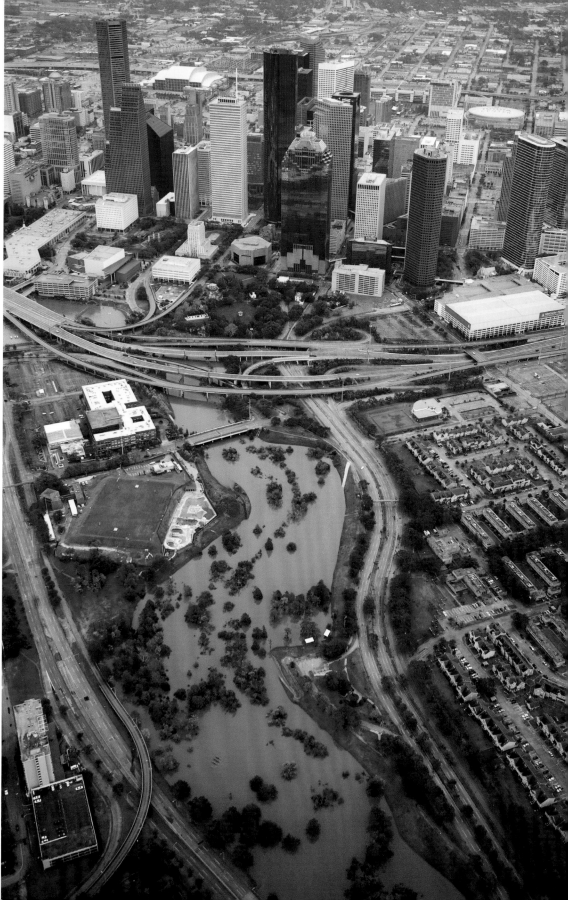

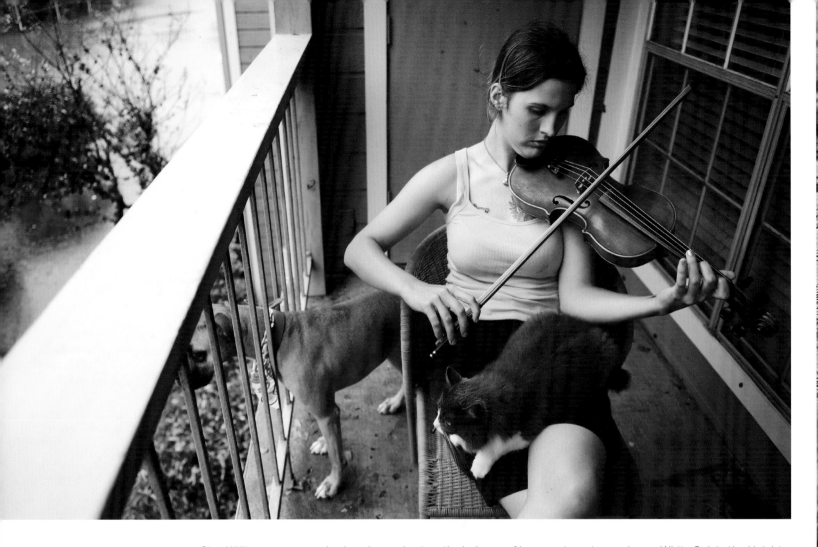

SOOTHING SOUNDS | ABOVE | Gina Williamson serenades her dog and cat on the balcony of her apartment complex on White Oak in the Heights. "There's nothing else to do but sit here," she said. Williamson, who works at a nearby animal hospital, planned to report to duty to care for the boarded animals of evacuees. | SEPT. 13 | HOUSTON | **SMILEY N. POOL**

WHIRLPOOL | OPPOSITE | Greg Schenck struggles to remove debris from a drain causing flooding on North Main just north of downtown. | SEPT. 13 | HOUSTON | **SMILEY N. POOL**

RIVER OF MUD | PREVIOUS LEFT | Debris covers Interstate 45 southbound. | SEPT. 13 | LA MARQUE | **SMILEY N. POOL**

BRIMMING | PREVIOUS RIGHT | Buffalo Bayou nears its banks. | SEPT. 13 | HOUSTON | **SMILEY N. POOL**

ROADBLOCKS | FOLLOWING LEFT | Debris covers the southbound lanes of Interstate 45. | SEPT. 13 | LA MARQUE | **ERIC KAYNE**

STADIUM | FOLLOWING TOP RIGHT | Damage to the retractable roof of Reliant Stadium. The Astrodome is at left. | SEPT. 13 | HOUSTON | **SMILEY N. POOL**

FIRST LOOK | FOLLOWING BOTTOM RIGHT | Adolfo Navia, right, and his son Miguel emerge from a shelter at Christ the King Catholic Church to survey damage on North Main. | SEPT. 13 | HOUSTON | **SMILEY N. POOL**

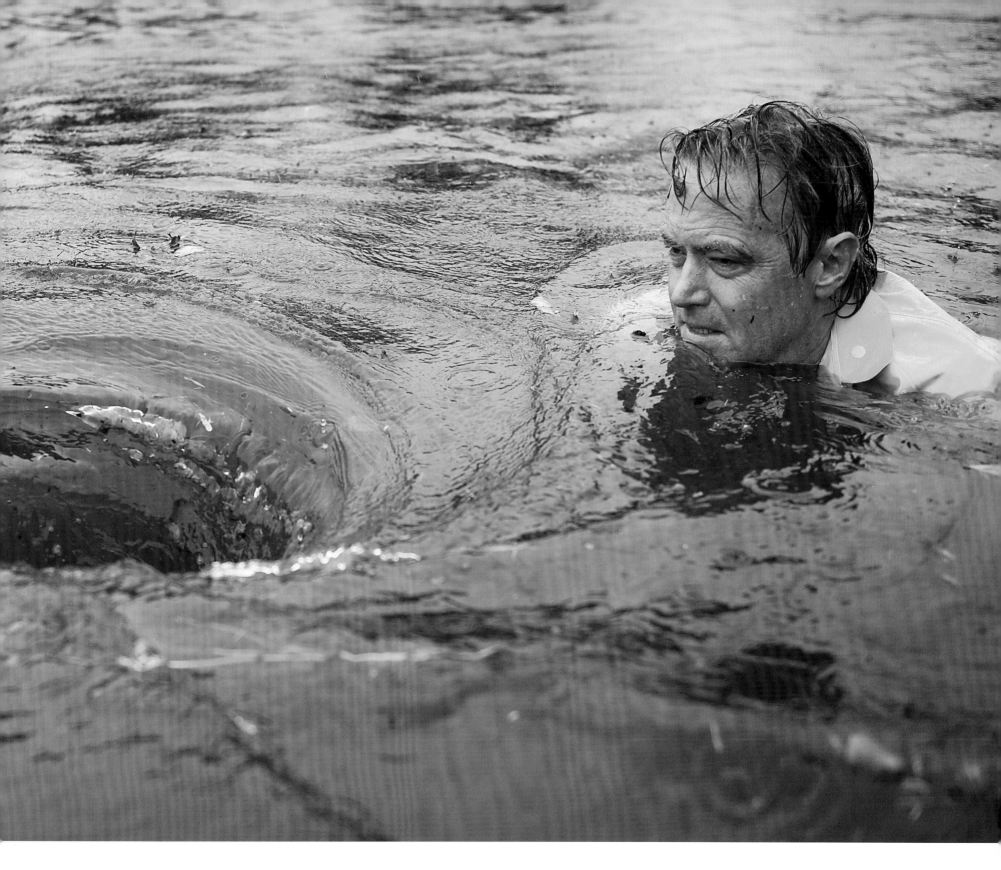

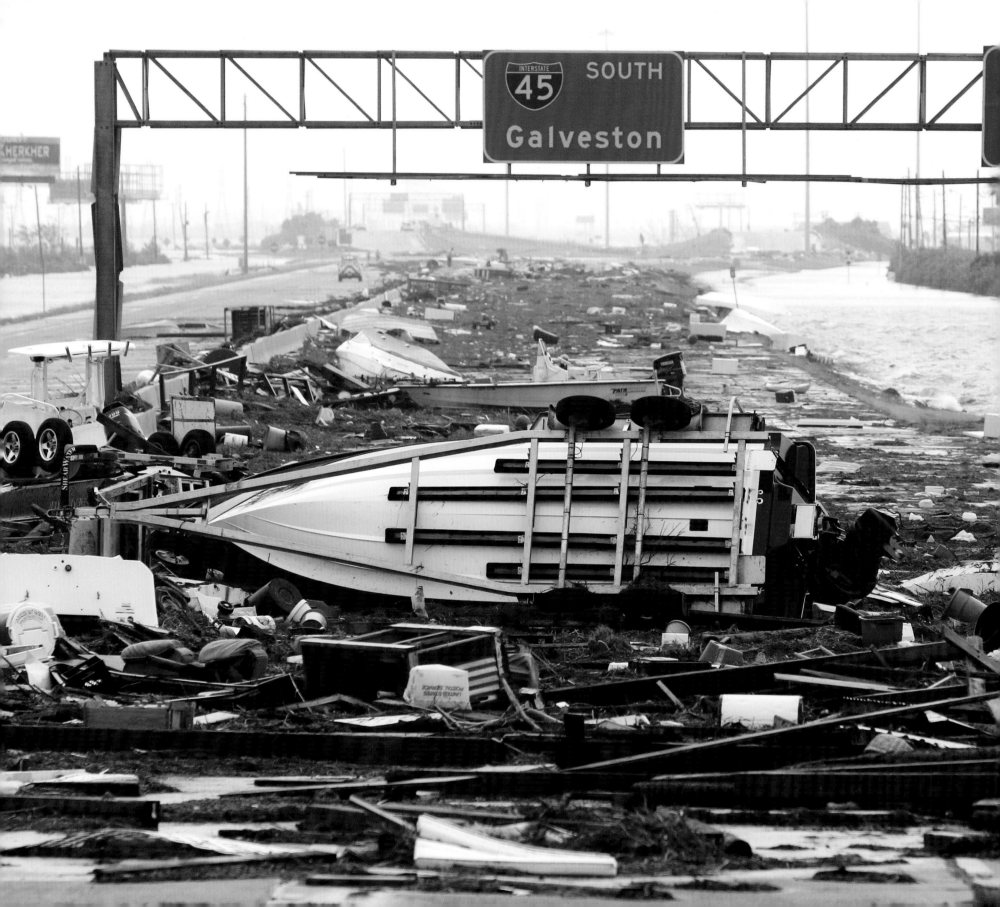

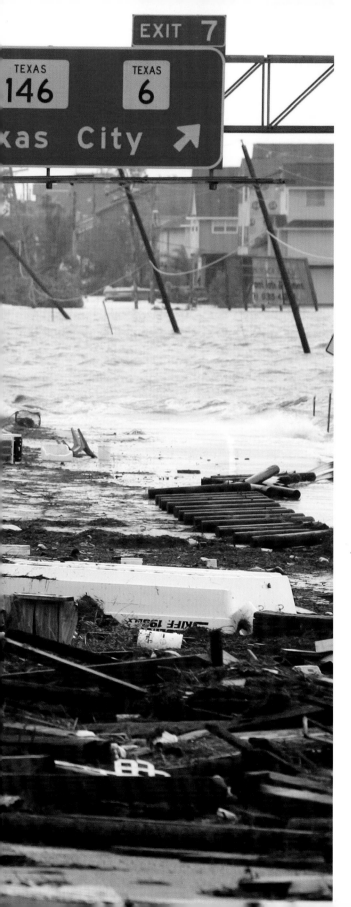

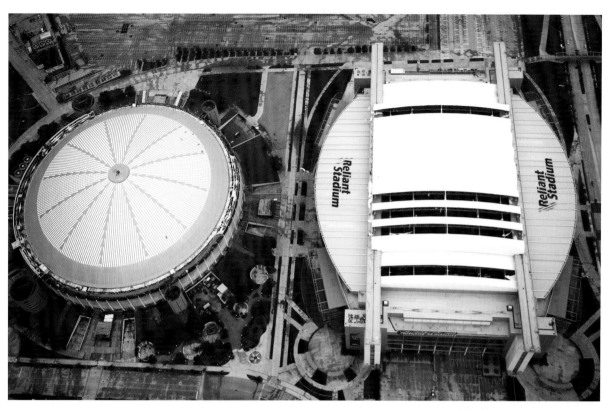

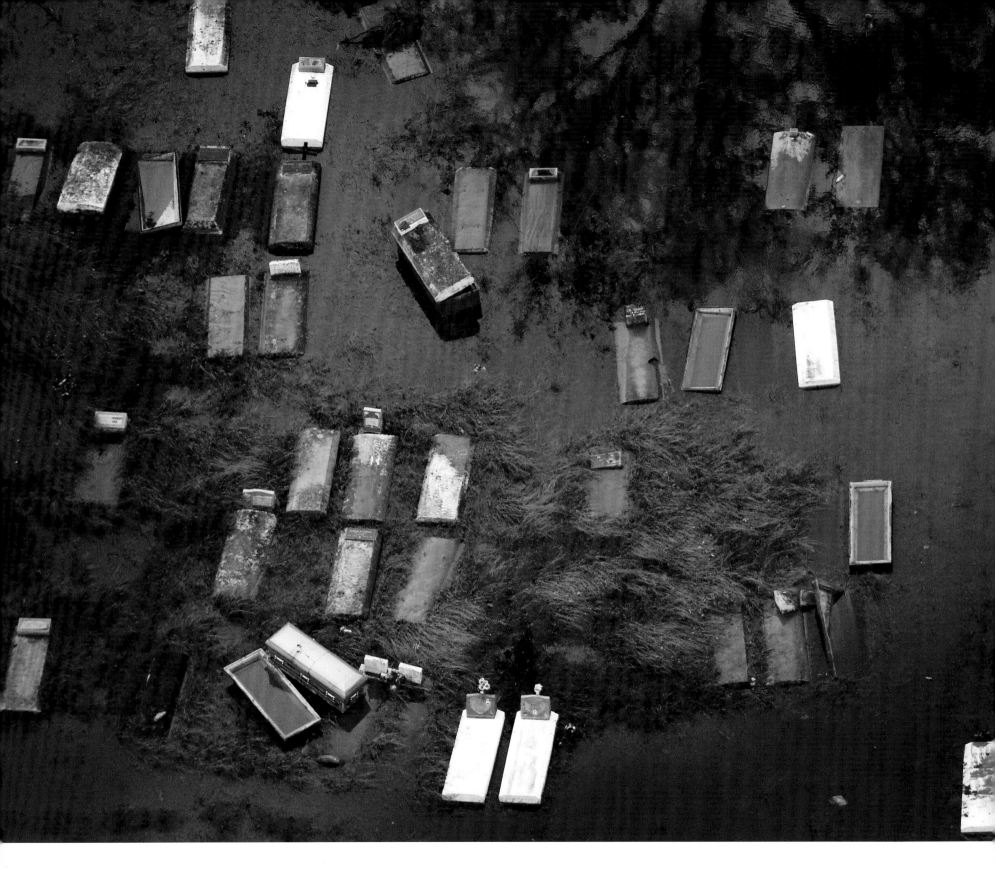

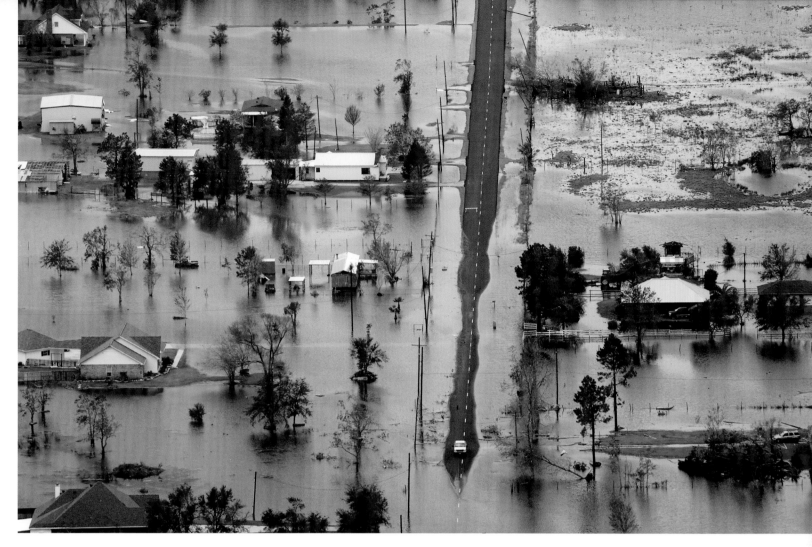

NARROWS | ABOVE | A road peeks out of the high waters surrounding several homes. | SEPT. 14 | WINNIE | **SMILEY N. POOL**

UNEARTHED | OPPOSITE | Murky water inundates a cemetery. | SEPT. 14 | ORANGE | **SMILEY N. POOL**

HAVOC | FOLLOWING LEFT | Debris surrounds damaged aircraft and hangars at Scholes International Airport. | SEPT. 13 | GALVESTON | **SMILEY N. POOL**

NO PLACE SAFE | FOLLOWING RIGHT | Alison Naquin, 14, takes a measure of all the damage to her bedroom. Naquin was in the game room with her family when the roof caved in over her bed. | SEPT. 13 | PEARLAND | **MAYRA BELTRÁN**

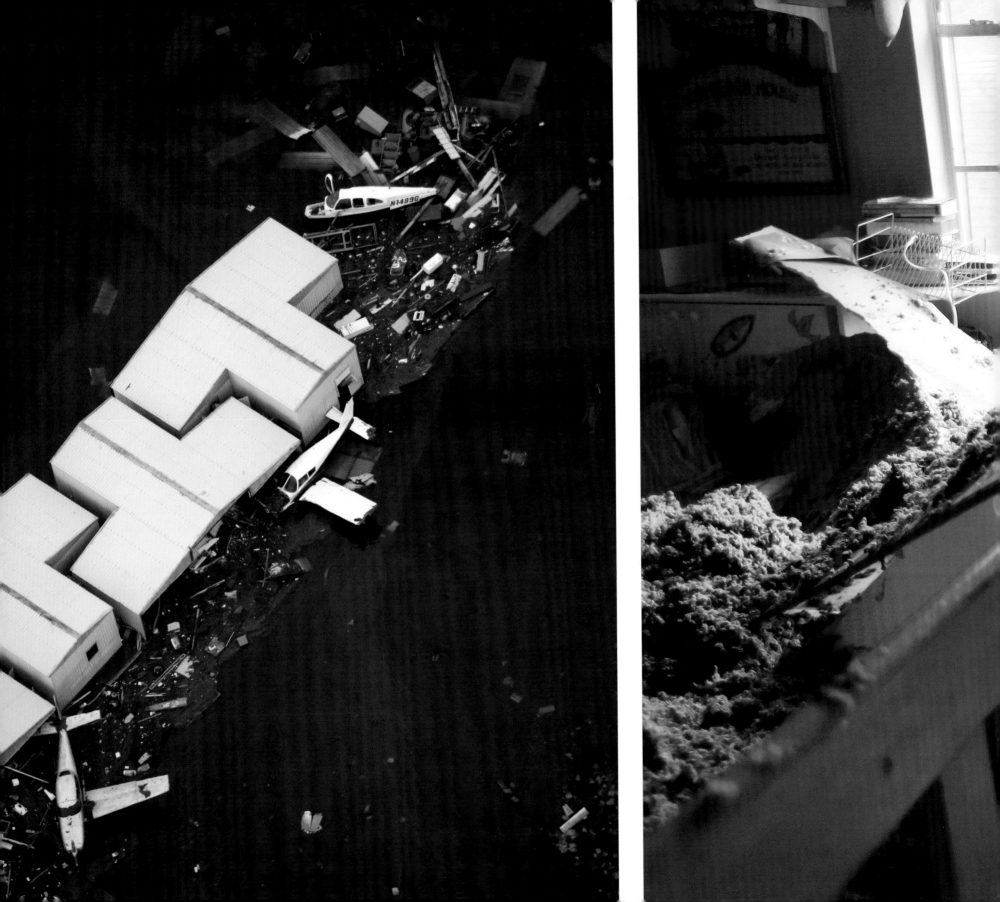

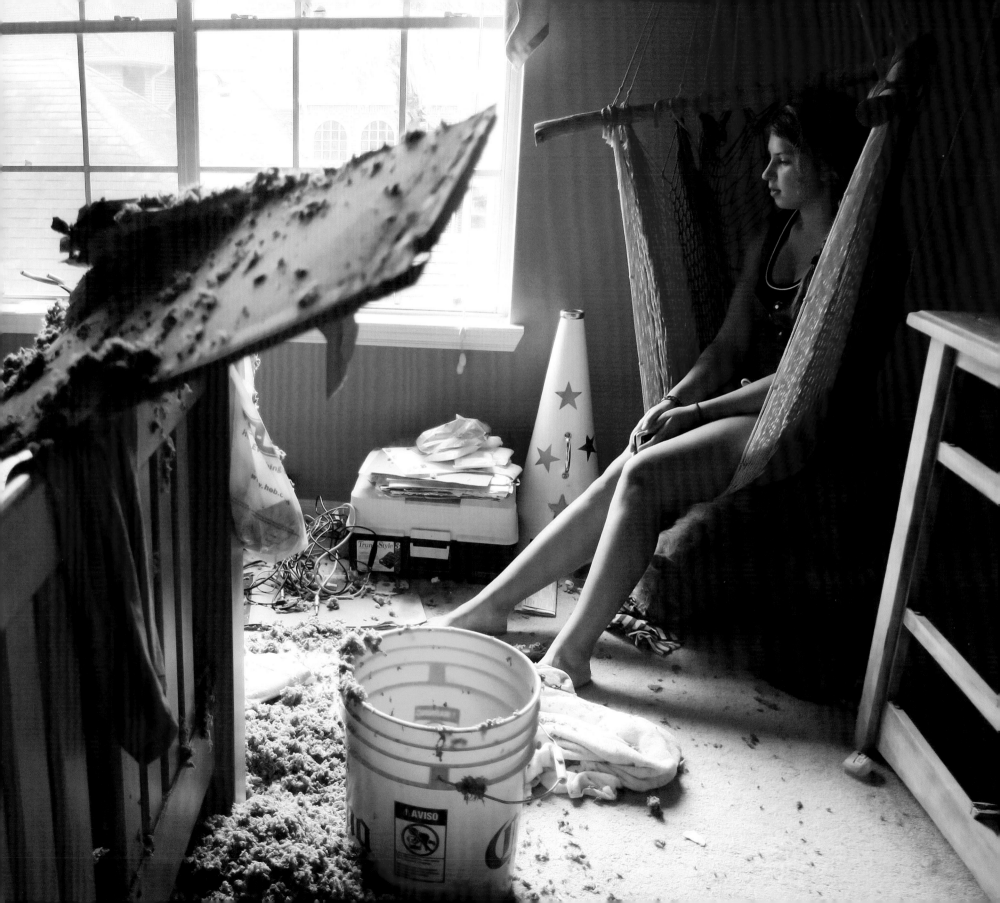

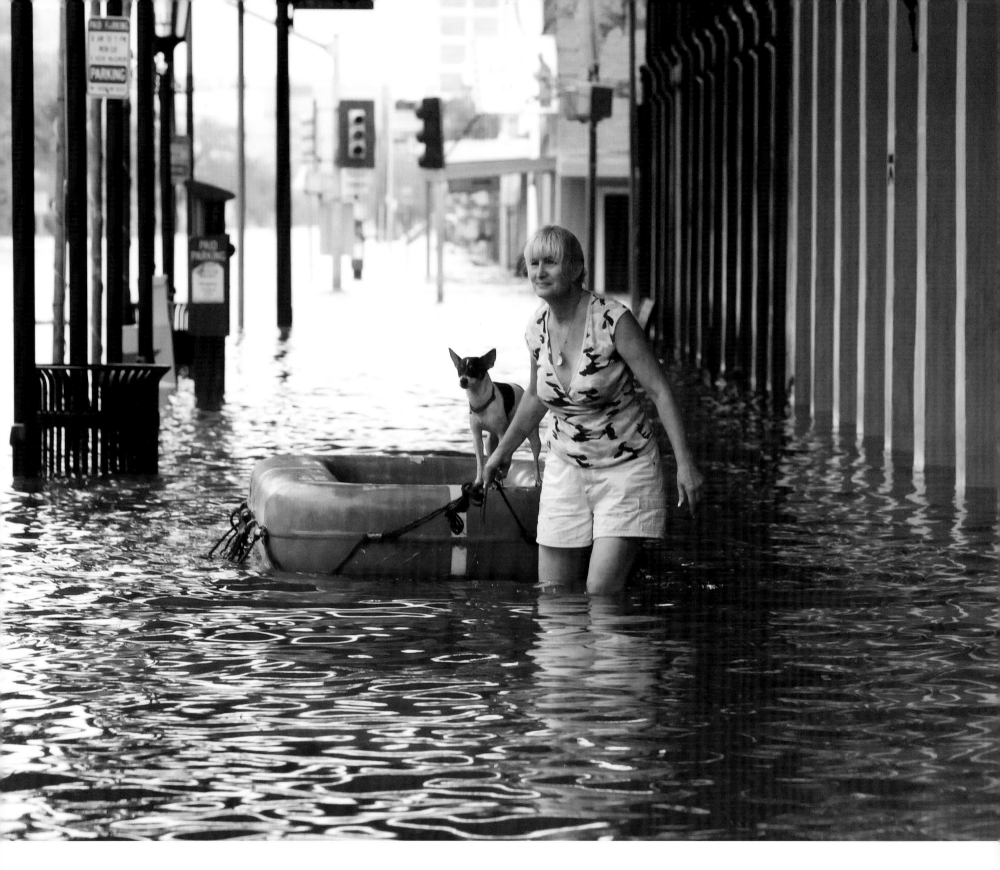

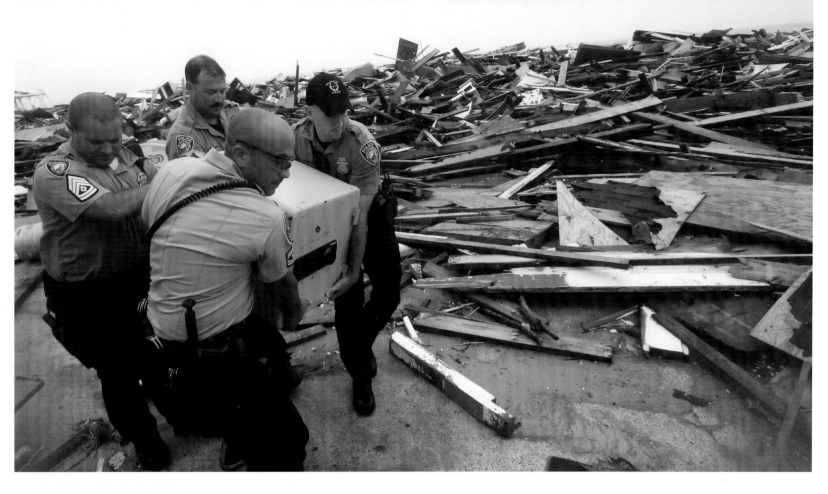

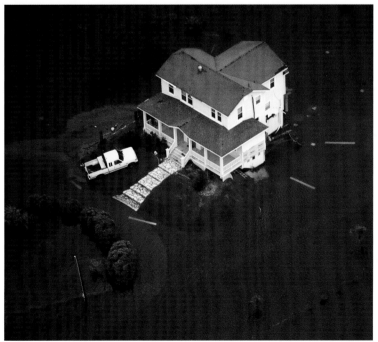

GETTING AROUND | OPPOSITE | Leslie Sundell floats her dog on a life raft as she walks along the Strand after the hurricane. | SEPT. 13 | GALVESTON | **BRETT COOMER**

CACHE OUT | TOP | Police remove a safe from the rubble of the Hooters restaurant on Seawall Boulevard. | SEPT. 13 | GALVESTON | **JOHNNY HANSON**

ISLAND HOME | BOTTOM | A house is surrounded by floodwaters. | SEPT. 13 | GALVESTON | **SMILEY N. POOL**

MURK AND MIRE | FOLLOWING TOP LEFT | Tom LeCroy wades through debris-choked floodwaters along the Strand after riding out the storm on the historic street. LeCroy's restaurant suffered major flood damage. | SEPT. 13 | GALVESTON | **BRETT COOMER**

URBAN SEA | FOLLOWING BOTTOM LEFT | Floodwaters cover Interstate 45 just north of downtown. | SEPT. 13 | HOUSTON | **SMILEY N. POOL**

BROKEN GLASS | FOLLOWING RIGHT | The Chase Tower is pockmarked with blown-out windows. | SEPT. 13 | HOUSTON | **JAMES NIELSEN**

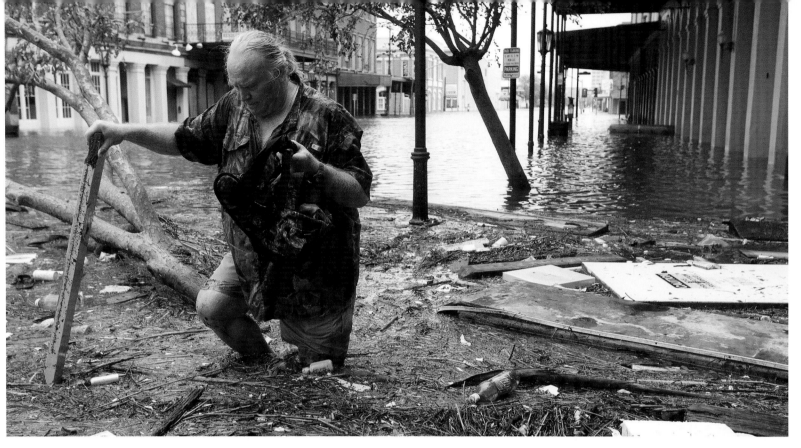

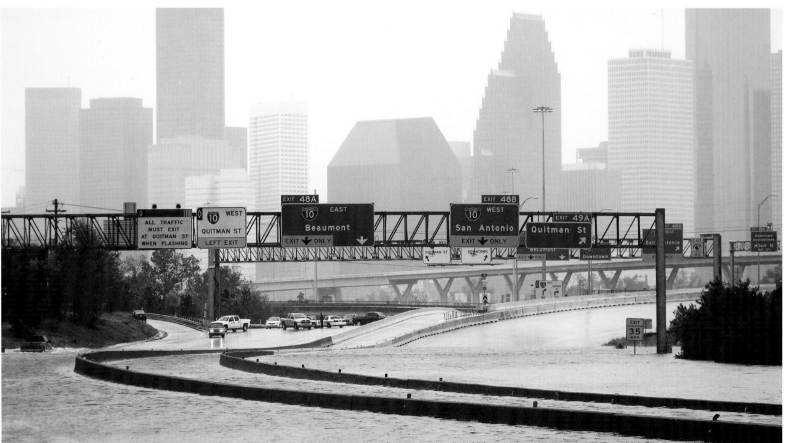

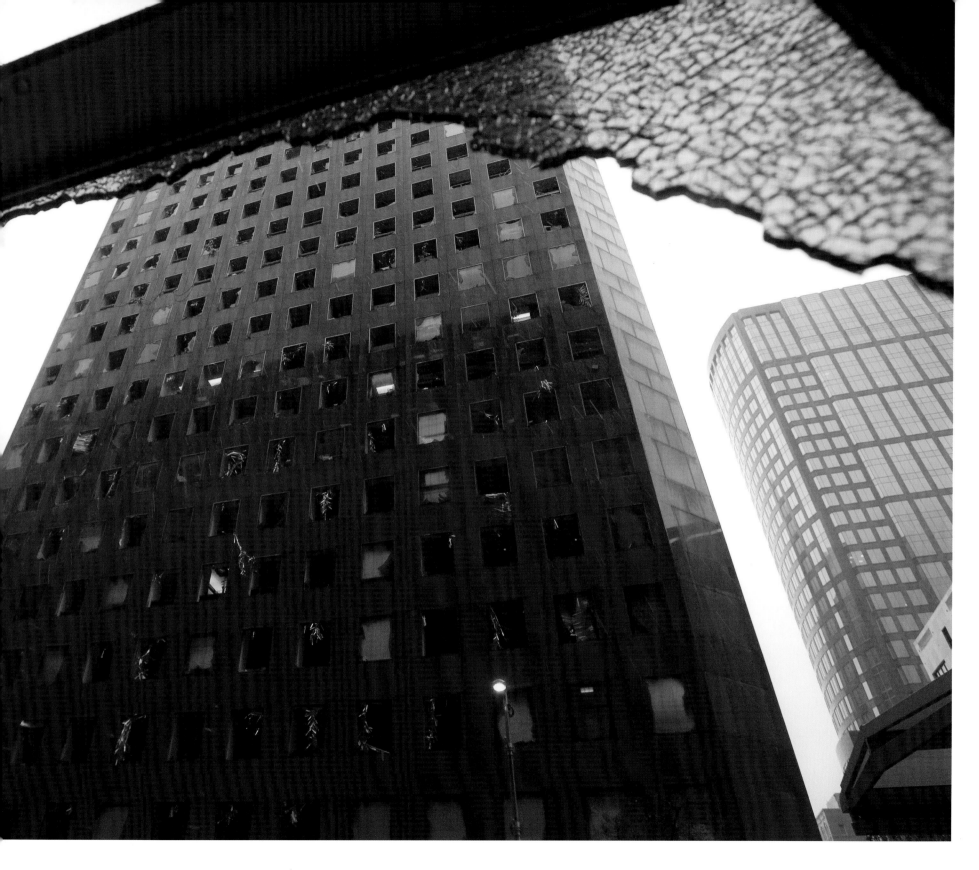

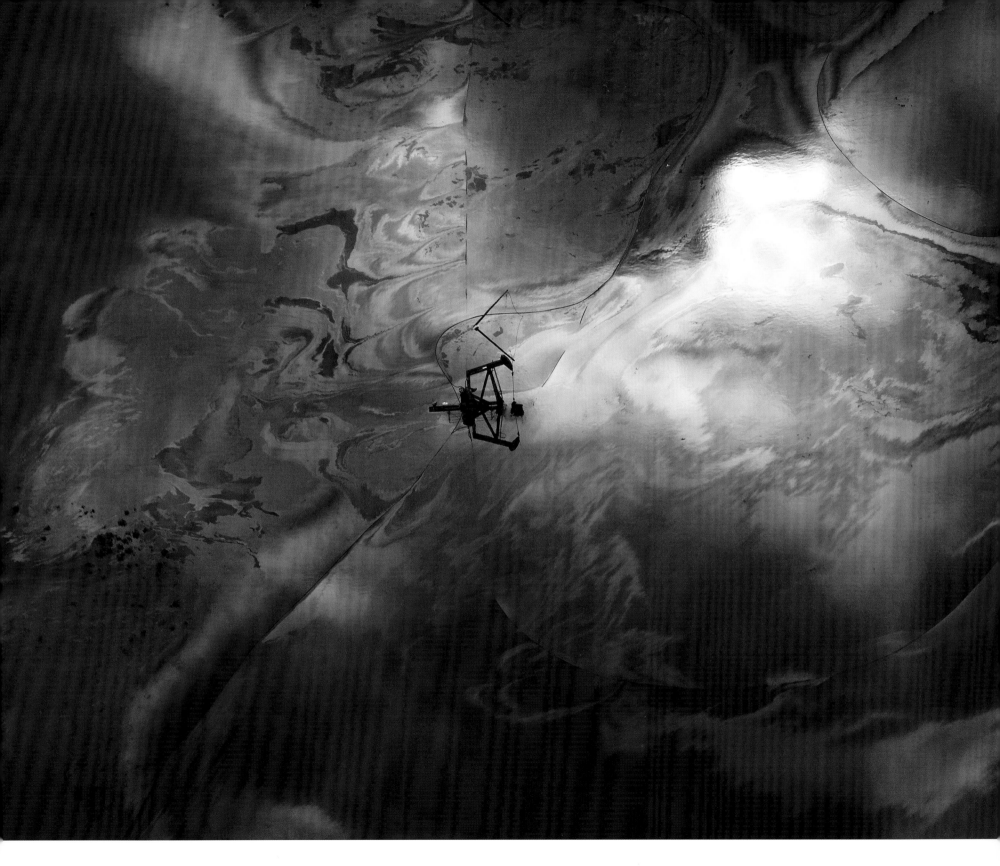

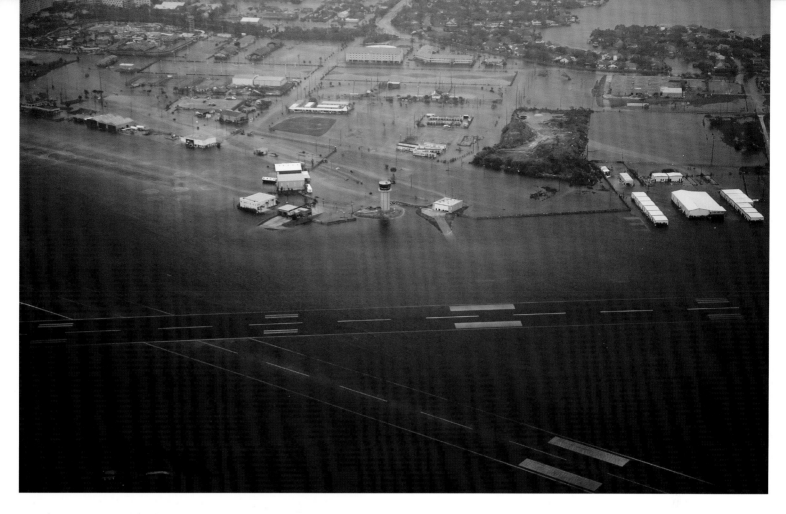

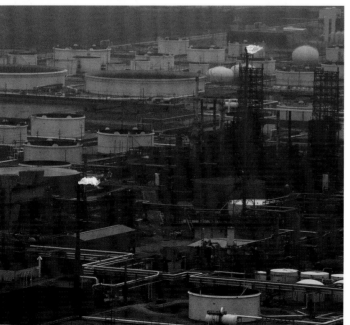

SHIMMER | OPPOSITE | A sheen of oil is seen in the floodwaters surrounding a pump jack. | SEPT. 14 | HIGH ISLAND | **SMILEY N. POOL**

FIELD OF WATER | TOP | Floodwaters cover Scholes International Airport. | SEPT. 14 | GALVESTON | **SMILEY N. POOL**

BACK TO WORK | BOTTOM | Flares light up a refinery as the facility starts up again after the hurricane. | SEPT. 13 | TEXAS CITY | **SMILEY N. POOL**

HARD RIDE | FOLLOWING LEFT | A man pedals his bicycle through floodwaters on North Main. | SEPT. 13 | HOUSTON | **SMILEY N. POOL**

GOING HOME | FOLLOWING RIGHT | Aletia Sikes pushes her mother, Emma Yarborough, and her dog Pablo in a wheelchair as her husband, Robert Sikes, carries their belongings. The family said the bad conditions at the shelter prompted them to leave. | SEPT. 13 | GALVESTON | **MELISSA PHILLIP**

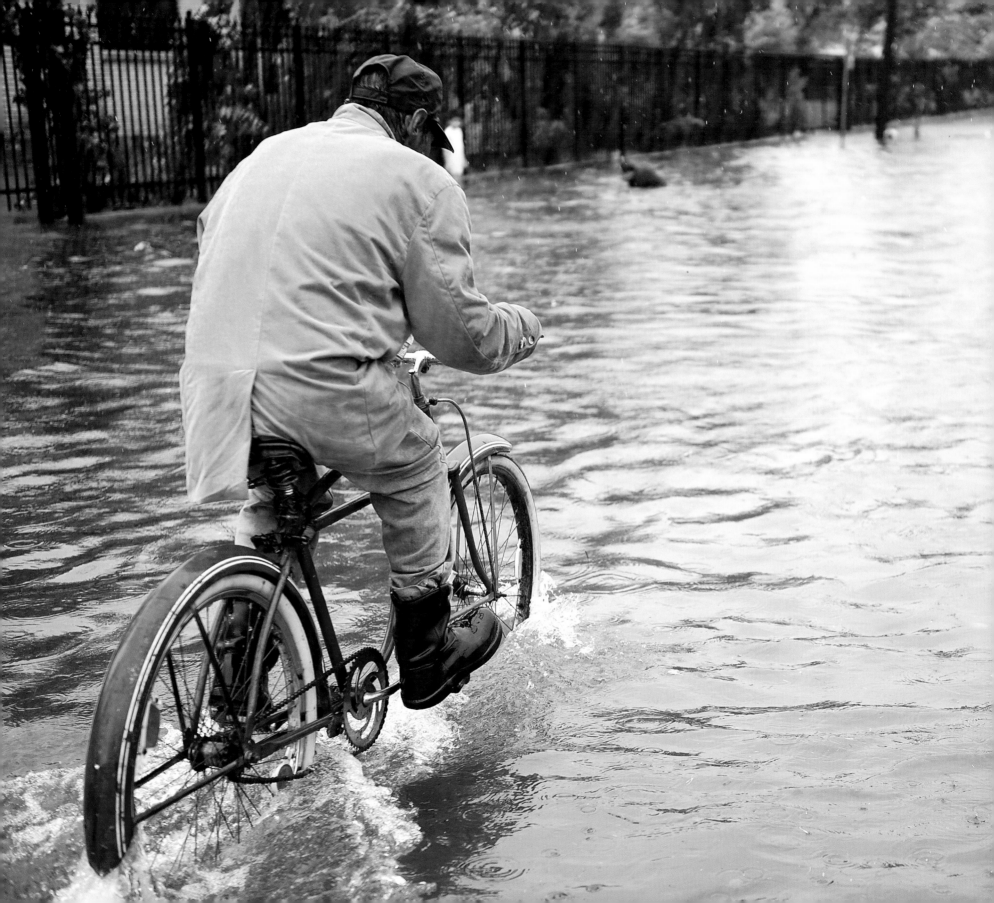

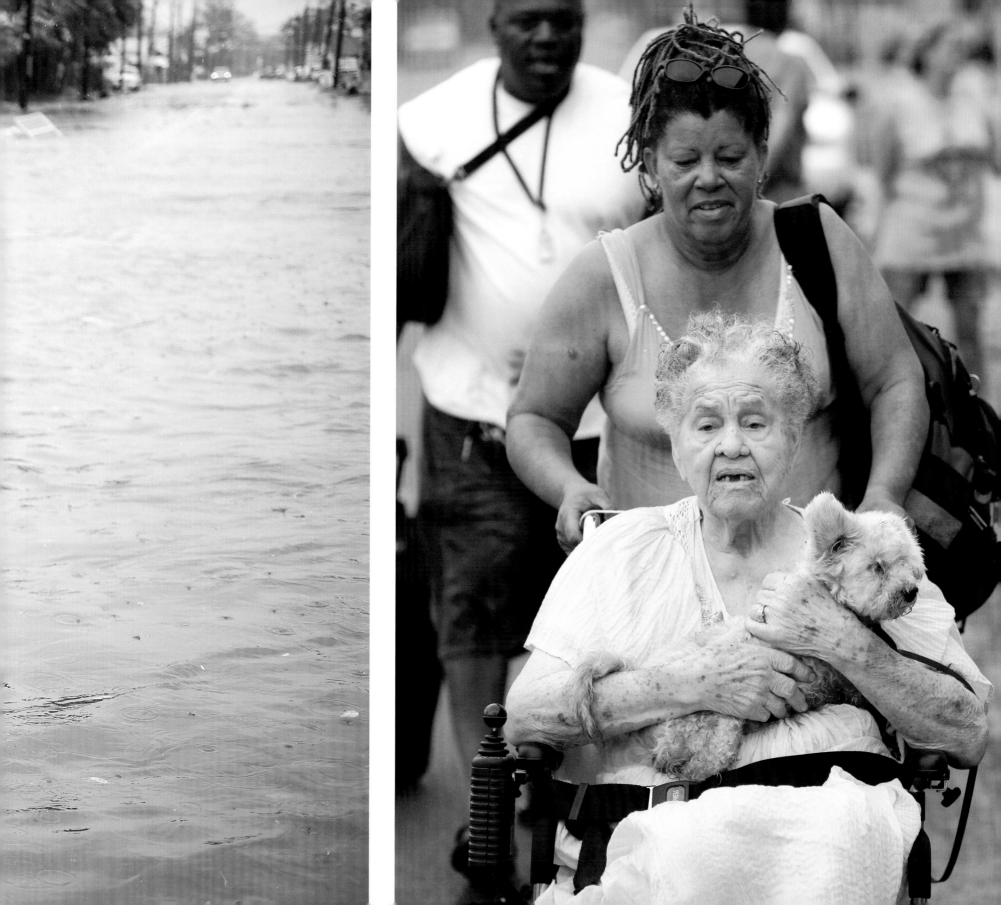

IN TOO DEEP | TOP | Chris Symank leaves his flooded Jeep after checking on a friend's house. He said he forgot about the road's dip in that spot until it was too late. | SEPT. 12 | KEMAH | **ERIC KAYNE**

GROUND COVER | BOTTOM | Residents survey the fallen limbs that litter Bayland Avenue in the Heights. | SEPT. 13 | HOUSTON | **SMILEY N. POOL**

IMPROVISATION | OPPOSITE | A pickup is turned into a makeshift ambulance as 76-year-old Peggy Eisworth is placed in the bed of the truck to be carried to a hospital. Eisworth tripped in the dark and broke her hip. | SEPT. 13 | PEARLAND | **MAYRA BELTRÁN**

SIGN OF IRONY | FOLLOWING LEFT | Henry Vasquez salvages a sign from the remains of Murdoch's Pier and Hooters that reads, "A bad day at the beach. What??? There is no bad day at the beach." | SEPT. 13 | GALVESTON | **JOHNNY HANSON**

FROM THE FIRE | FOLLOWING RIGHT | Frederika Kotin hugs her dog, Belle. Kotin's townhouse was one of six in a row that burned on Beaudelaire Circle. | SEPT. 13 | GALVESTON | **MELISSA PHILLIP**

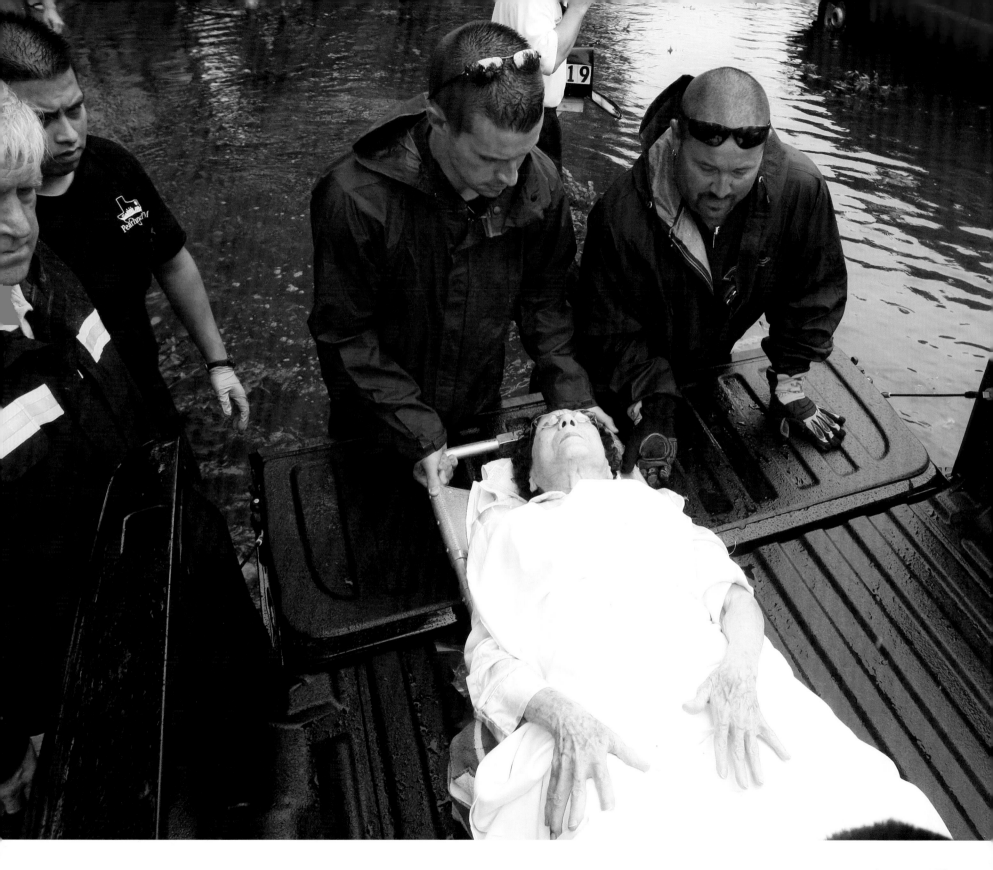

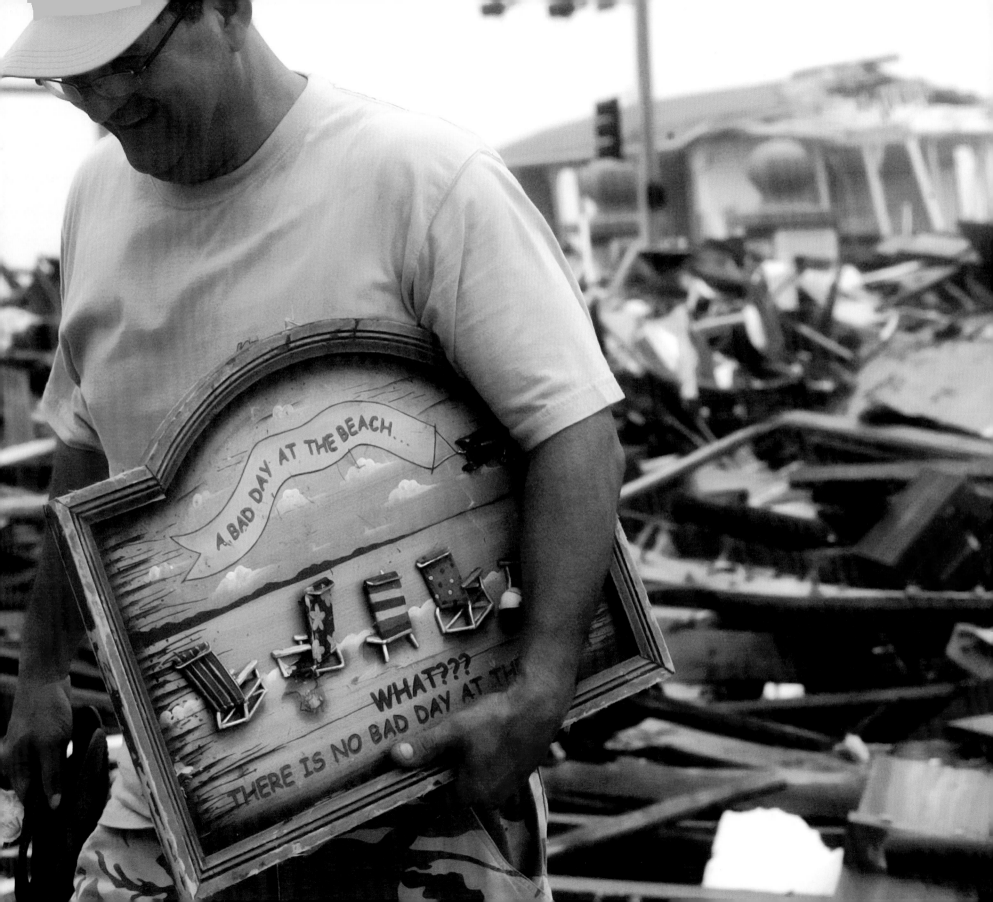

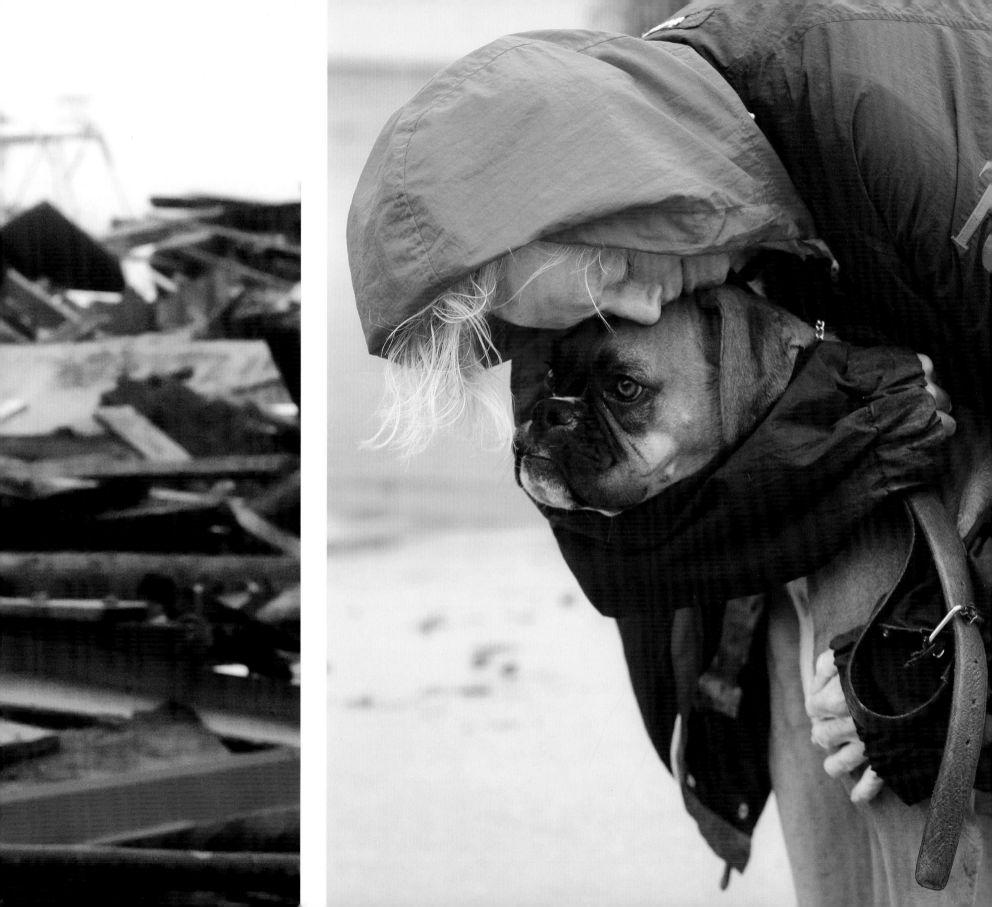

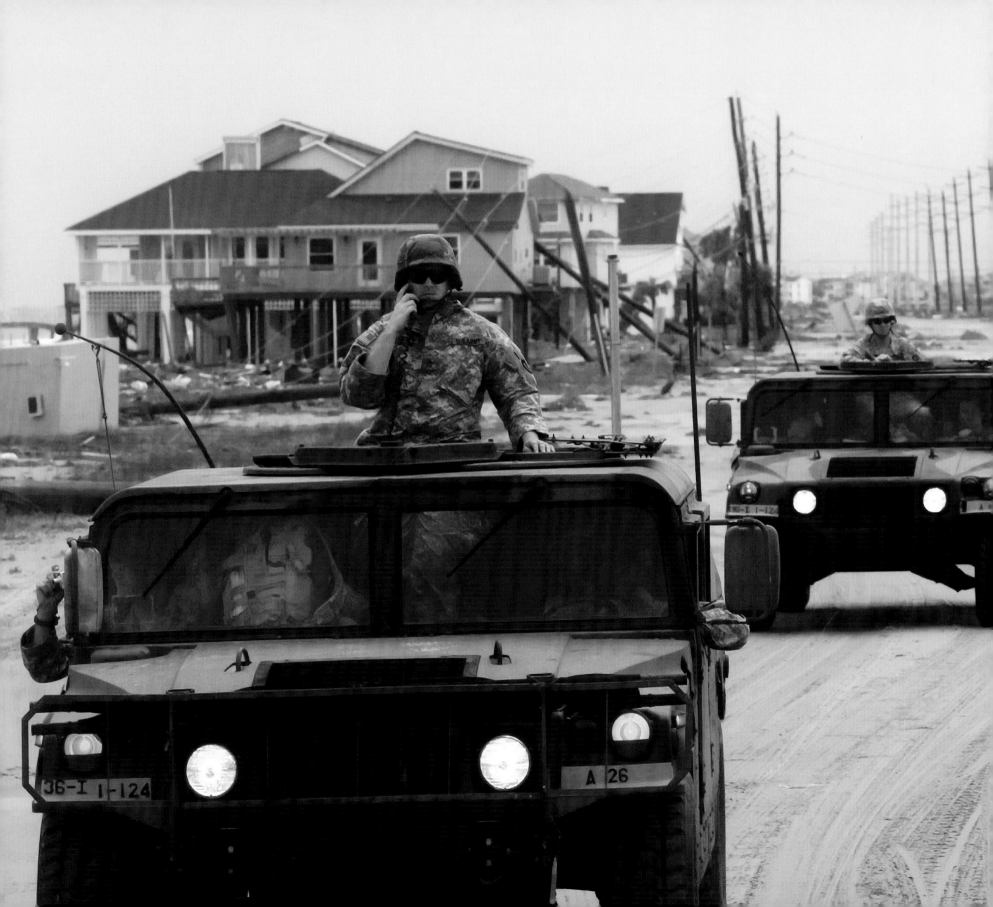

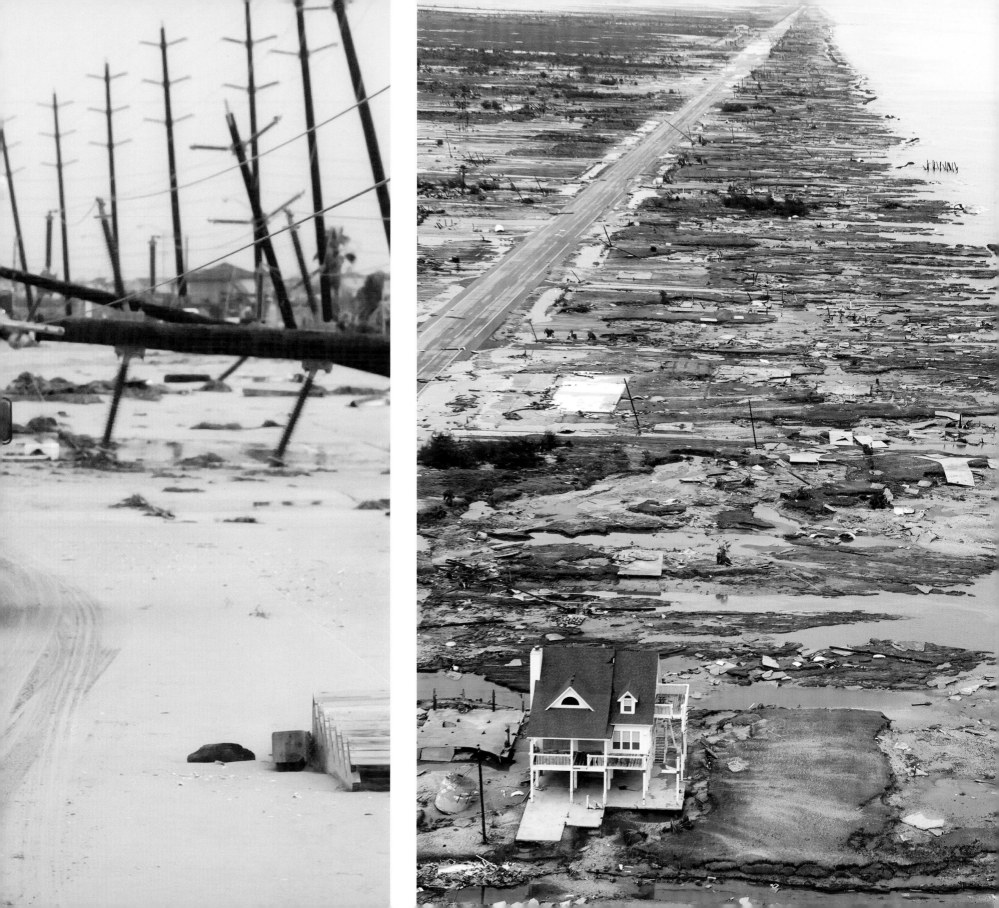

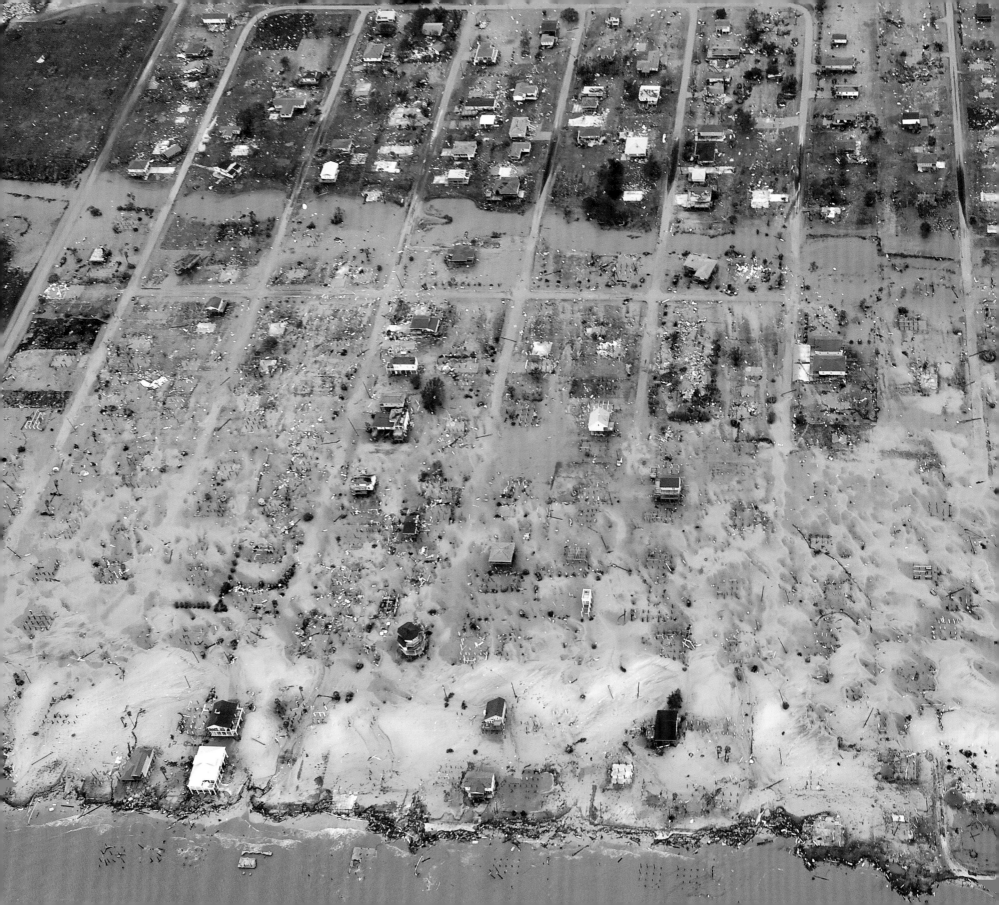

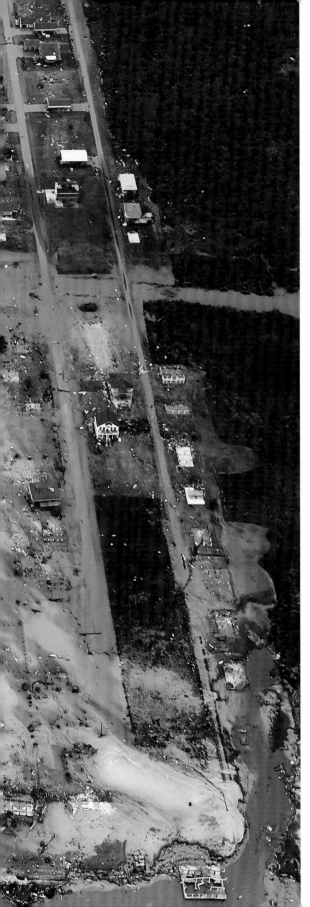

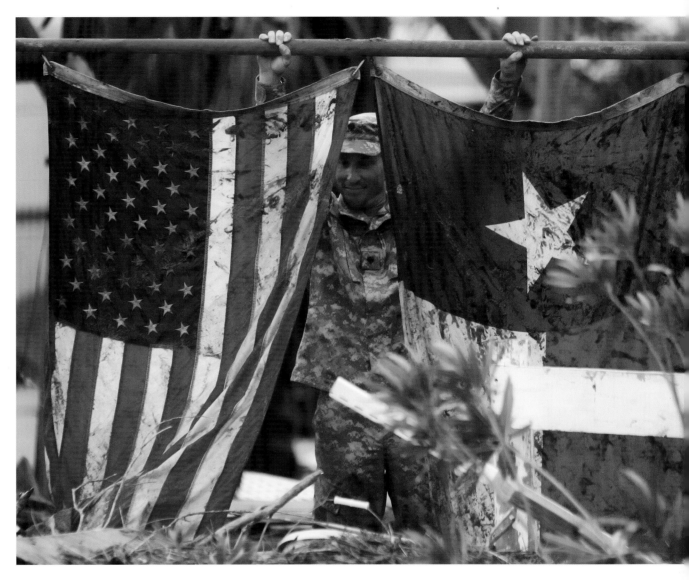

TATTERED | ABOVE | Spc. Scott Hayes with the Texas Army National Guard hoists a muddied set of flags as guardsmen conduct search and rescue operations. | SEPT. 14 | GALVESTON | **SHARÓN STEINMANN**

WIPED OUT | OPPOSITE | A tableau of devastation left by the hurricane. | SEPT. 13 | CRYSTAL BEACH | **SMILEY N. POOL**

RESCUE MISSION | PREVIOUS LEFT | Members of the Army National Guard's C-Troop make their way past the destruction to rescue two stranded women in the Pointe West neighborhood. | SEPT. 14 | GALVESTON | **JOHNNY HANSON**

STILL STANDING | PREVIOUS RIGHT | A single house is left standing amidst the devastation. | SEPT. 14 | GILCHRIST | **SMILEY N. POOL**

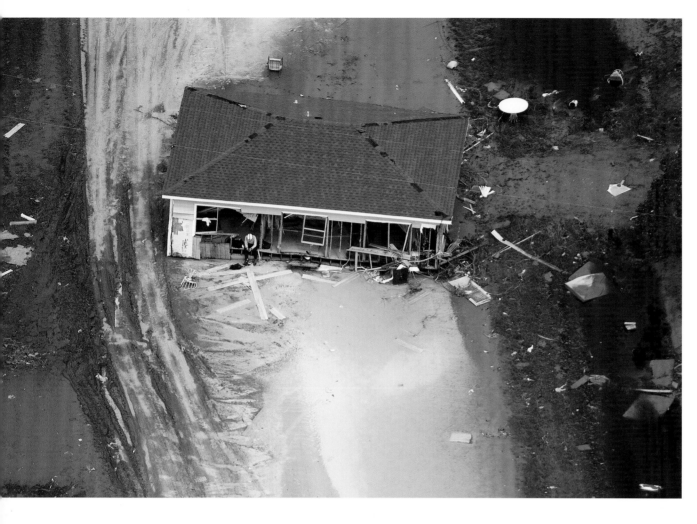

WEARY | ABOVE | A search worker rests on the porch of a house pushed askew during the hurricane. | SEPT. 15 |
CRYSTAL BEACH | **SMILEY N. POOL**

CUT OFF | OPPOSITE | A lone horse graces a flooded yard as waters close in. | SEPT. 14 | WINNIE | **SMILEY N. POOL**

LIVING UP TO ITS NAME | FOLLOWING LEFT | Water washes out roads heading into High Island. | SEPT. 14 | HIGH ISLAND |
SMILEY N. POOL

DRIVE THROUGH | FOLLOWING RIGHT | A pickup truck loaded with passengers in its bed braves the high waters.
| SEPT. 14 | HIGH ISLAND | **SMILEY N. POOL**

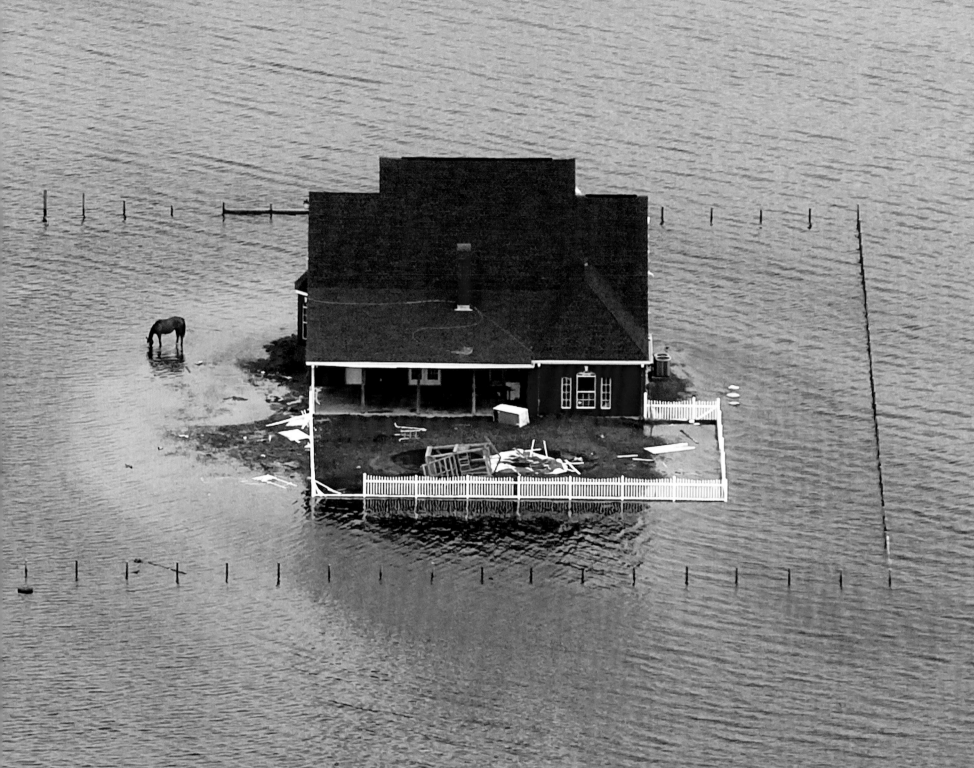

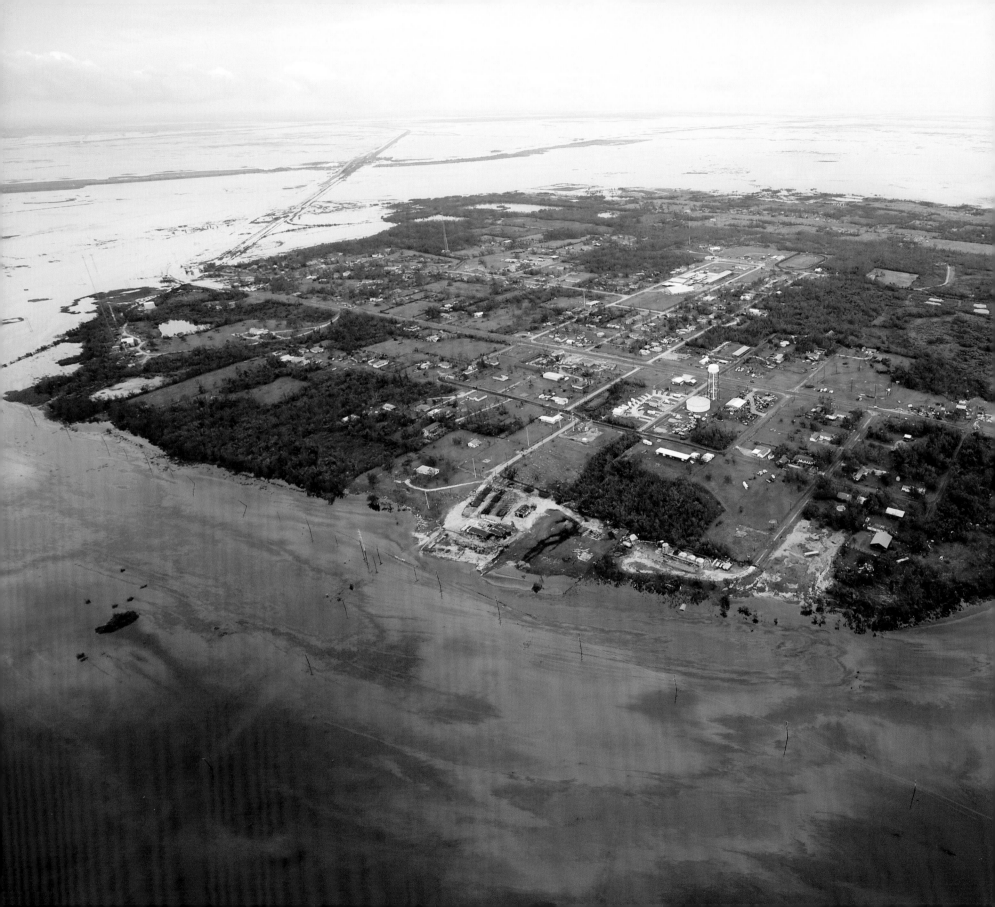

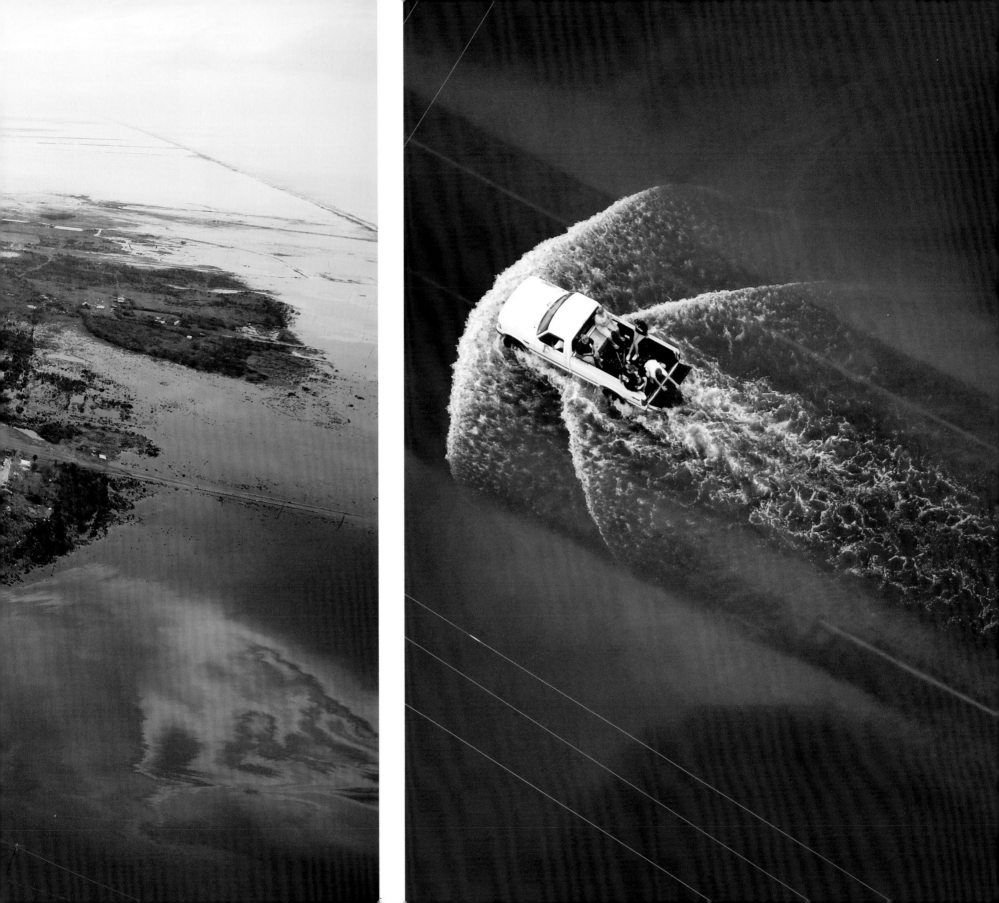

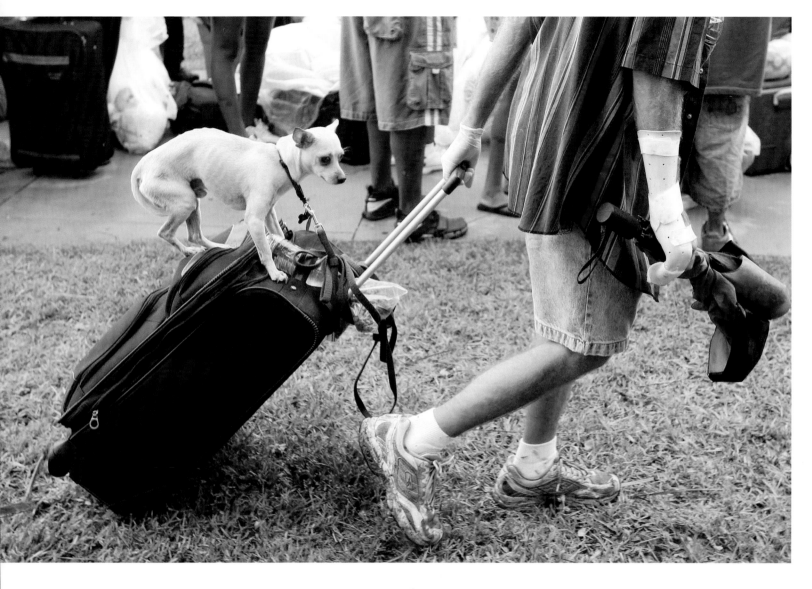

HITCHING A RIDE | ABOVE | Barry Warnke lugs his luggage — and his dog Kilo — to a waiting area where people with pets were being grouped together for a bus ride to a San Antonio shelter. | SEPT. 14 | GALVESTON | **MELISSA PHILLIP**

BUNDLED UP | OPPOSITE | Alina Van Epps is evaluated by emergency personnel as she waits to be evacuated. | SEPT. 14 | GALVESTON | **SHARÓN STEINMANN**

AMONG THE MASSES | FOLLOWING LEFT | Gilbert Cisneros holds his 2-year-old daughter, Gillissa, as they wait in line to be evacuated. | SEPT. 14 | GALVESTON | **MELISSA PHILLIP**

A WAY OUT | FOLLOWING MIDDLE | Ellie Cox carries her 6-month-old daughter, Jazya, as an unidentified California National Guardsman helps them to a helicopter so they can be evacuated to Texas City. | SEPT. 13 | GALVESTON | **MELISSA PHILLIP**

PACKED | FOLLOWING RIGHT | Joyce Earls and her daughter, Derica Williams, 4, wait with their family's dog, Blackie, for an evacuation bus. | SEPT. 14 | GALVESTON | **MELISSA PHILLIP**

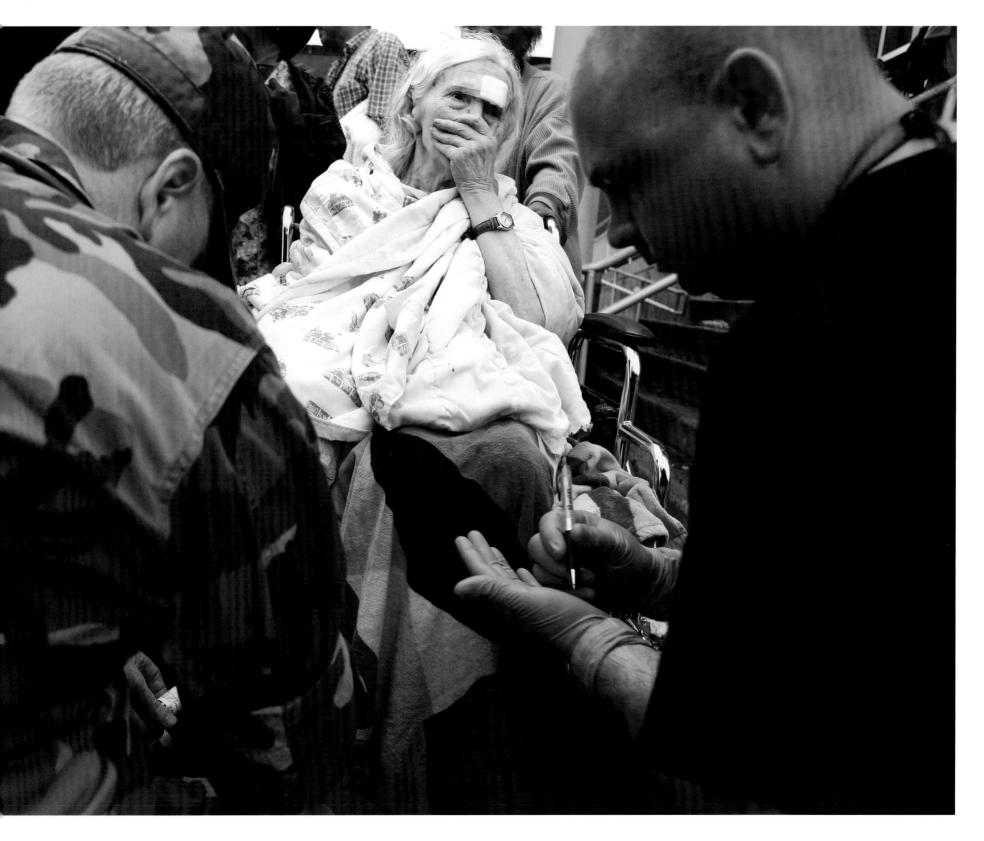

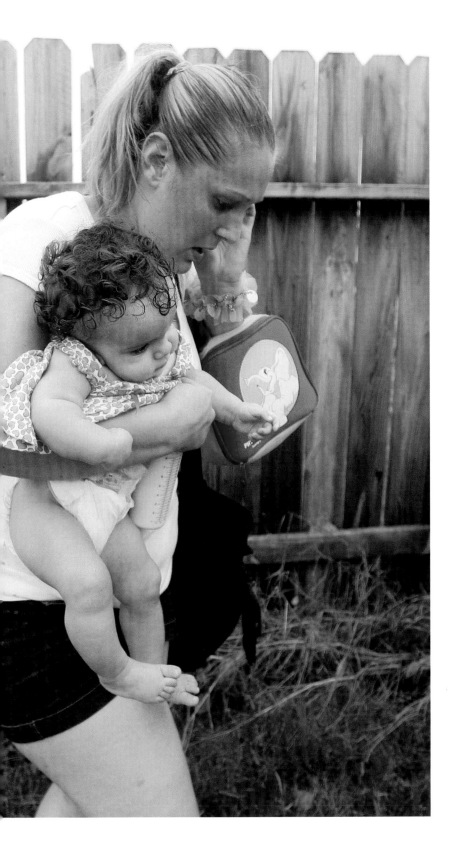
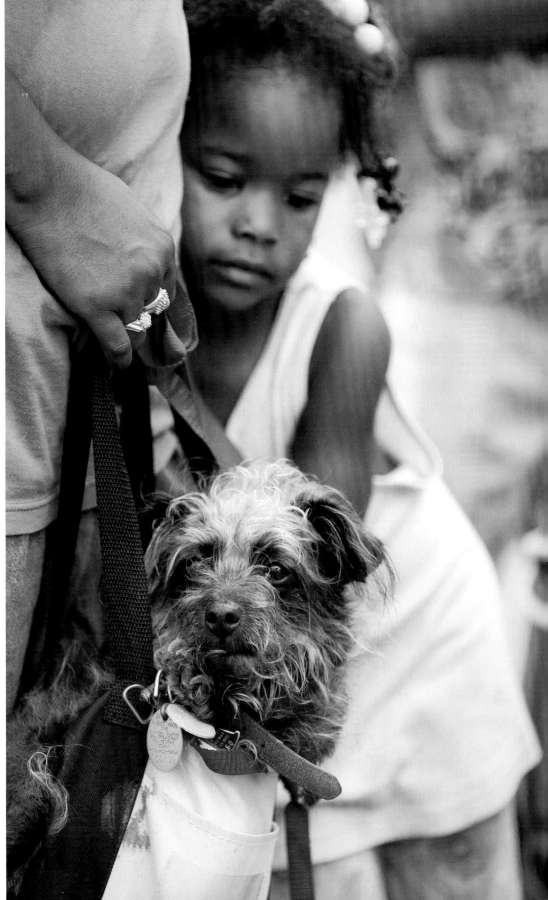

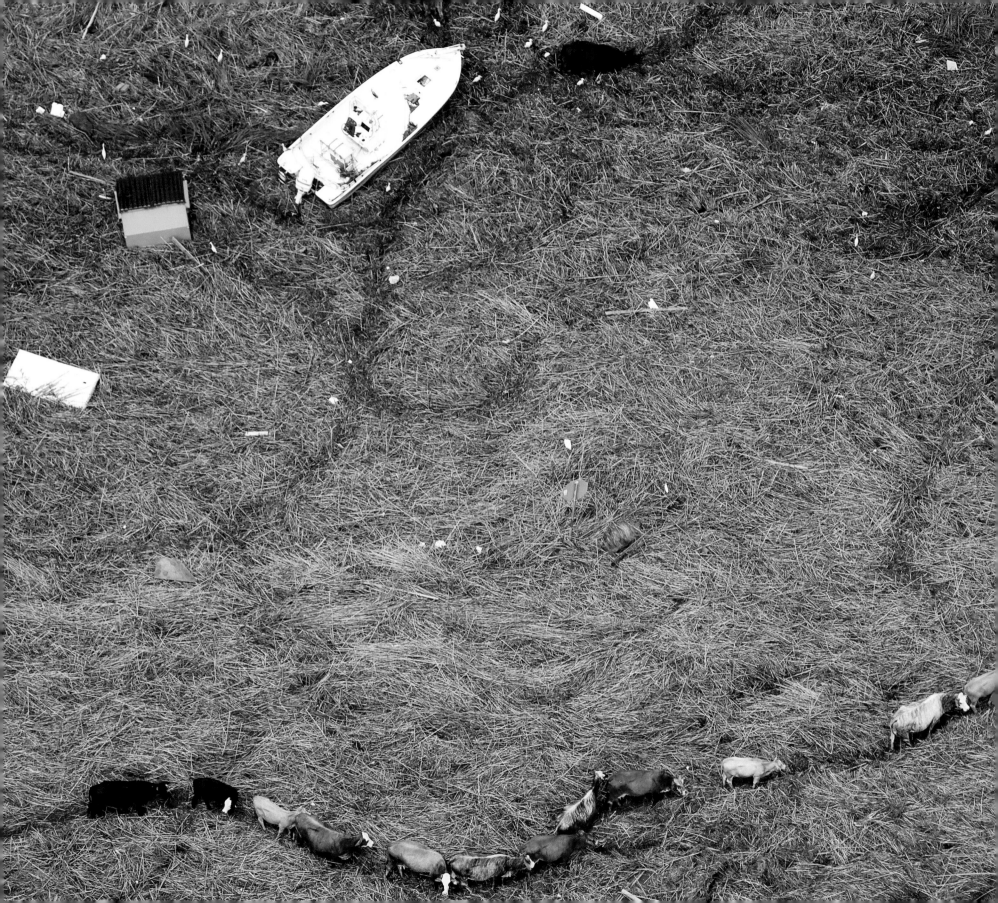

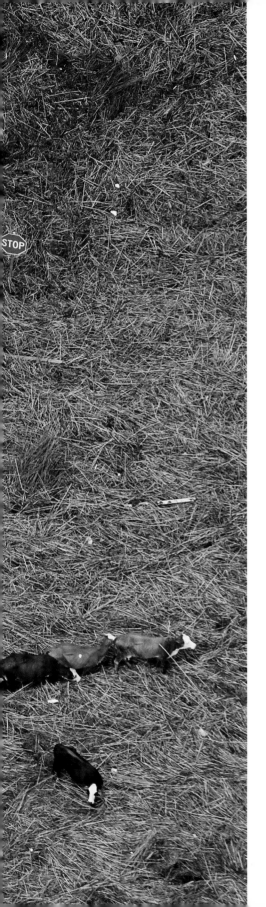

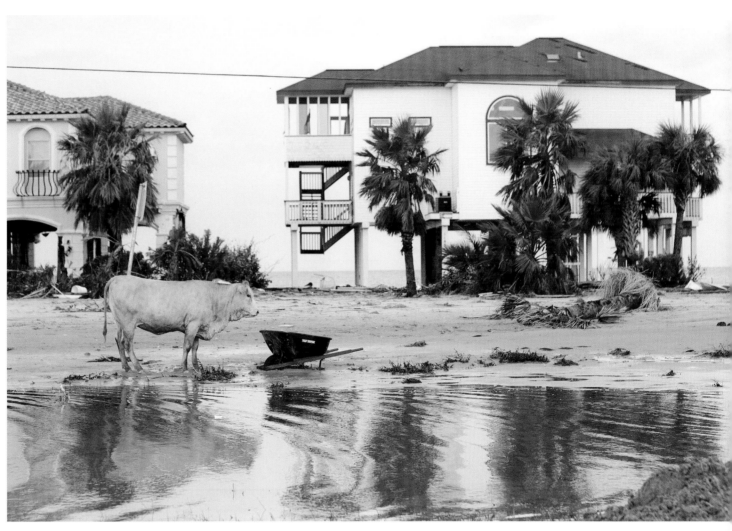

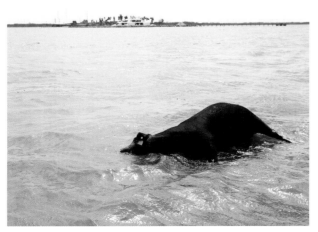

SINGLE FILE | OPPOSITE | Cattle navigate the debris covering Texas 73. | SEPT. 14 | WINNIE | **SMILEY N. POOL**

OUT OF PLACE | TOP | A cow wanders near damaged beach homes. | SEPT. 14 | GALVESTON | **BRETT COOMER**

LOSSES | BOTTOM | The hurricane scattered the carcasses of cattle and other animals into waterways, posing health risks. | SEPT. 15 | GALVESTON | **NICK de la TORRE**

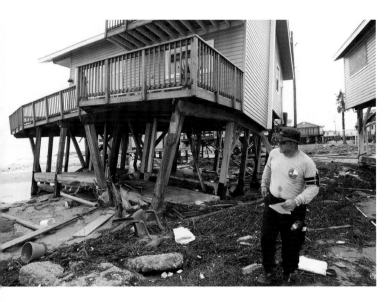

STILL UPRIGHT | LEFT | A resident surveys damage near a constellation of battered beach homes. | SEPT. 14 | GALVESTON |
BRETT COOMER

STRANDED | MIDDLE | Bill Smith, who said he had neither the money nor a car to be able to leave, ducked under the radar of security and emergency personnel and rode out the hurricane in a friend's home. | SEPT. 14 | SURFSIDE BEACH |
JULIO CORTEZ

UP CLOSE | OPPOSITE | Kara Bridwell, 26, left, and her brother, Paul Bisso, 17, climb atop the roof of their neighbor's house, which washed into the front of their family's beach house.
| SEPT. 14 | SURFSIDE BEACH | **JULIO CORTEZ**

SOGGY COMMUTE | FOLLOWING LEFT | Traffic gingerly passes through high water on Interstate 45 at Tidwell as the city encounters more rain and flooding. | SEPT. 14 | HOUSTON |
SMILEY N. POOL

PLAN OF ACTION | FOLLOWING RIGHT | Rescue boats convene near a stop sign on a flooded road. | SEPT. 14 | BRIDGE CITY |
SMILEY N. POOL

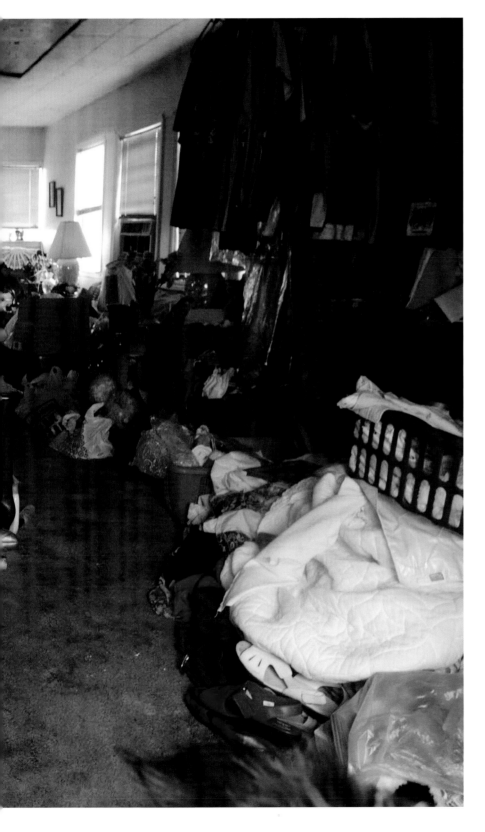

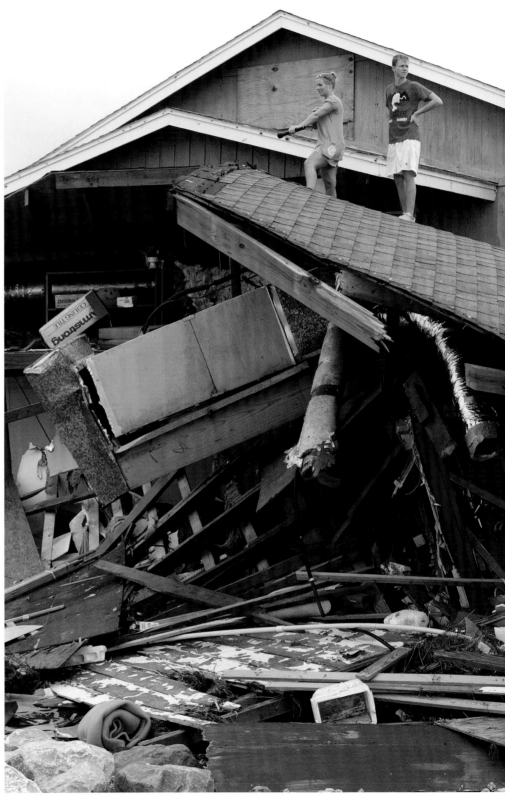

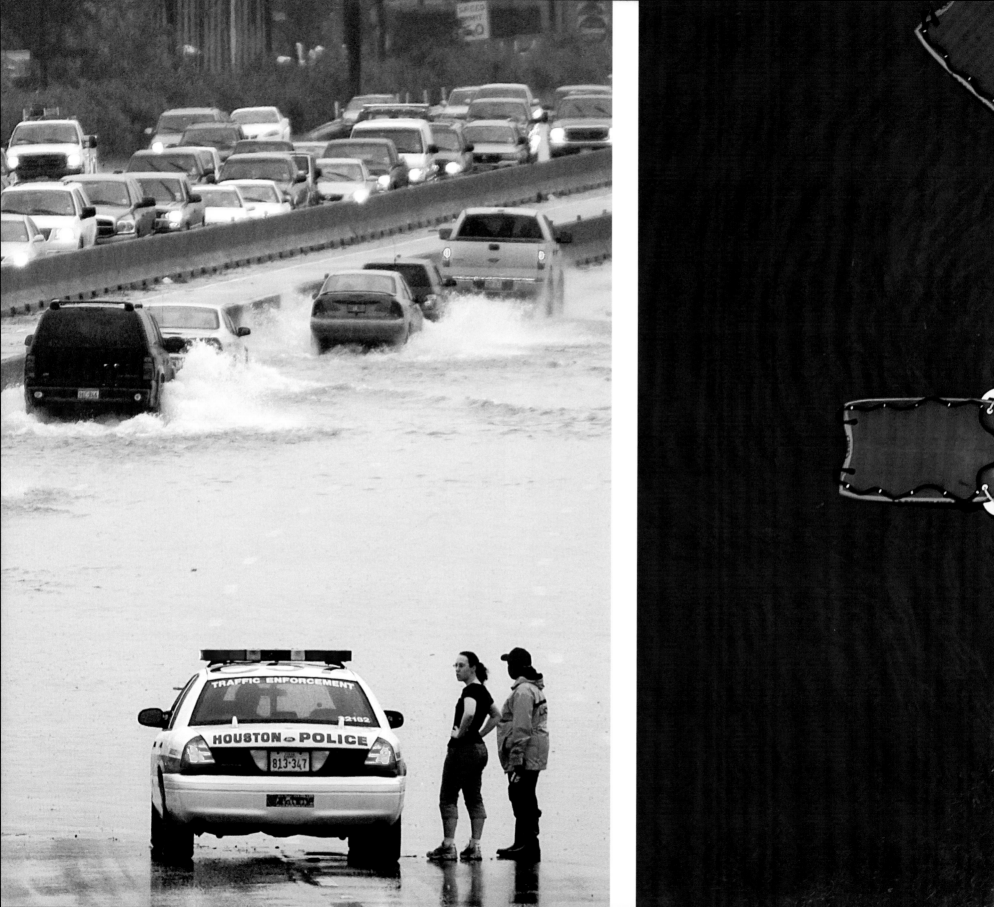

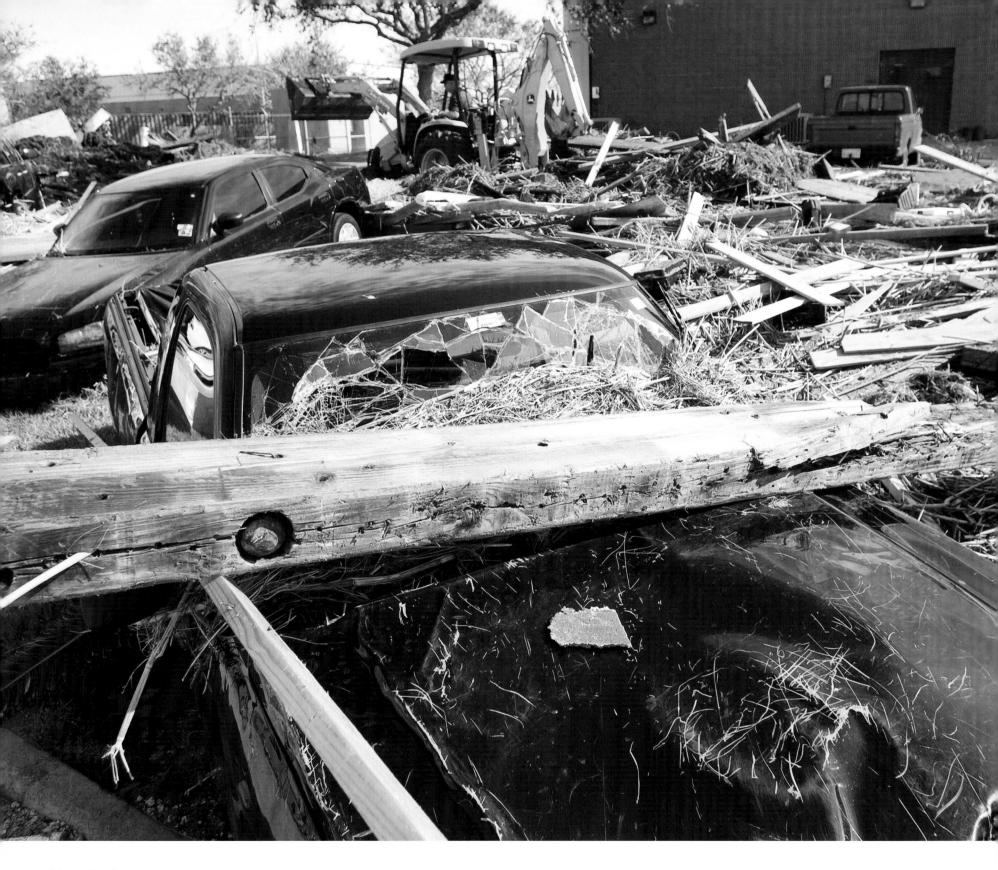

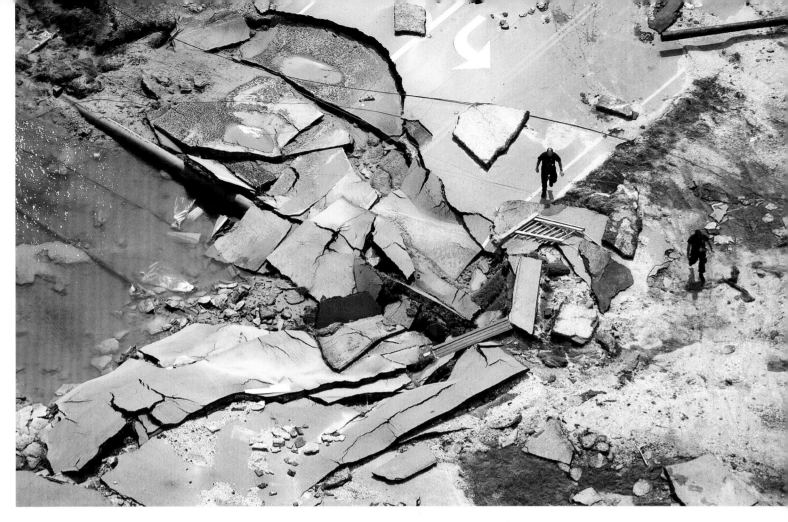

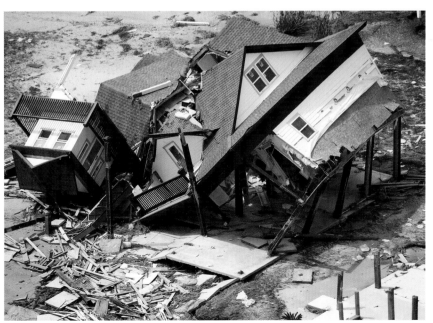

IMMOVABLE OBJECTS | OPPOSITE | Cars are trapped under debris at a Coast Guard station. | SEPT. 15 | GALVESTON | **BRETT COOMER**

BROKEN ROAD | TOP | Workers tread through the rubble of Texas 87. Ike's storm surge tossed debris and ravaged the road, breaking asphalt into giant chunks. | SEPT. 15 | BOLIVAR PENINSULA | **SMILEY N. POOL**

DECIMATED | BOTTOM | A crumpled house lies amid the rubble. | SEPT. 15 | CRYSTAL BEACH | **SMILEY N. POOL**

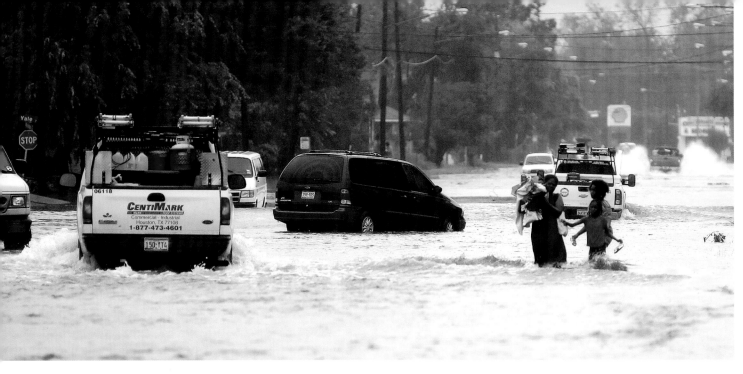

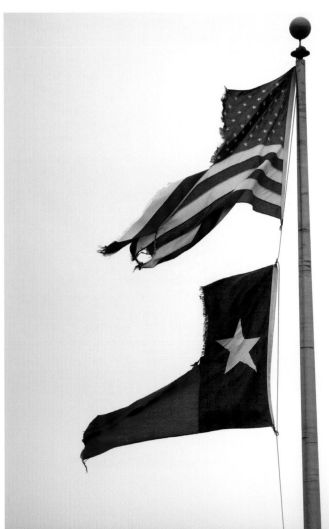

PERILOUS WALK | TOP | A woman and her children wade through floodwaters on Yale in Independence Heights. | SEPT. 14 | HOUSTON | **KAREN WARREN**

TORN BUT STILL ALOFT | BOTTOM | Tattered flags flutter in the wind. | SEPT. 13 | LEAGUE CITY | **NICK de la TORRE**

PRECIOUS COMMODITY | OPPOSITE | Long lines form at a Shell station on the corner of Beltway 8 and Veterans Memorial. | SEPT. 14 | HOUSTON | **SMILEY N. POOL**

LONG WAIT | FOLLOWING | Customers lined up for as long as three hours to buy gas at Texaco, one of the few open stations. The station used a generator to keep powered up. | SEPT. 14 | SPRING | **STEVE CAMPBELL**

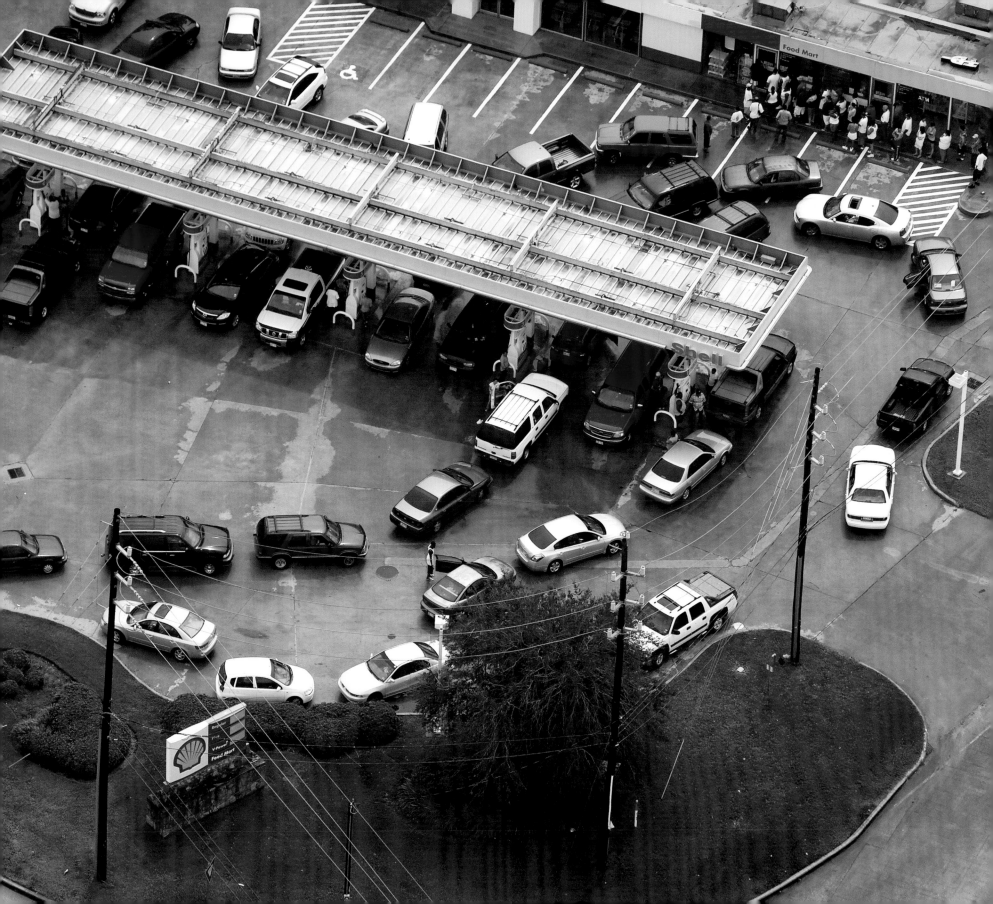

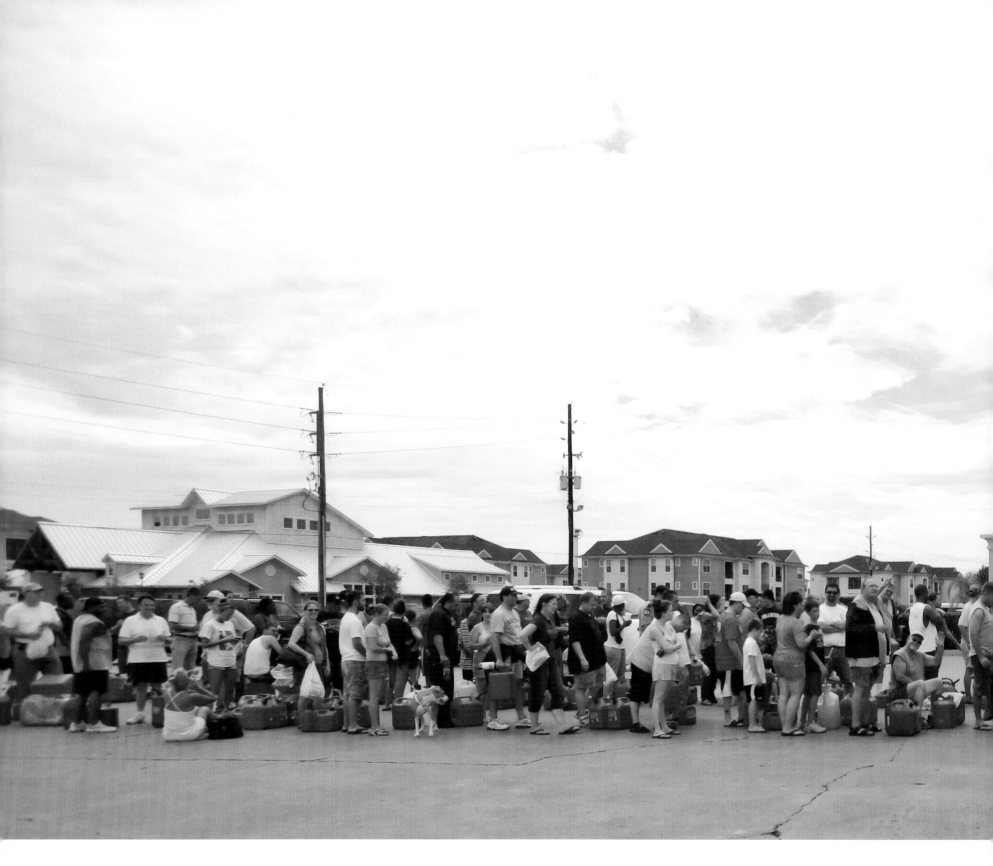

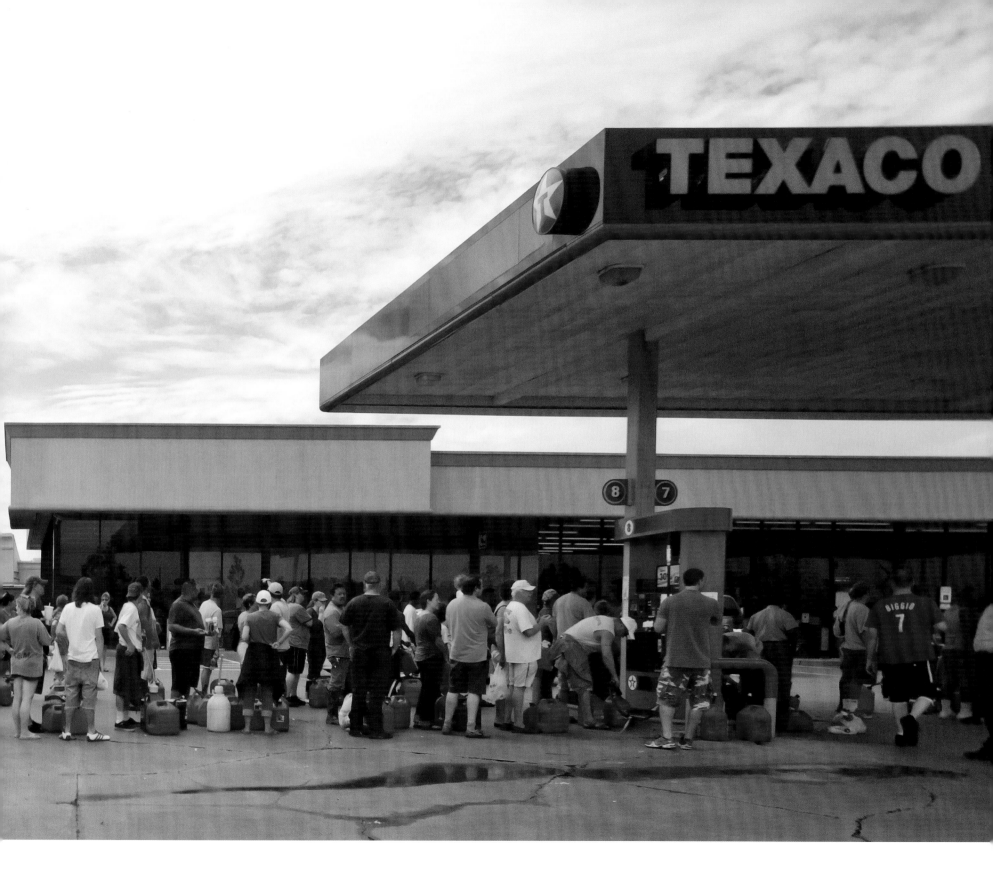

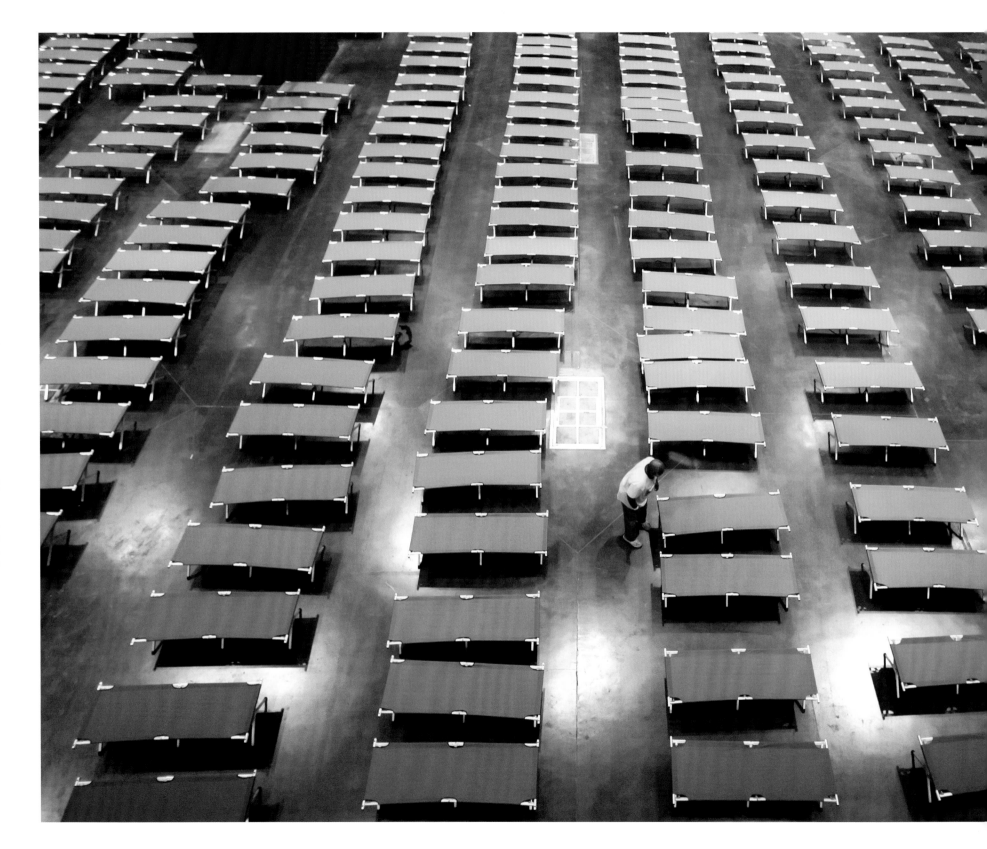

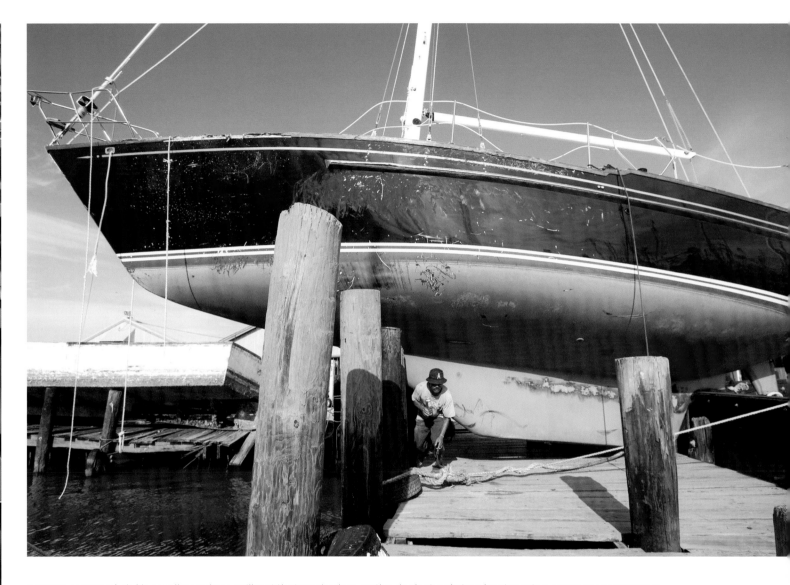

DOCKED | ABOVE | Anh Ngo walks under a sailboat that washed up on the dock at a shrimp boat marina. | SEPT. 15 | GALVESTON |
BRETT COOMER

SEA OF COTS | OPPOSITE | A volunteer arranges cots at the George R. Brown Convention Center, where the Red Cross and other organizations set up a staging center for evacuees. | SEPT. 15 | HOUSTON | **KAREN WARREN**

IN NEED | FOLLOWING TOP LEFT | An unidentified woman fell ill and was taken to a nearby hospital while waiting in line to get supplies such as water, ice and MREs at a FEMA distribution hub on Imperial Valley and Greens. | SEPT. 15 | HOUSTON | **MAYRA BELTRÁN**

BOTTLE UP | FOLLOWING BOTTOM LEFT | Tiffany Cunningham cools off 10-month-old Isiah as they wait in line to get supplies at a FEMA distribution hub. They were in line for more than 4 hours. | SEPT. 15 | HOUSTON | **MAYRA BELTRÁN**

LOADED DOWN | FOLLOWING RIGHT | Residents return to their vehicles after receiving their allotment of FEMA supplies. | SEPT. 15 | HOUSTON |
MAYRA BELTRÁN

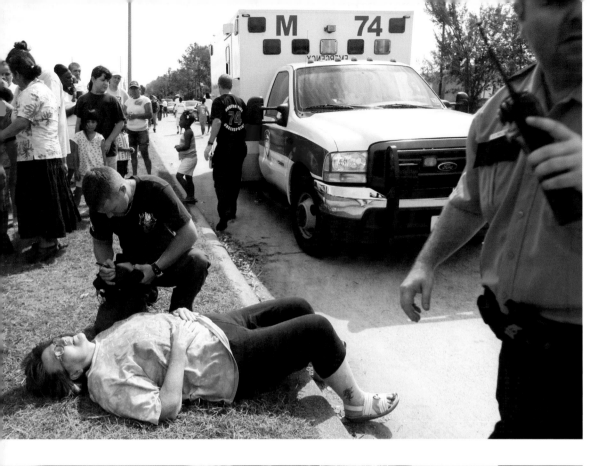

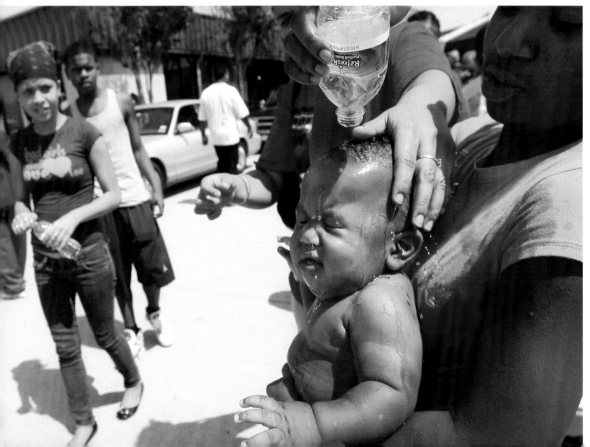

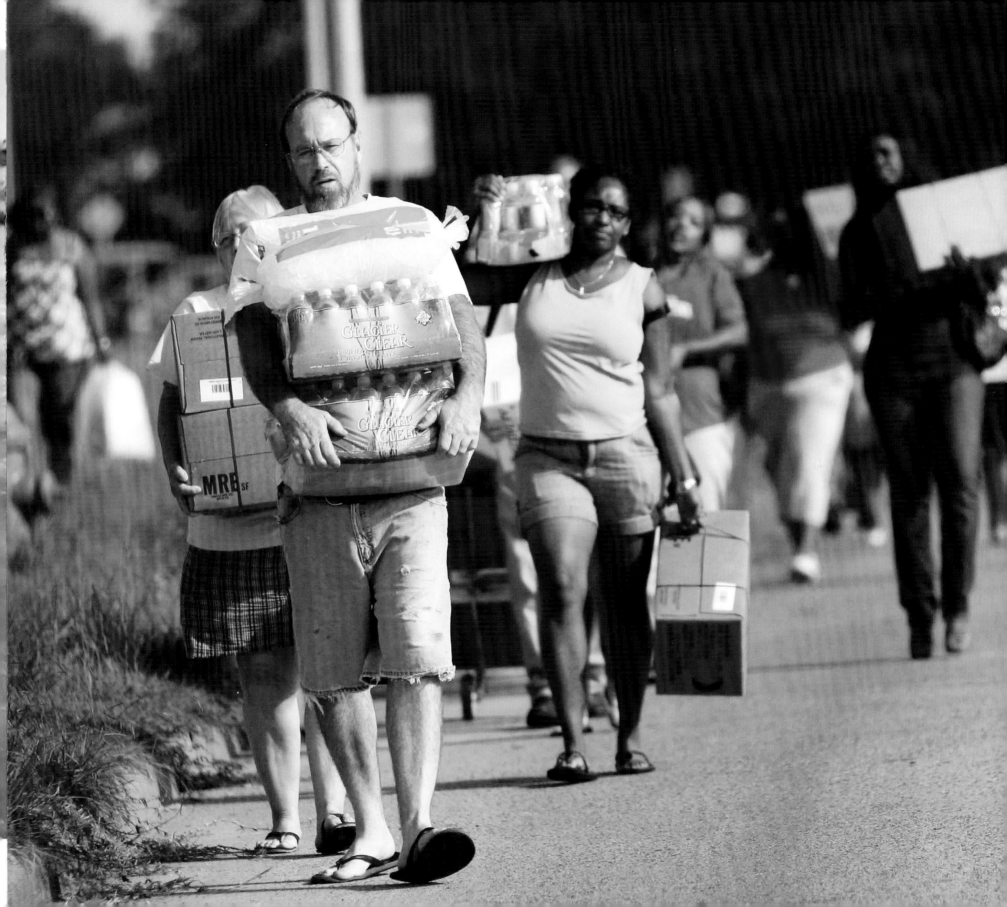

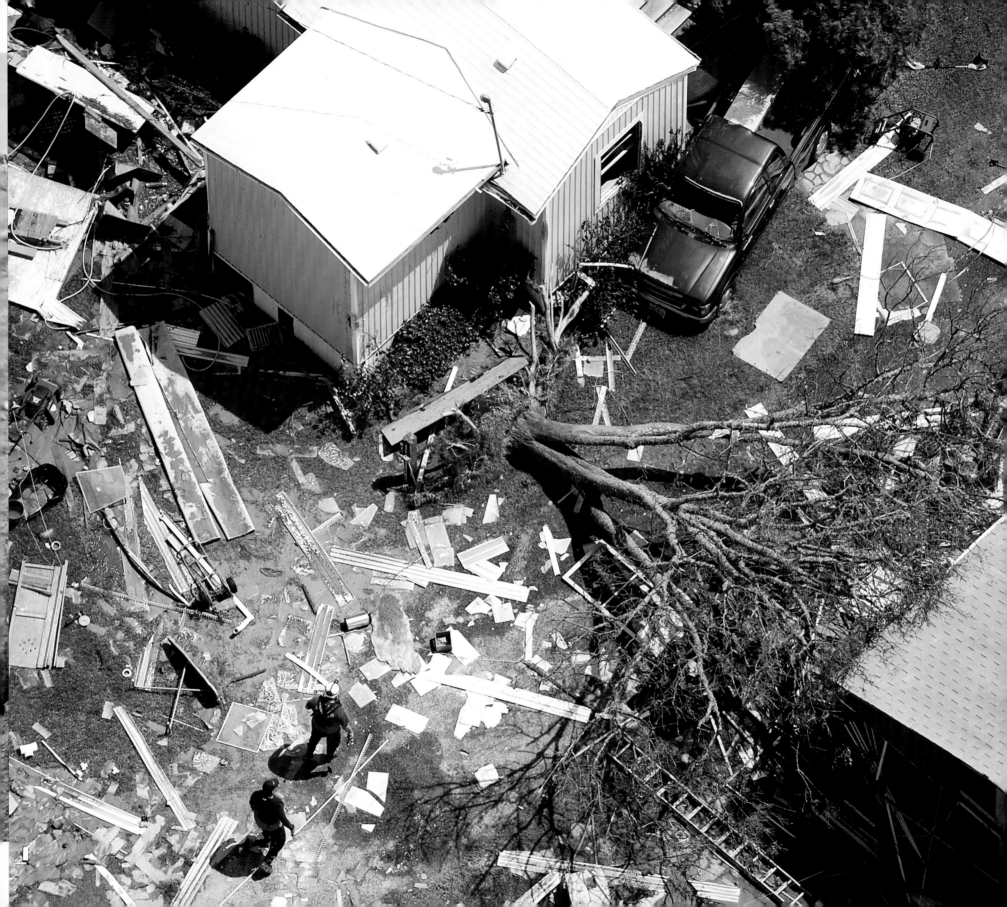

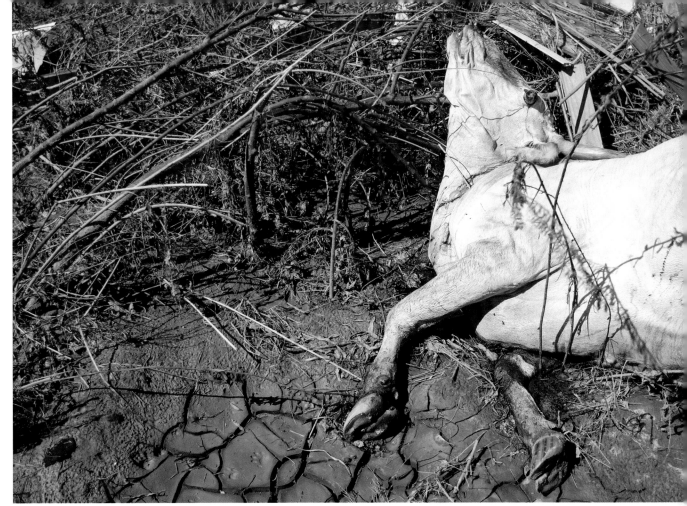

DEATH | ABOVE | Weeks after the hurricane, search crews encounter dead cattle and other animals while hiking through piles of debris and vegetation in search of human remains. | OCT. 3 | GOAT ISLAND | **MAYRA BELTRÁN**

INTO THE DEBRIS | OPPOSITE | Search teams comb damaged neighborhoods. | SEPT. 15 | PORT BOLIVAR | **SMILEY N. POOL**

OVERWHELMED | PREVIOUS LEFT | Jacqueline Harris wipes tears as she stands on a jetty near 21st and Seawall Boulevard. She is searching for items washed away during Hurricane Ike. | SEPT. 15 | GALVESTON | **BRETT COOMER**

JUMBLED | PREVIOUS TOP LEFT | Boats are stacked on top of each other at a marina. | SEPT. 15 | GALVESTON | **BRETT COOMER**

OFFICIAL VISIT | PREVIOUS TOP RIGHT | U.S. Rep. Ron Paul, R-Lake Jackson, inspects the damage wrought by the hurricane. | SEPT. 15 | SURFSIDE BEACH | **JULIO CORTEZ**

WHAT'S LEFT BEHIND | PREVIOUS BOTTOM RIGHT | Sam DiMiceli visits the dock of his waterfront property for the first time since the hurricane. DiMiceli had just finished painting the house before the storm hit and planned to retire there. The first floor of the house was destroyed. | SEPT. 15 | BACLIFF | **ERIC KAYNE**

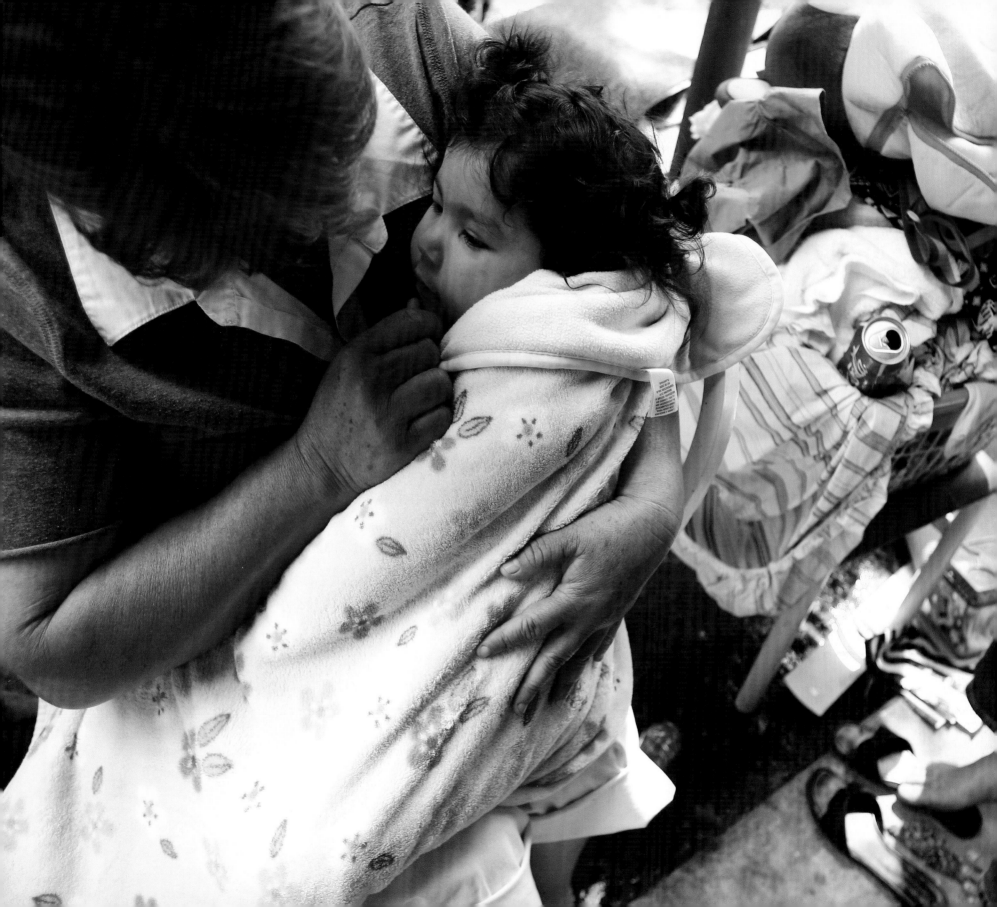

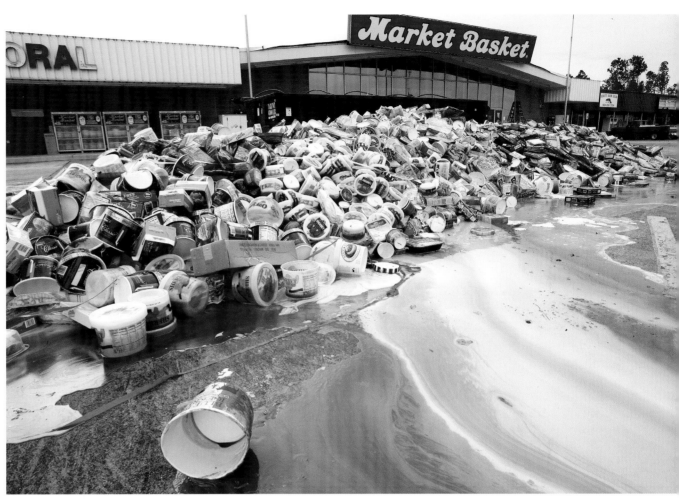

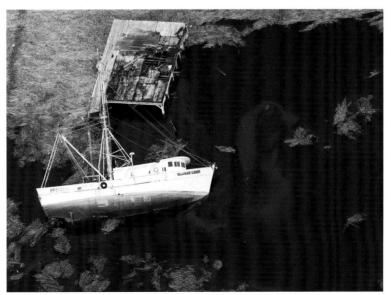

SMALL COMFORTS | OPPOSITE | Maria Suarez comforts her sick niece, Rosalinda Galvan, 1, at the Casa Real Apartments at Little York near Interstate 45. Residents of the waterlogged complex were struggling to clean out their homes. | SEPT. 16 | HOUSTON | **SHARÓN STEINMANN**

INEDIBLE | TOP | Thawed foodstuffs pulled from the shelves of the Market Basket grocery are piled high in front of the store. | SEPT. 15 | WINNIE | **JAMES NIELSEN**

UPENDED | BOTTOM | A boat is overturned along Texas 73. | SEPT. 14 | WINNIE | **SMILEY N. POOL**

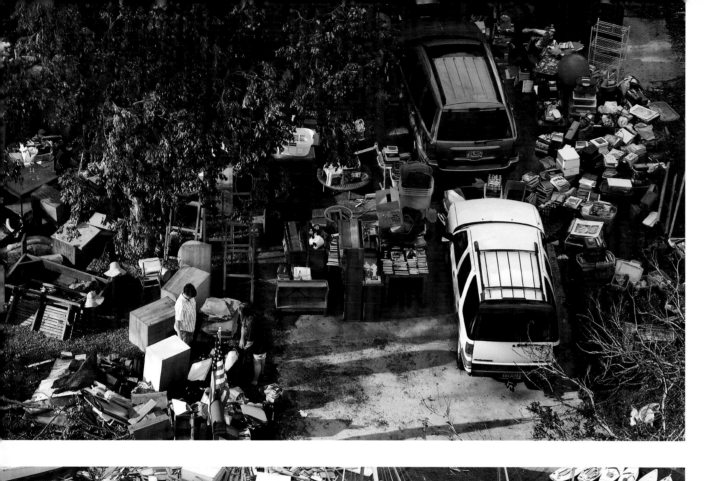
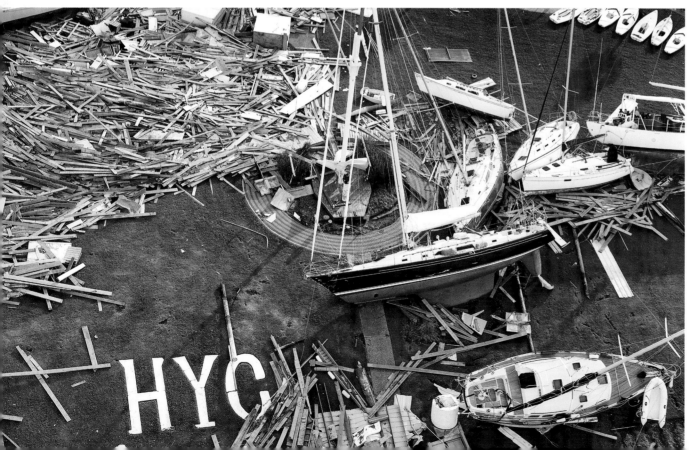
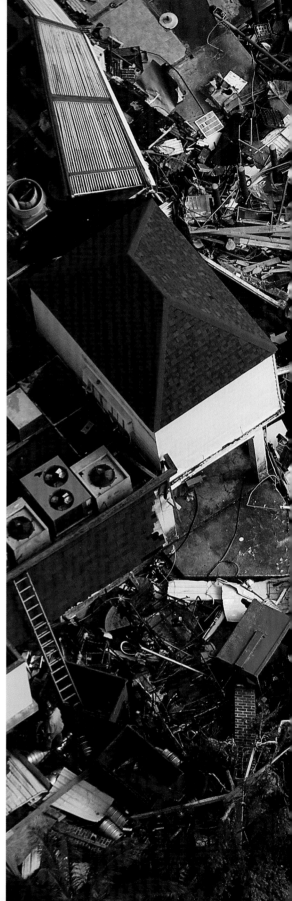

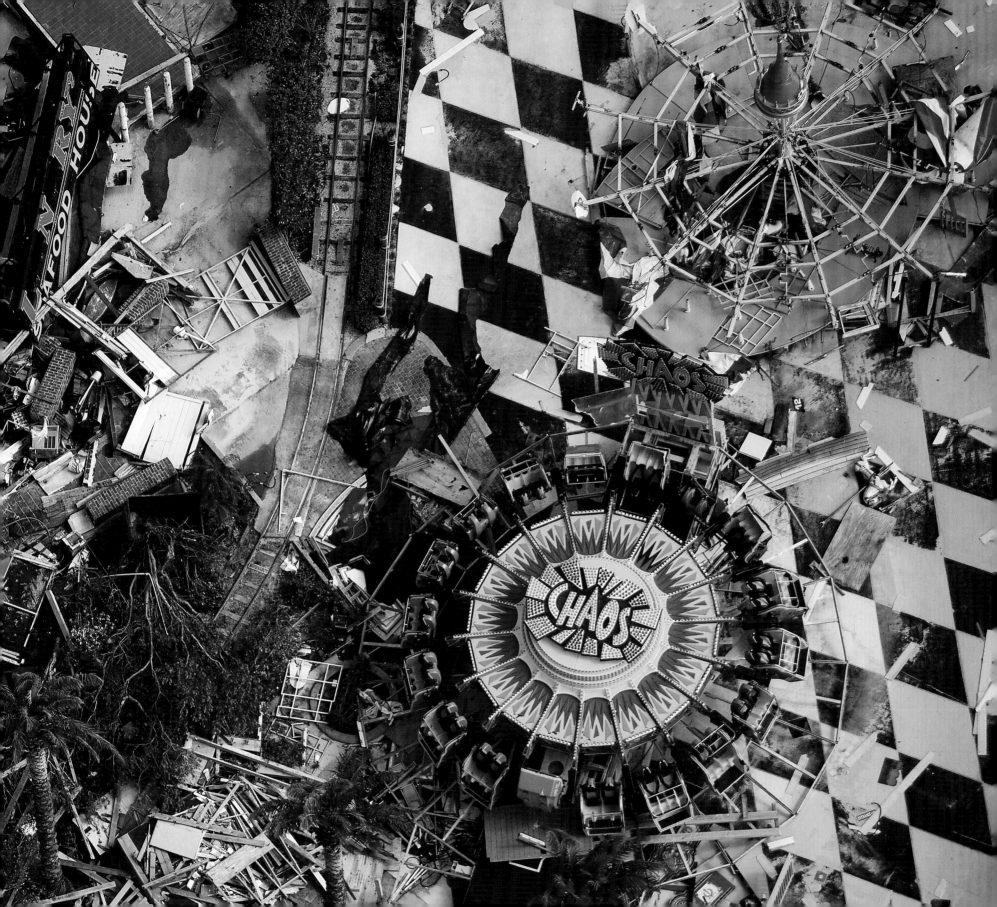

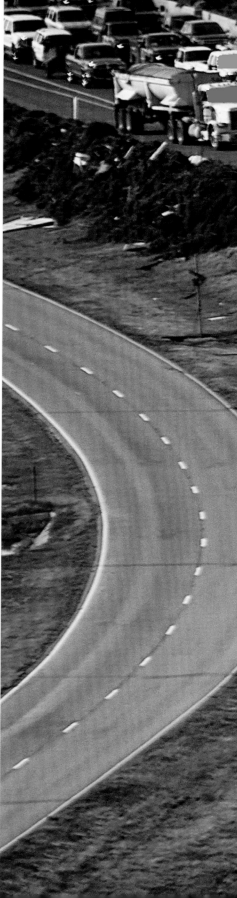

A LITTLE PUSH | ABOVE | Jevin Gardner steers his car as his friends, Bobby Lewis and Terry Ross, push it to a gas station after it ran out of fuel on Beltway 8. | SEPT. 15 | SPRING | **STEVE CAMPBELL**

SLOW RETURN | OPPOSITE | Traffic backs up on Interstate 45 just before the Galveston Causeway as evacuees are allowed back on the island for the first time. It was lines like these that caused island officials to reverse the look-and-leave policy. | SEPT. 16 | GALVESTON | **SMILEY N. POOL**

TAKING INVENTORY | PREVIOUS TOP LEFT | The contents of a home are spread out on the lawn as residents begin cleaning up. | SEPT. 16 | SHOREACRES | **SMILEY N. POOL**

COSTLY DAMAGE | PREVIOUS BOTTOM LEFT | All manner of sailboats and debris are strewn about the Houston Yacht Club. | SEPT. 16 | SHOREACRES | **SMILEY N. POOL**

APTLY NAMED | PREVIOUS RIGHT | Amusement rides mingle with debris on the Boardwalk. | SEPT. 15 | KEMAH | **SMILEY N. POOL**

A CLEARER VIEW | FOLLOWING TOP LEFT | Steven Frasier, a contract worker from Georgia, cleans windows at the Stork Club. | SEPT. 18 | GALVESTON | **JOHNNY HANSON**

HOUSE OF WORSHIP | FOLLOWING BOTTOM LEFT | Workers remove wet carpet at the historical Trinity Episcopal Church, which flooded during the hurricane. | SEPT. 18 | GALVESTON | **MAYRA BELTRÁN**

GAME'S ON | FOLLOWING BOTTOM RIGHT | Mike Gilbert, an Astros season-ticket holder, listens to the play by play on the radio as the team faces off against the Florida Marlins. Gilbert planned to stay even though his East End home was without power. | SEPT. 18 | GALVESTON | **JOHNNY HANSON**

AT THEIR SERVICE | FOLLOWING RIGHT | Ralph Hayes kisses Bobbie Davis, 79, after bringing food and water to her and other residents of the Heights House, whose elderly and disabled tenants were without water or electricity. | SEPT. 14 | HOUSTON | **KAREN WARREN**

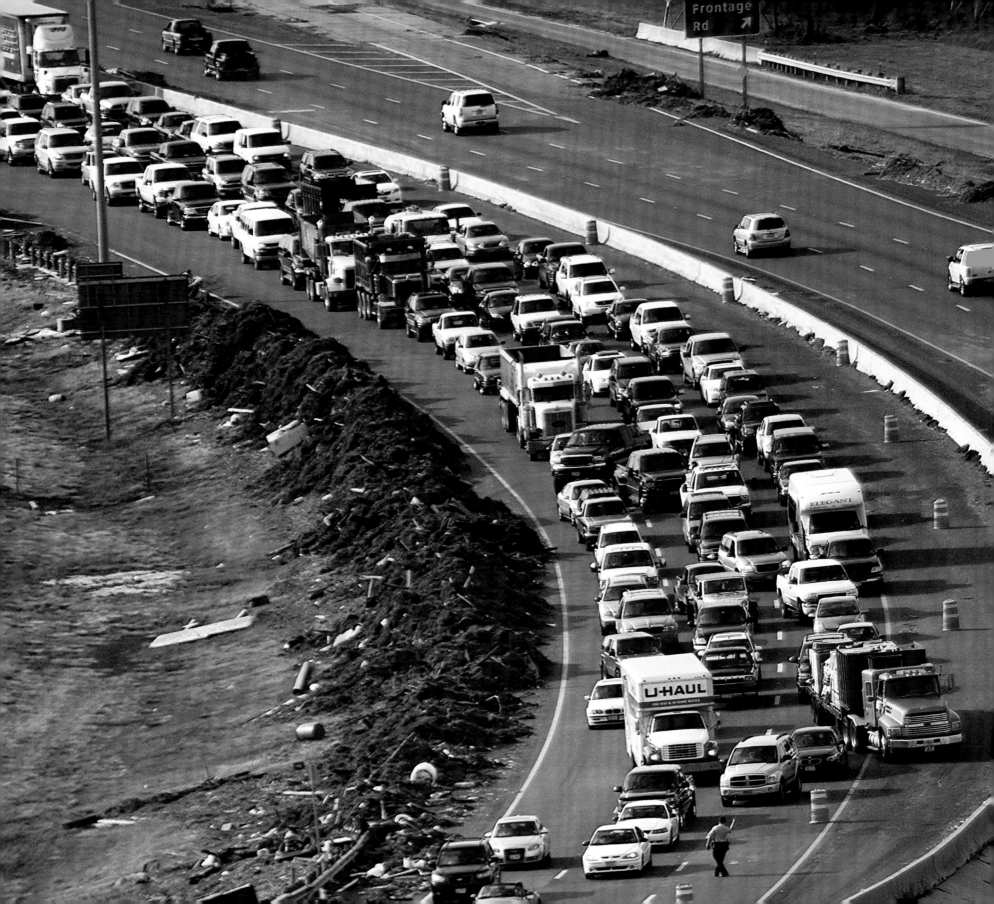

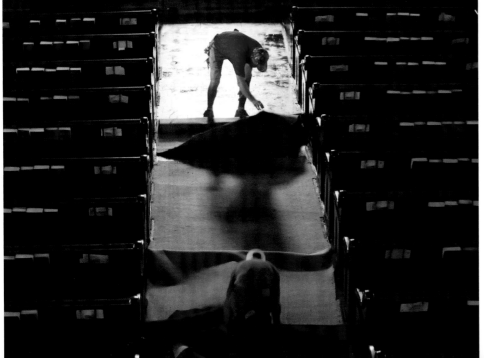

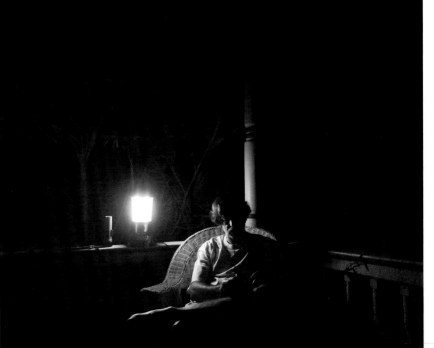

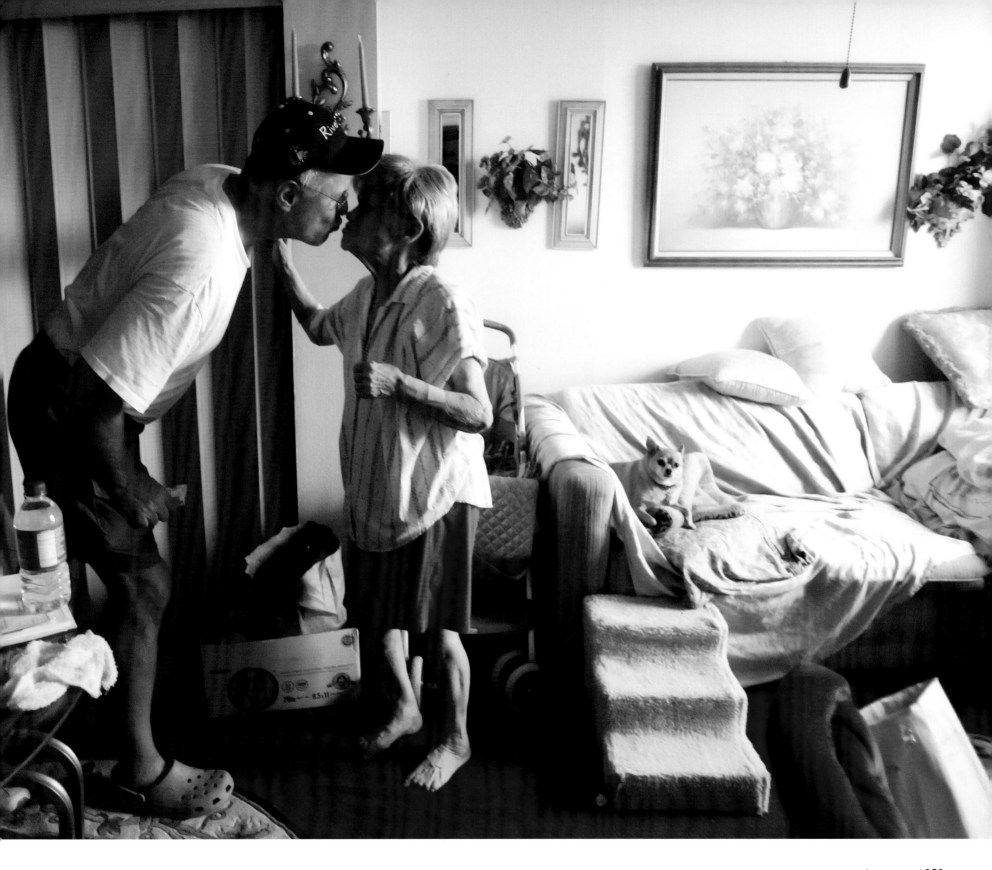

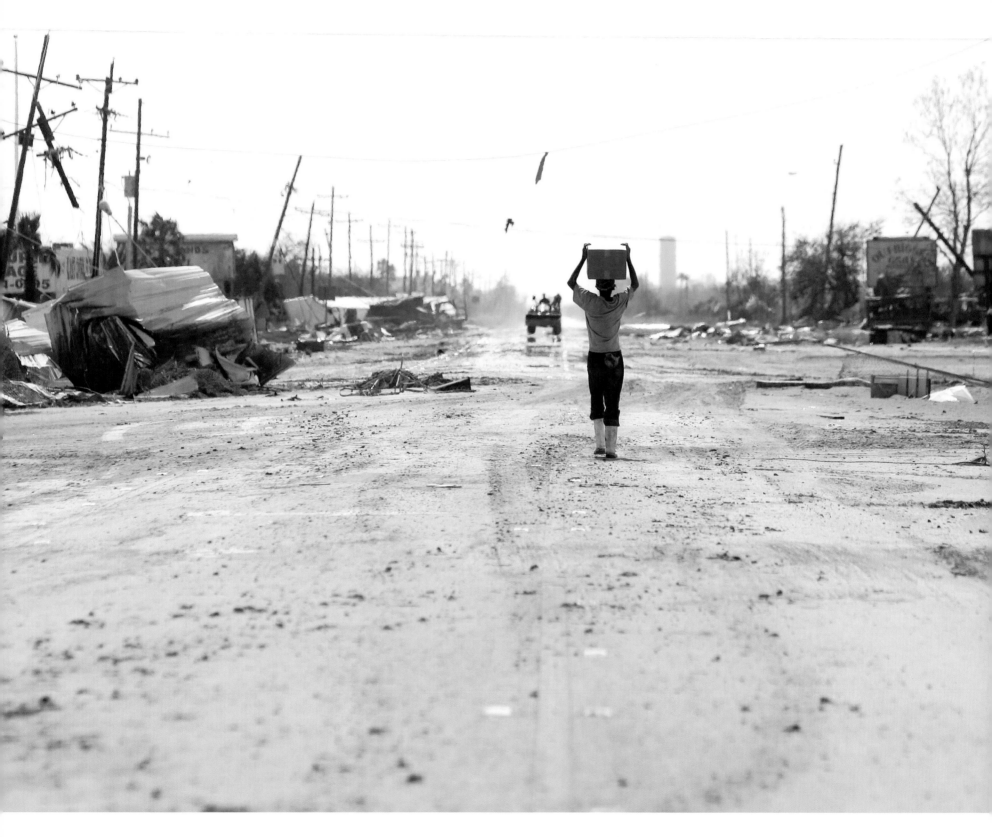

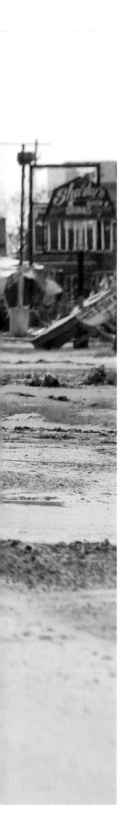

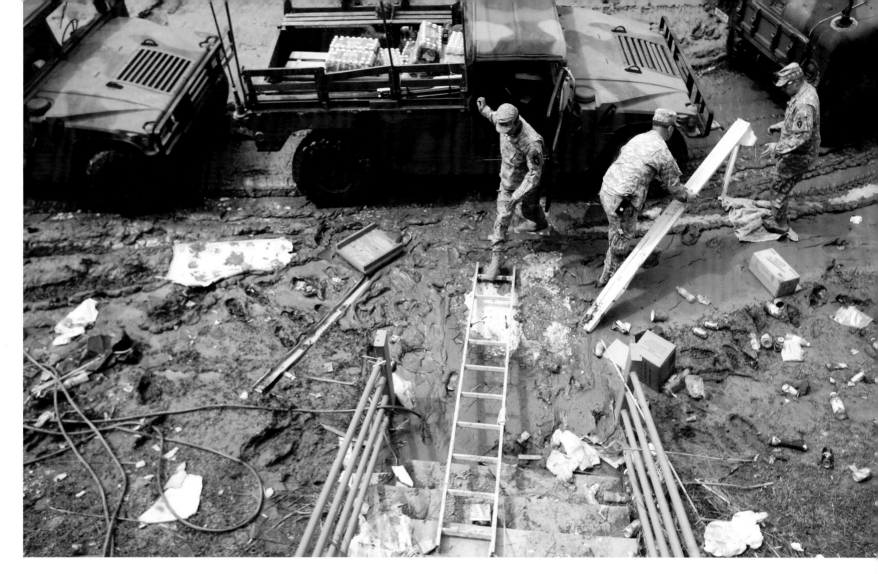

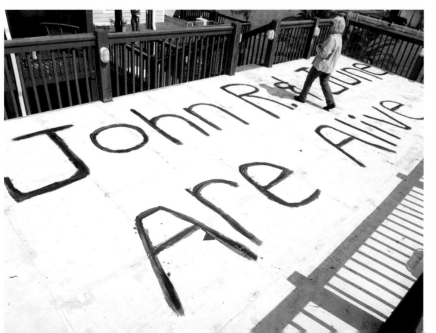

FOOD DELIVERY | OPPOSITE | Michael Clow, who rode out the hurricane with his two cats, carries a box of MREs. He said he did not plan to leave the hard-hit area. | SEPT. 17 | PORT BOLIVAR | **SHARÓN STEINMANN**

HOLDOUTS | TOP | Texas Army National Guardsmen use a ladder and old boards to traverse the mud surrounding the Crystal Palace Resort. The troops delivered MREs and water to the five people who refused to leave the hotel. | SEPT. 17 | CRYSTAL BEACH | **SHARÓN STEINMANN**

SIGN OF LIFE | BOTTOM | June Peveto, 59, walks over a sign she painted after the storm passed. "I was hoping someone would see it from the air and let our family and friends know we were OK," she said. Peveto and her husband, John, 75, were rescued by Army National Guard soldiers four days after the hurricane. | SEPT. 17 | CRYSTAL BEACH | **SHARÓN STEINMANN**

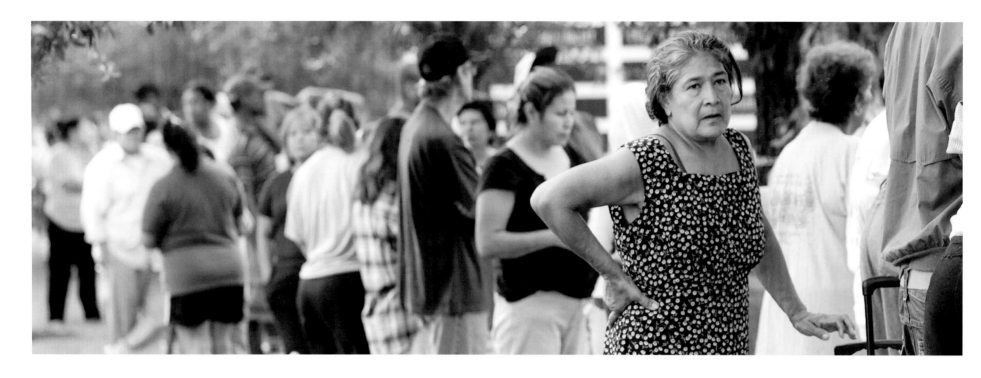

ESSENTIALS | TOP | Amelia Aguilar, 65, waits in line at a FEMA distribution site. She arrived at 5:30 a.m. to be one of the first people to get supplies when the site opened at 9 a.m. | SEPT. 18 | HOUSTON | **JULIO CORTEZ**

SAFEKEEPING | BOTTOM | Steven Merlos, 3, tries to keep a tight grip on the MREs that his family got from a FEMA distribution site set up at the Willow Creek Apartments. | SEPT. 18 | HOUSTON | **JULIO CORTEZ**

VICTIMIZED | OPPOSITE | Maria Morales, 60, said bad luck continued to pile up after the hurricane. Not only was her home on Whitaker damaged, she said, but the generator she was using to light her home was stolen from her backyard. | SEPT. 18 | PASADENA | **JULIO CORTEZ**

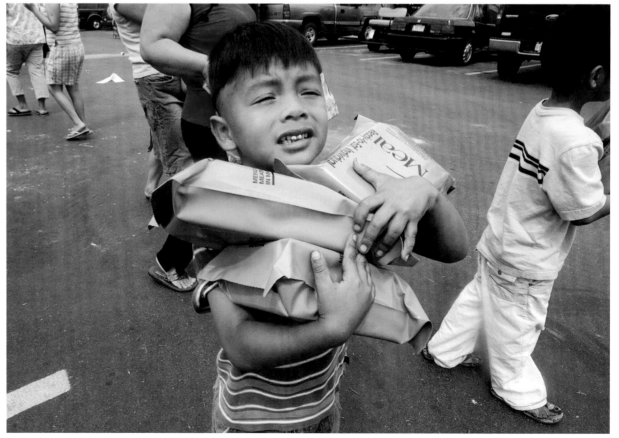

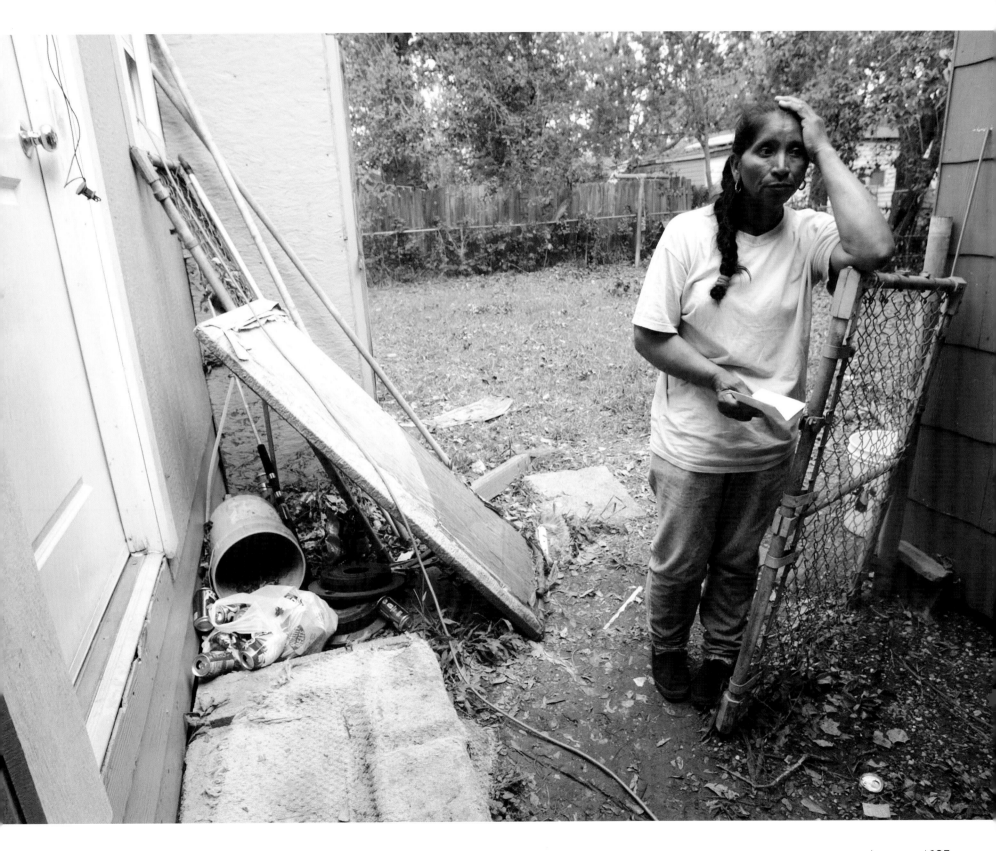

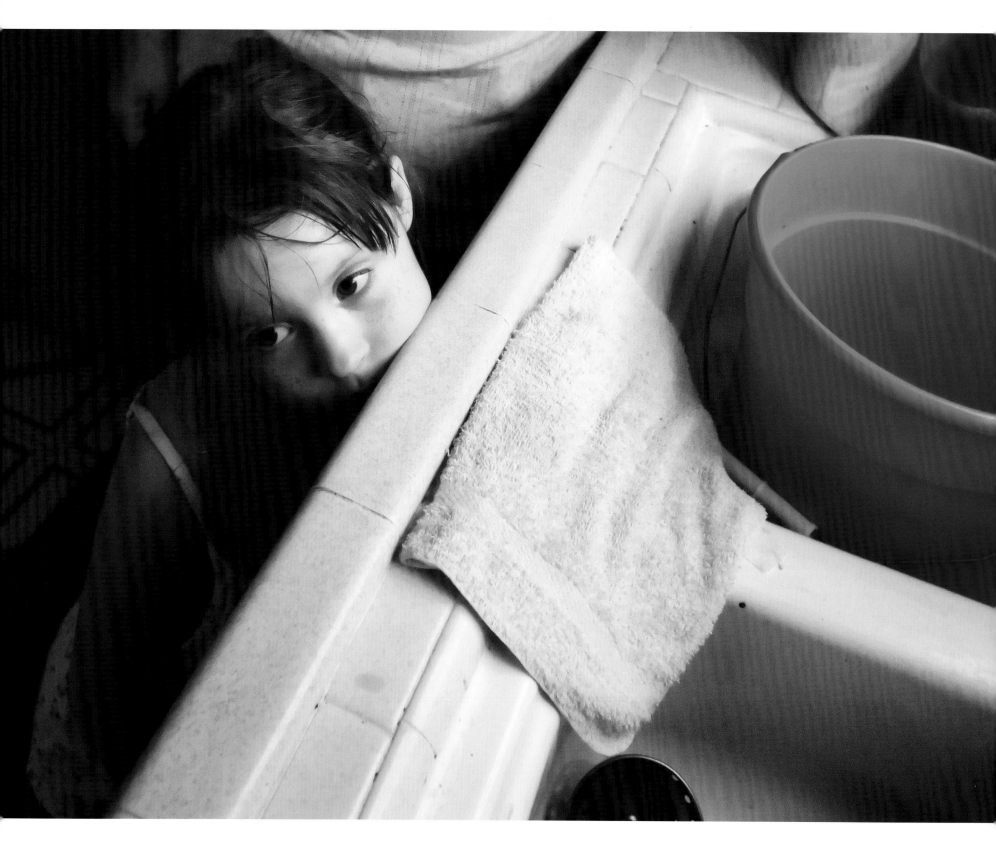

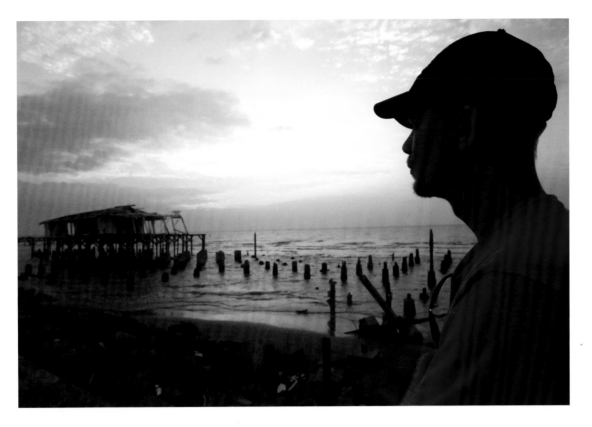

NO WATER | OPPOSITE | Kloey Spahni, 5, stands at the sink where her mom washes dishes with water carried in a bucket. The Spahnis were among the tens of thousands of people in the area still without running water. | SEPT. 23 | HOUSTON | **STEVE UECKERT**

LOST MEMORIES | TOP | Ralph Crawford Jr. of Conroe came to town to clean debris along the Seawall, where he has memories of romance and friendships. He spent the night after his prom at the Flagship Hotel, numerous days surfing with friends at the beach and romantic weekends with his wife at the San Luis Hotel. "I'm sad for Galveston," Crawford said, standing near Murdock's Pier. "I see people's lives and memories in what we are cleaning up." | SEPT. 19 | GALVESTON | **JOHNNY HANSON**

LEFT OUT | BOTTOM | Madelaine Carter had gone a week and a half without lights or air conditioning in her apartment on the northwest side of the city. A few doors away, though, neighbors had electricity. "Sometimes I feel like I'm going crazy," she said. | SEPT. 23 | HOUSTON | **JOHNNY HANSON**

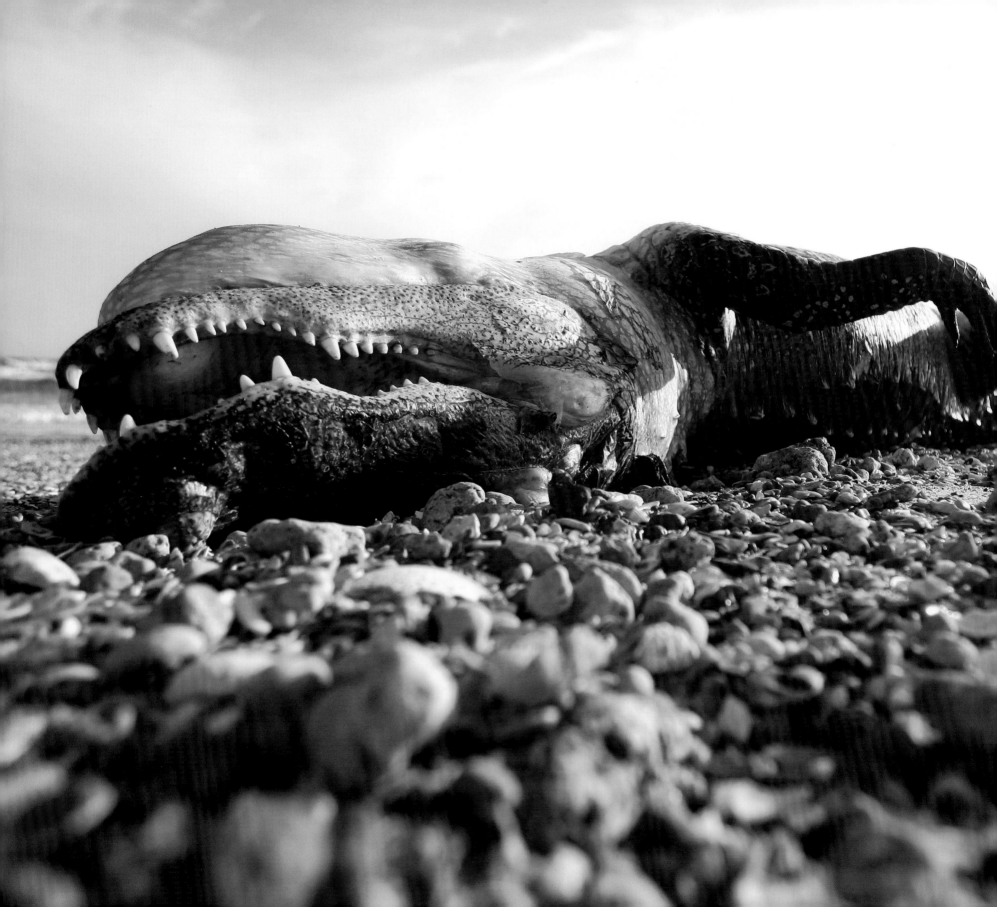

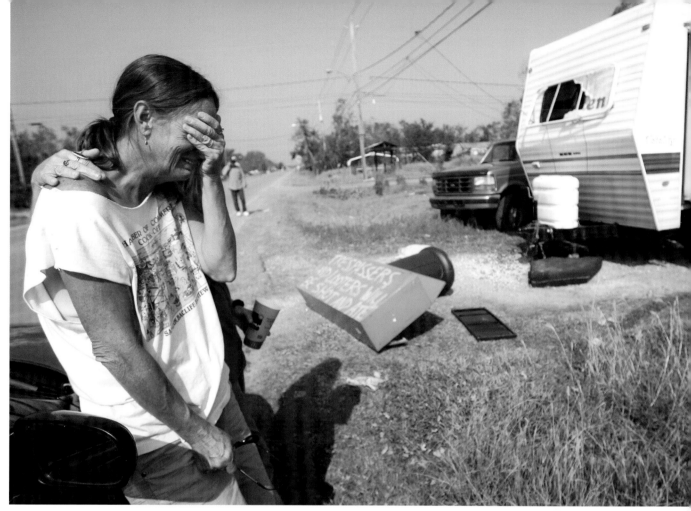

EMOTIONS | ABOVE | Elizabeth Jones weeps about a friend who has been missing since the storm. "I'm scared to call his mother because I don't know where he is or what happened to him," said Jones. | SEPT. 19 | SAN LEON | **SHARÓN STEINMANN**

LIFELESS | OPPOSITE | A dead alligator lies on the beach more than a week after the hurricane. | SEPT. 23 | BOLIVAR PENINSULA | **SHARÓN STEINMANN**

LOOKING FOR HELP | FOLLOWING LEFT | Along with hundreds of other people, Crystal Adams waits to apply for food stamps at the Health and Human Services office on Telephone Road. She and her boyfriend, who have a 2-month-old child, haven't been able to return to their jobs since the hurricane. | SEPT. 22 | HOUSTON | **SHARÓN STEINMANN**

SENDUP | FOLLOWING TOP RIGHT | The Silliman family posted a sign in their front yard pointing to a tent as "FEMA Housing." | SEPT. 22 | GALVESTON | **KAREN WARREN**

CONSOLED | FOLLOWING BOTTOM RIGHT | Chaplain Wade Mathis consoles a hurricane evacuee as a group returns from a San Antonio shelter. "I know a Marine isn't supposed to cry," the evacuee said. | OCT. 1 | GALVESTON | **NICK de la TORRE**

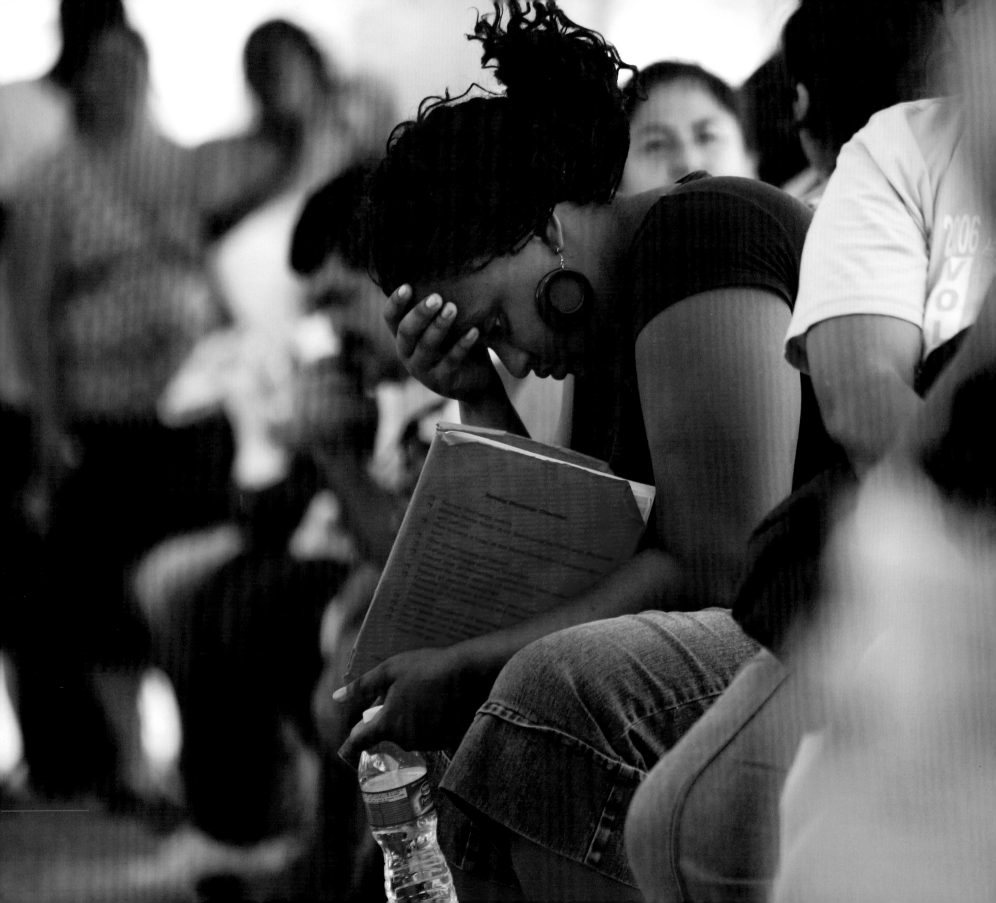

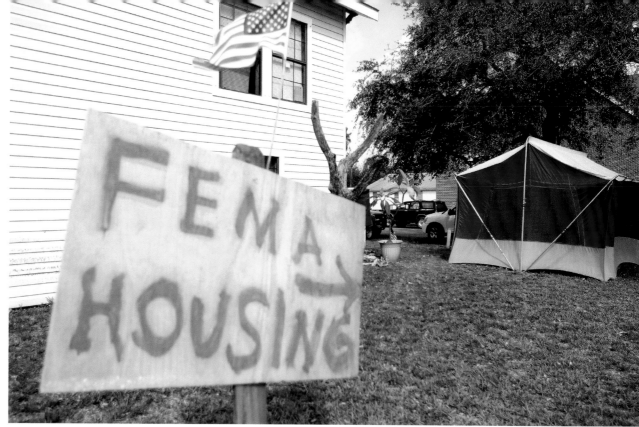
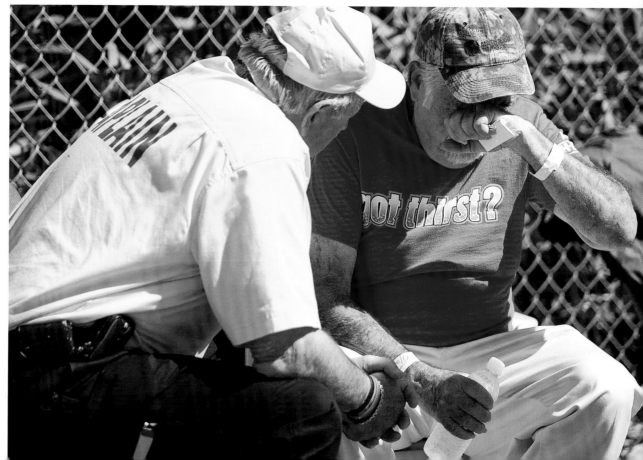

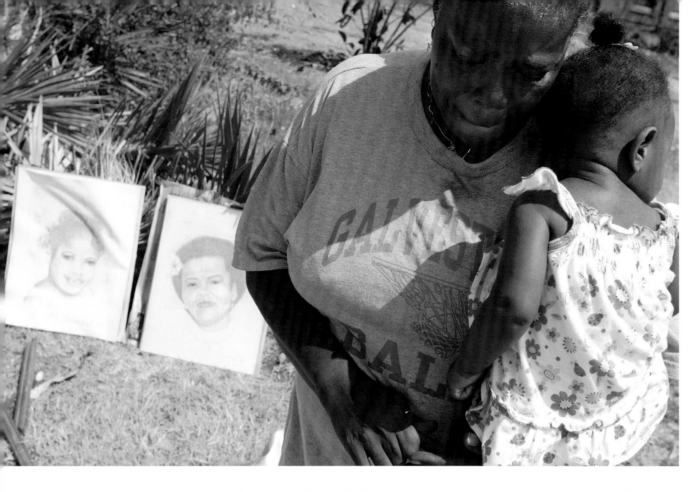

HANGING BY A THREAD | ABOVE | Catherine Malone holds her great-granddaughter, 9-month-old Veruschka Matthews, outside her destroyed apartment at a public housing complex. The complex was condemned and residents are being forced to leave. "I don't have no help," Malone said. "No husband, no boyfriend, no son." The drawings in the background are of her daughter and mother, both of whom recently passed away. | SEPT. 26 | GALVESTON | **ERIC KAYNE**

IN SHAMBLES | OPPOSITE | Rolando Garza takes a break from cleaning his moldy and muddy kitchen. Garza said his family lost everything after floodwaters surged into his home. | SEPT. 23 | GALVESTON | **BRETT COOMER**

MAYBE SOON | FOLLOWING LEFT | A sign in a window of a high-rise on Allen Parkway expresses the frustration of many in the same dark situation. | SEPT. 25 | HOUSTON | **KAREN WARREN**

TAKING IT ALL IN | FOLLOWING RIGHT | Lucas Betances sits on the Seawall near the memorial to the Great Storm of 1900. "There's no beach," Betances said, stunned. "The ocean ate the sand." | SEPT. 29 | GALVESTON | **STEVE CAMPBELL**

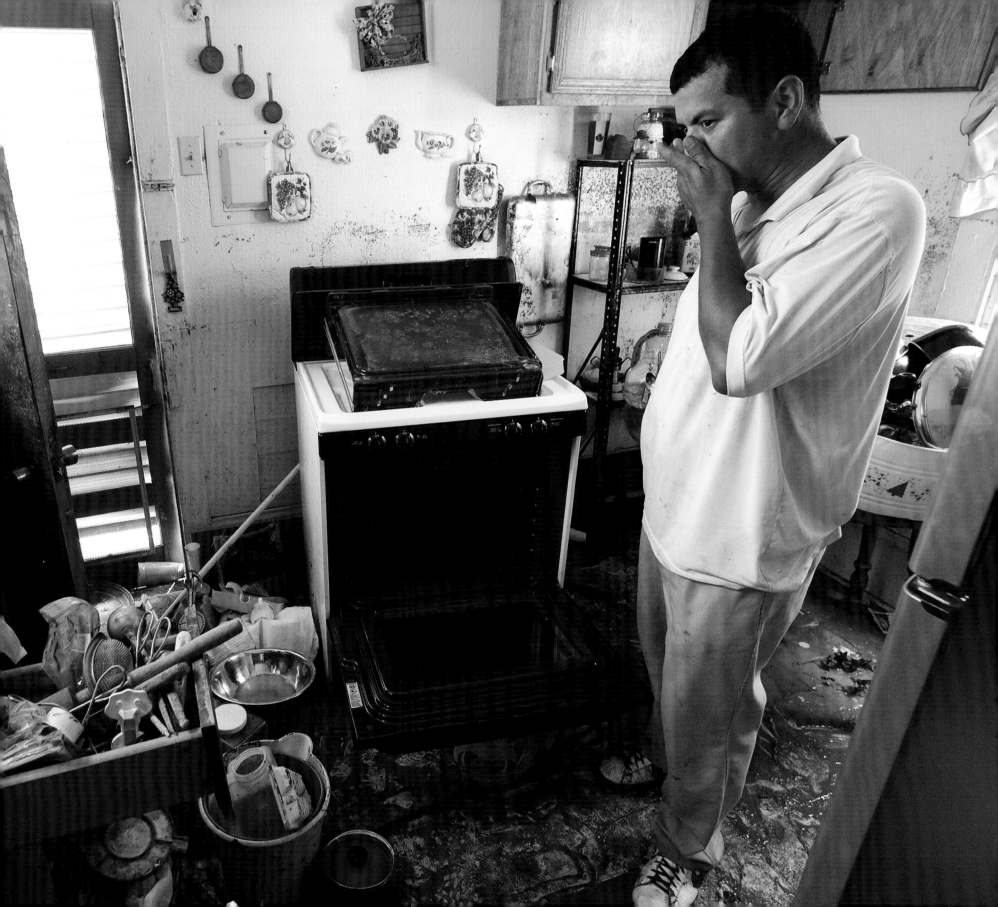

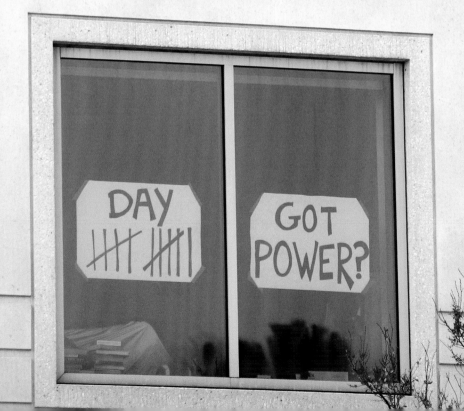

DAY ~~||||~~ ~~||||~~ I

GOT POWER?

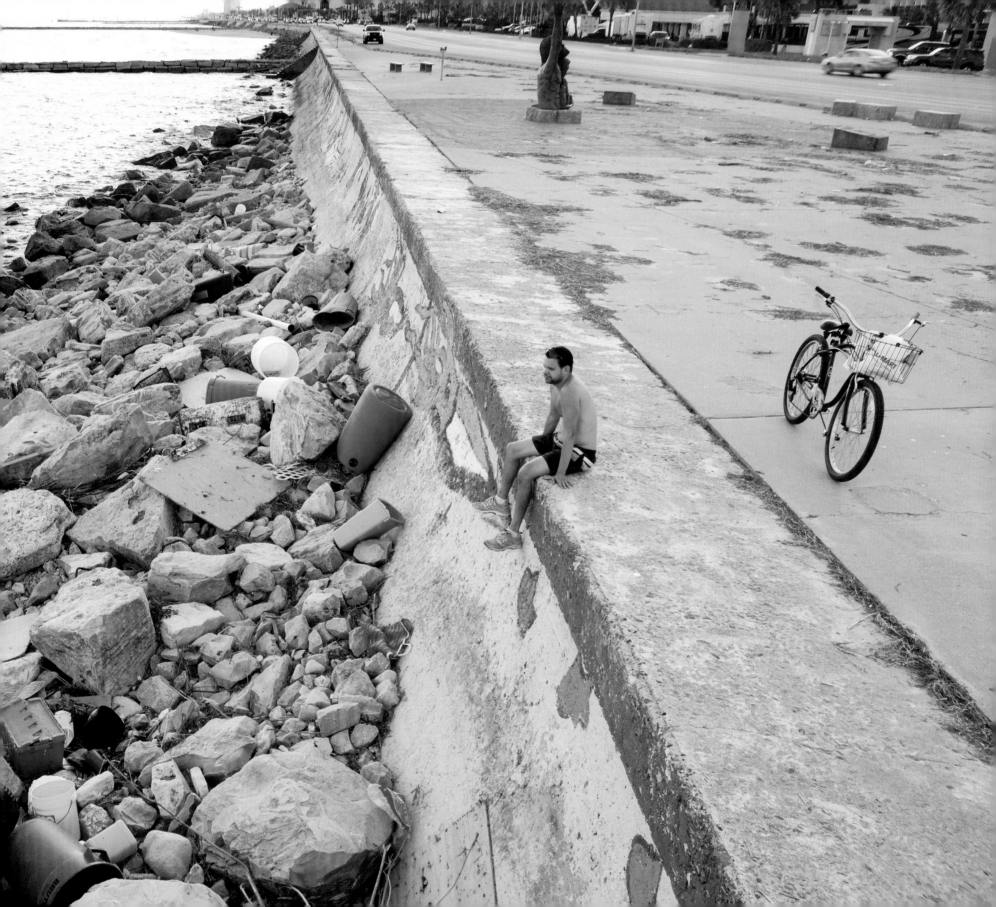

A little ice would be nice

By ALISON COOK

Ice, beautiful ice. Cold and crystalline. Cloudy or clear. Snapping and crackling its way out of an ice-cube tray, swooshing crisply from a plastic bag, chinking and tinkling in a tall glass.

Please excuse me for going on like that. But never in recent memory have so many Houstonians been so fixated on water in its precious solid form. Hurricane Ike has made ice an obsession even for people who have bigger things to worry about. Chainsawing the tree that landed on your roof, negotiating with FEMA or cleaning out the reeking contents of your lifeless refrigerator somehow seem less daunting when you've got a cooling, palliative beverage close at hand.

By Sunday, ice supplies stashed in coolers around the city were melting away and by midday, in the sweltering September heat, folks were beginning to feel a little desperate.

I was one of them. Over the endless dank weekend, I drank a dozen glasses of ice water, pressed a cold compress of St. Arnold's Lawnmower beer to my forehead and ran through my stash of long, coiled, re-freezeable "Ice Snakes," which I wore slung about my torso like feather boas (an idea cribbed from the Beijing Olympic marathoners in their ice vests). When I scrabbled my hand through the double Ziplocs where my carefully manufactured and hand-harvested ice-cube trove had resided, I felt only the emptiness of cold water.

Just as my third and final Ice Snake reached room temperature, I heard on my weather radio that free ice was being distributed on Fuqua off the Gulf Freeway. I didn't even wait to hear the address. "I'm going for ice!" I shouted across to a gaggle of neighbors, who were barbecuing next door. They hustled a giant cooler out to my SUV and I took off, happy to see traffic moving at a fast clip.

By the time I hit Almeda Mall, I realized thousands of my fellow Houstonians were on the hunt, too. The feeder road was a parking lot miles before Fuqua and cars crawled, three abreast, on the approaching freeway. Police lights flashed ahead. When I drew nearer, I spied a squad car blocking the Fuqua exit. A herd of cars encircled the Hilton Furniture lot, where workers handed out white bags — so near and yet so far — from a long, white truck.

With visions of ice riots dancing in my head, I made a U-turn at the next exit and returned home with my tail between my legs. "No way," I had to report to my hopeful neighbors.

Three days later, with my house still lacking power, the only ice I have been able to score was a half-gallon milk jug of homemade block ice from a charitable neighbor whose power had returned.

If I want a glass of ice water to sip while I read by Coleman lantern light before slipping off to a restive sleep, it's just too bad.

I've already ditched the perishables that perished when my ice melted. That workout required two trips across the street to beg for ice cubes to cool my water glass. I've heard they have ice at the Whole Foods Market in Sugar Land (2 bags per customer, if you please), but I no longer have enough gas to drive there and back.

Mayor Bill White has rightly dubbed the ice shortage one of Houston's biggest problems in the storm's aftermath, and I wish him luck in his efforts to procure ice-making machines. Until that miracle occurs, we'll all be hoarding and retelling our own poignant ice stories. Jeff and Luke Cordes, two young men who have a lawn business in my Idylwood neighborhood, were treated to dinner at El Jardin Mexican restaurant on Harrisburg by grateful neighbors whose yards they had cleared of downed trees.

"They had margaritas," Jeff told me, as they stood, exhausted, in the mercifully cool dark late on Tuesday night.

They were physically wrecked from days of non-stop manual labor. Their house had no power, nor did it seem likely to in the near future.

But a few miles away, there was a place churning out Texas' frozen beverage of choice, and life seemed that much more livable again.

COLD CACHE | OPPOSITE | Barbara Lawson carries a bag of ice she picked up at a FEMA distribution site at Texas Southern University. | SEPT. 16 | HOUSTON | **BILLY SMITH II**

New blooms bring hope

By KATHY HUBER

The hurricane lilies are blooming.

My front garden looked like tossed salad on Monday morning thanks to Hurricane Ike, but the lilies, tough little bulbs, greeted me through the debris.

The deep-crimson flowers of Rhodophiala bifida pop up each September. They're joined by their cousins, the spidery lycoris. Both arrive at the height of the storm season and share the common name hurricane lilies.

This week I took their return as a sign I would have a garden again — and I have been in great need of reassurance.

Since Ike passed, I have breathed a constant "thank you" as my family and our home are unharmed. I have pushed aside the images of ruin glimpsed in the dim, gray light of the storm's wake Saturday. I avoided looking out the many windows and French doors we installed so we could enjoy our garden from indoors. But when eventually I faced the grim sight, it got the best of me.

I, like many gardeners, lost some dear old friends. Ike's winds reduced our gnarly red oak to a Charlie Brown's Christmas tree. The oak, our family's favorite tree and the heart of our front garden, has shaded our yard for years. Its bumpy burls and serpentine branches made for an oddball but beloved silhouette.

The oak now lies in a pile of chain-saw-carved chunks. The remains of four trees from our back garden lie beside it in the streetside tree cemetery.

Without the trees, the concept of our back landscape is gone — a private woodland garden with winding paths and large beds. For 24 years, I've found refuge strolling beneath the canopies of our tall trees. (And thanks to their shade, our electric bill was lower than most.)

Now the playing field is leveled. Without the fences, it's naked. Without the dense, lush green of the shrubs and perennials that thrived here, it's raw.

Ike shredded the towering Bradford pears, which in turn flattened the large cherry laurel that was part of our son's childhood fort. The storm slung a massive helping of green ash on the oakleaf hydrangeas, Chinese mahonias and 6-foot leucothoes, forcing the large shrubs and the east fence to their knees. And we can forget the fall color show of the red maple, my second-favorite tree. It will take a long time for it to recover, if it does.

The wind-blown west fence crushed a large trial bed of Viburnum awabuki and 'Endless Summer' hydrangeas that were climbing their way up my "best shrubs" list. The high-gloss surfaces of the viburnum leaves are especially attractive, and the hydrangeas repeat bloom. Their branches are splayed like spilled matchsticks. But with roots intact, they may gradually recover.

Other shade collections were crushed beneath the toppled trees: crested iris; peacock, butterfly and hidden gingers; rhizomatous and cane begonias; several types of ferns; and flowering perennials such as rose pinecone plant (Porphyrocoma pohliana). To add insult, many of them were further minced as the tree debris was removed. Hopefully, I can salvage and relocate some of the rhizomes.

Meanwhile, a few signs of wildlife have returned. The hummers are visiting the uprighted hummingbird bush in the front garden. And I've heard the sweet chip, chip, chip of a cardinal.

I called our son at Tulane University to warn him home would look different when he returns for the holidays. Living in Katrina-ravaged New Orleans, he understands the loss of a large tree.

"It's not like a fallen picture you can rehang," he said.

No, but I can paint another picture. I can plant a sun garden. It will take time, but I can adjust. The hurricane lilies always do.

UPROOTED | OPPOSITE | A single palm was transported by the hurricane, roots and all, to its final resting place on the beach. | SEPT. 15 | CRYSTAL BEACH | **SMILEY N. POOL**

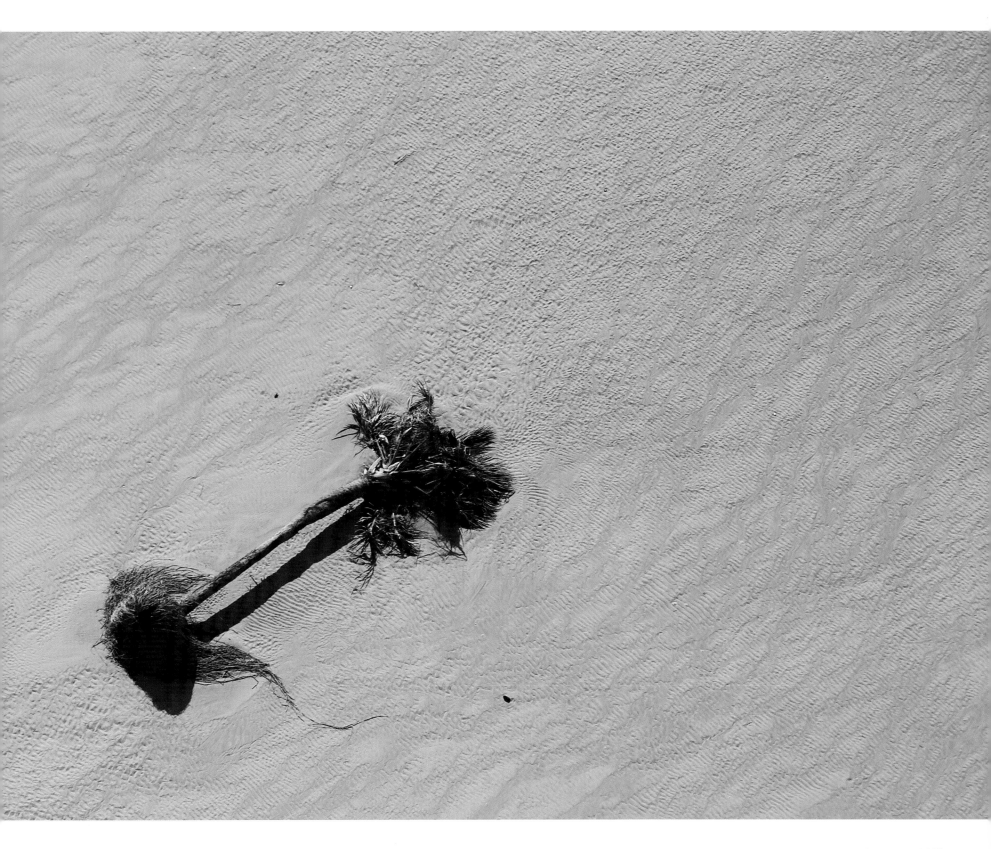

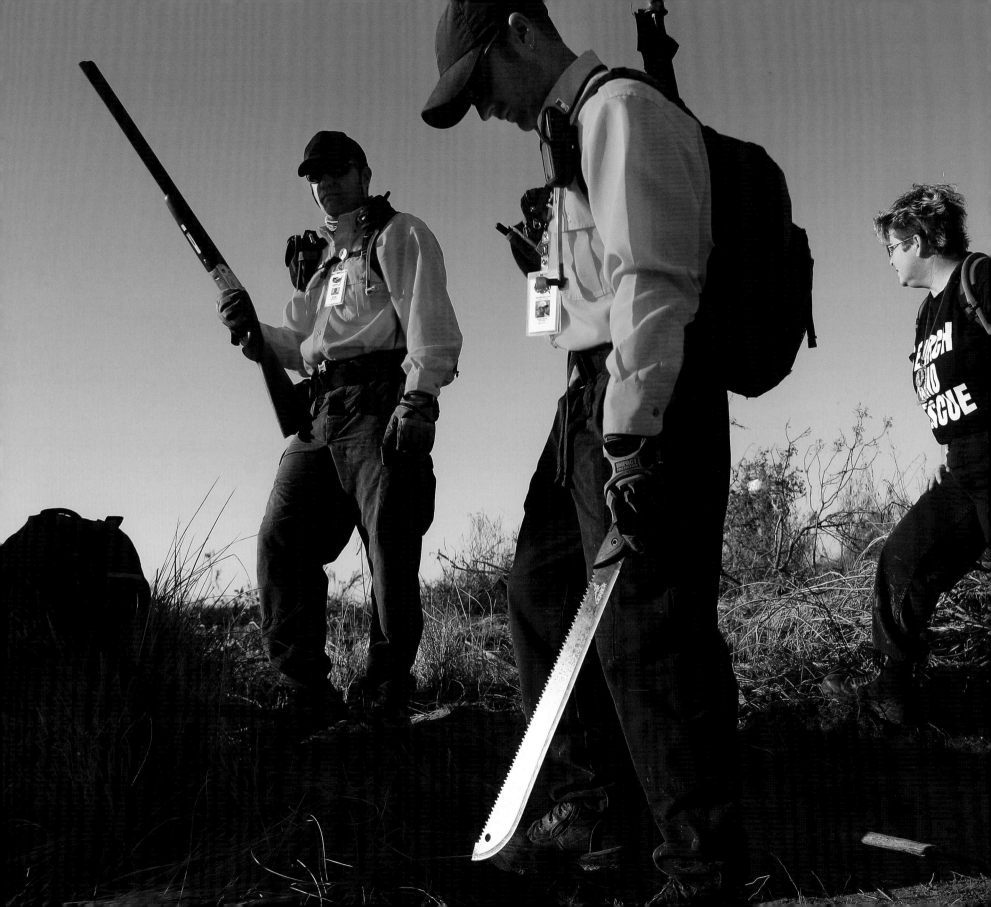

CHAPTER *Four*

recovery and hope

As every trip begins with but one step, the recovery of Greater Houston was first felt with a single restored power line, a boat removed from a highway, a home cleared of moldy carpet, a prayer completed before a communal candlelit buffet in the front yard. As we pondered the sometimes thin veneer of modern civilization, and commiserated and cooperated with neighbors in need, workers from other states arrived by the hundreds to help. The electricity poles went up a street at a time. The lines dwindled for meals, water and gasoline. One by one the generators fell silent. Piles of trash and tree limbs were steadily carted off. Schools reopened and T-ball games resumed. Blue FEMA tarps remained atop countless thousands of roofs, but daily activities moved on beneath them with comforting constancy. The work to be done along the coastal areas is immense, the sense of defeat negligible. Galveston will be rebuilt. Tears dry, replaced by sweat. And at some future date, soon or generations hence, another storm will come calling. This is life in the place we call home.

GRIM TASK | OPPOSITE | Bryan Bible, left, Brandon Goering, center, and Kim Frost, a search-and-rescue team from U.S. HERO, take a break from searching for human remains. They joined dozens of volunteer cadaver dog teams in an effort to mark potential recovery sites. | OCT. 3 | GOAT ISLAND | **MAYRA BELTRÁN**

A PLACE FOR REFLECTION | TOP | Workers' footprints are pressed in the mud inside the historical Trinity Episcopal Church. The church flooded during the storm and the stained-glass window behind the altar was broken. | SEPT. 18 | GALVESTON | **MAYRA BELTRÁN**

HEAVY LIFTING | TOP | Chris Casanover, 18, carries a tub through the rubble of his father's house. At least 1,000 homes throughout Chambers County were either destroyed or rendered uninhabitable. | SEPT. 15 | OAK ISLAND | **SHARÓN STEINMANN**

OLD GLORY | BOTTOM | A search worker pulls a muddy American flag from the debris of a damaged home. The workers dipped it in a puddle to clean it. | SEPT. 15 | PORT BOLIVAR | **SMILEY N. POOL**

IN ONE PIECE | OPPOSITE | Michael Casanover, left, and Jeffrey Hill hang Casanover's Texas flag, which they found a mile from Casanover's destroyed home. | SEPT. 15 | OAK ISLAND | **SHARÓN STEINMANN**

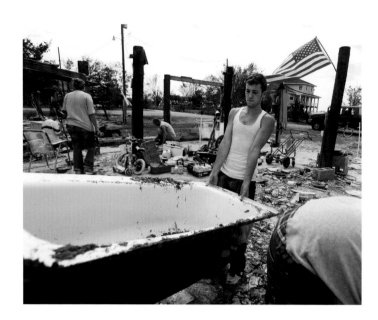

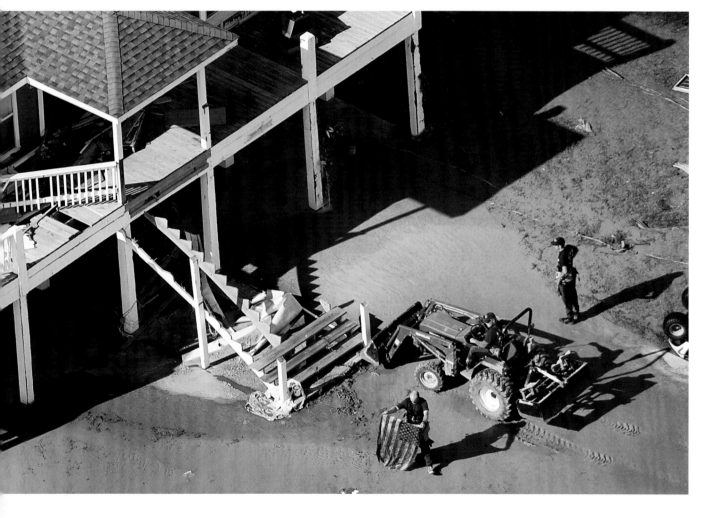

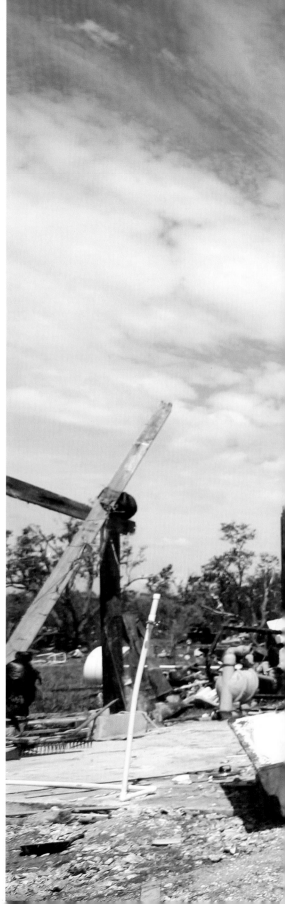

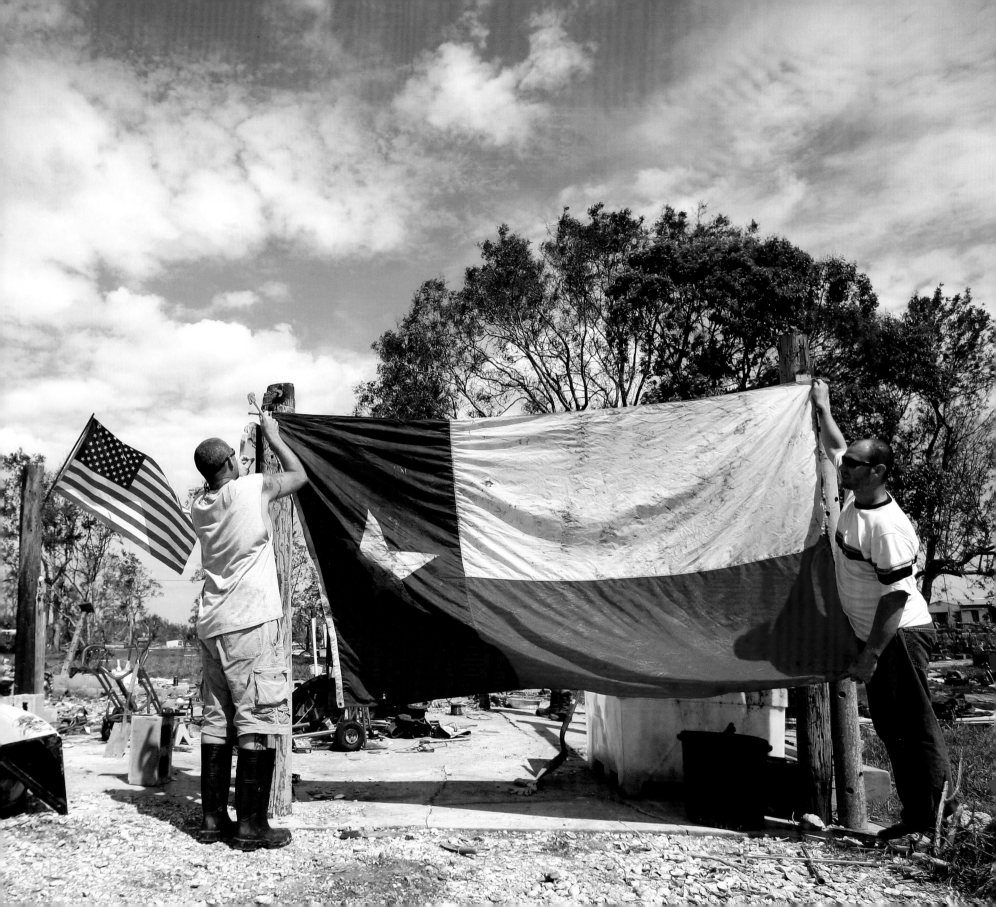

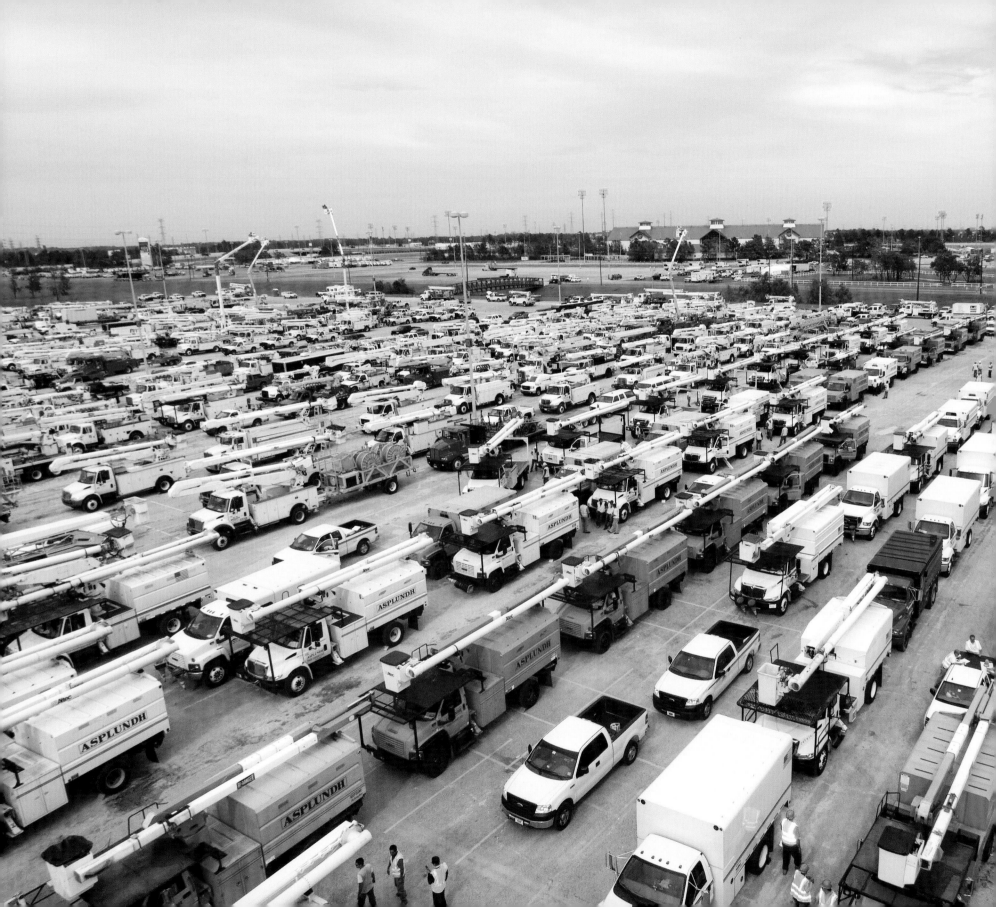

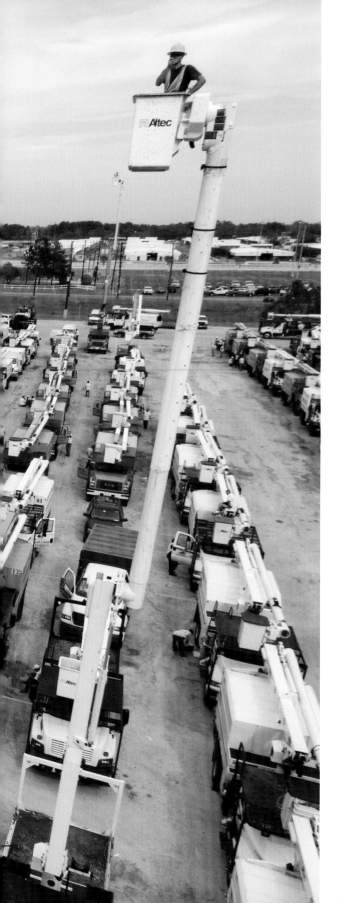

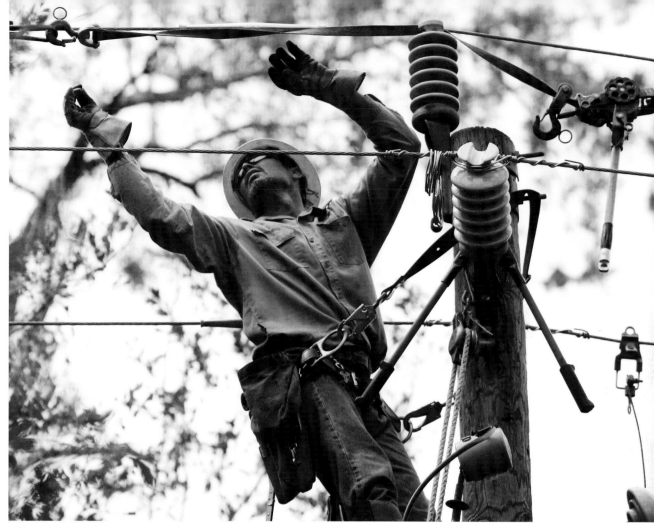

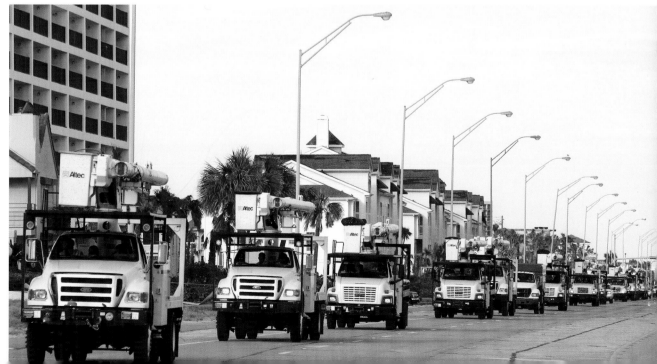

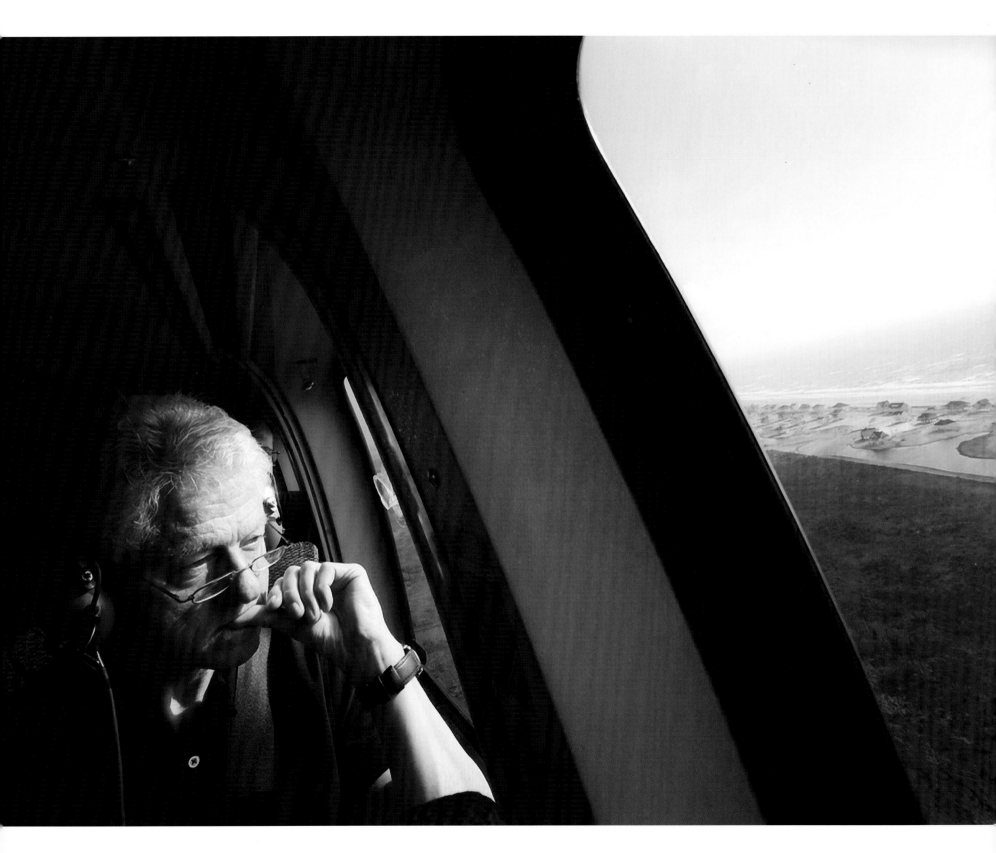

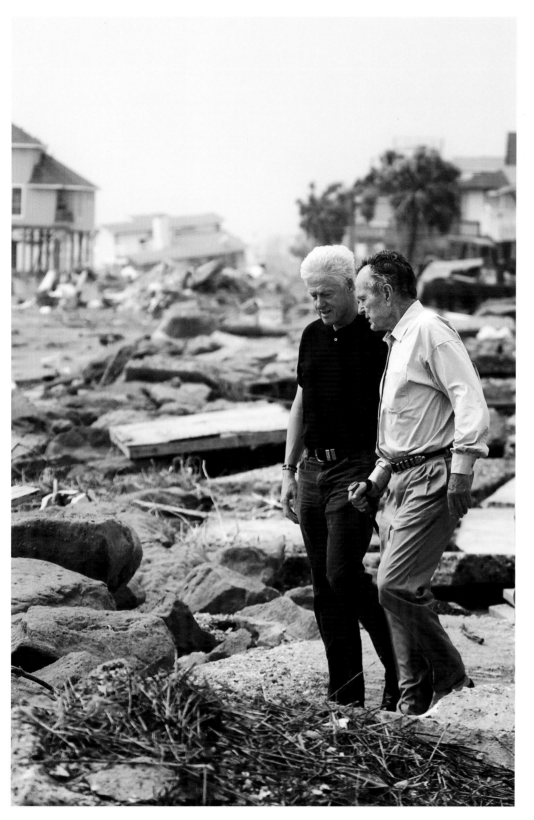

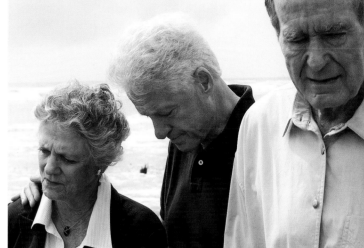

'DON'T FORGET' | OPPOSITE | Former President Bill Clinton looks out at the hurricane-devastated scenery as he tours the area with former President George H.W. Bush. Clinton acknowledged that the nation's attention quickly drifted from Hurricane Ike as the financial meltdown began just days later. "What we hope is to say, 'Hey, don't forget about this place.'" | OCT. 14 | BOLIVAR PENINSULA | **SMILEY N. POOL**

ON THE SCENE | LEFT | The two former presidents, surveying the damage, came together to help raise funds for roads and other community systems. | OCT. 14 | BERMUDA BEACH | **SMILEY N. POOL**

MEDIA NOTES | TOP | Bush and Clinton address the media with Galveston Mayor Lyda Ann Thomas. Thomas said she is optimistic that her city will receive the money it needs to rebuild. "They've raised a lot of money in the past," she said of the two former presidents. "I think they are sincerely interested." | OCT. 14 | BERMUDA BEACH | **SMILEY N. POOL**

READY TO ROLL | PREVIOUS LEFT | Thousands of linemen and tree service workers arrive and are dispatched from Sam Houston Race Park to restore electricity and remove limbs. | SEPT. 15 | HOUSTON | **STEVE UECKERT**

POWER UP | PREVIOUS TOP RIGHT | CenterPoint Energy lineman Kevin Allen repairs a power line. | SEPT. 16 | BAYTOWN | **BILLY SMITH II**

HELP IS ON THE WAY | PREVIOUS BOTTOM RIGHT | An army of tree cutters and cleanup personnel travel west on Seawall Boulevard. | SEPT. 16 | GALVESTON | **NICK de la TORRE**

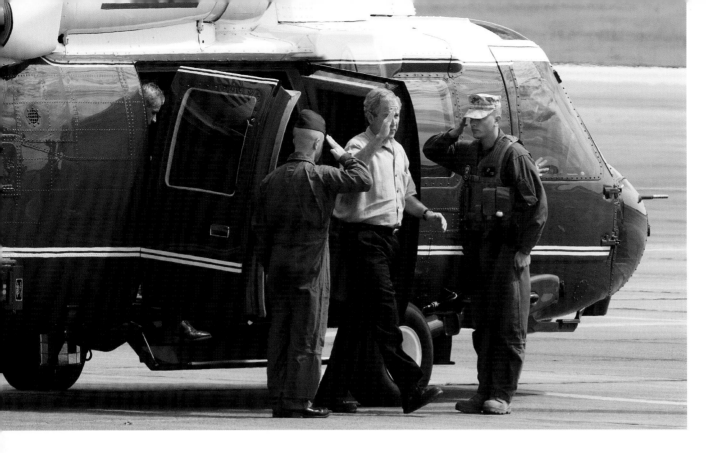

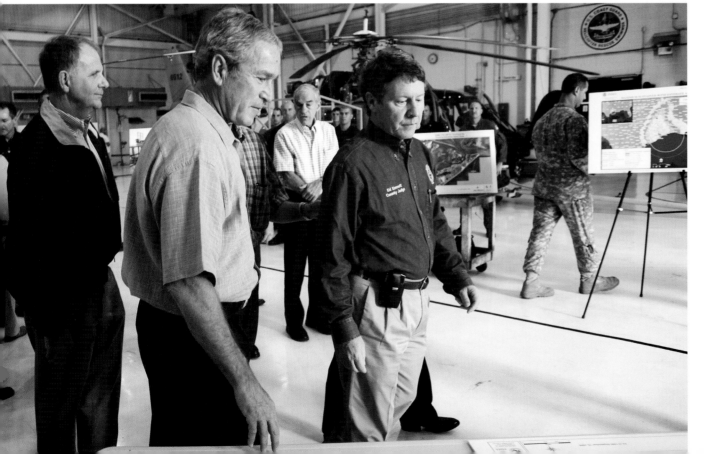

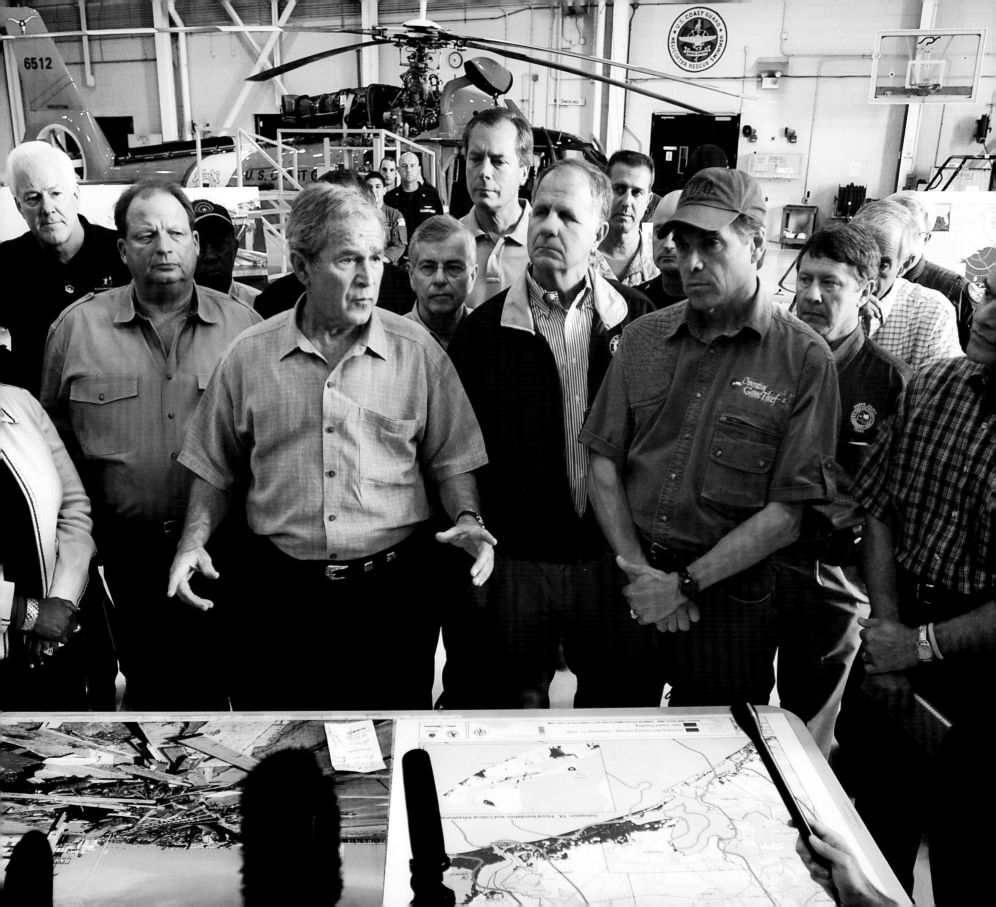

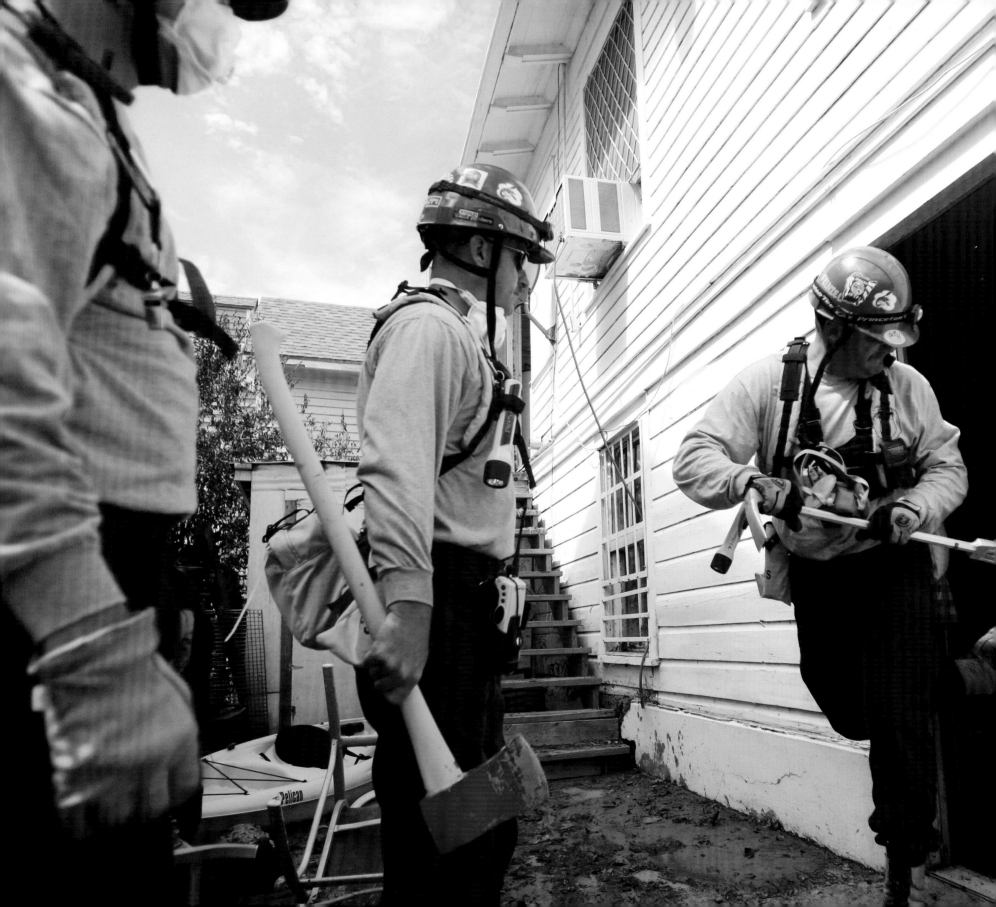

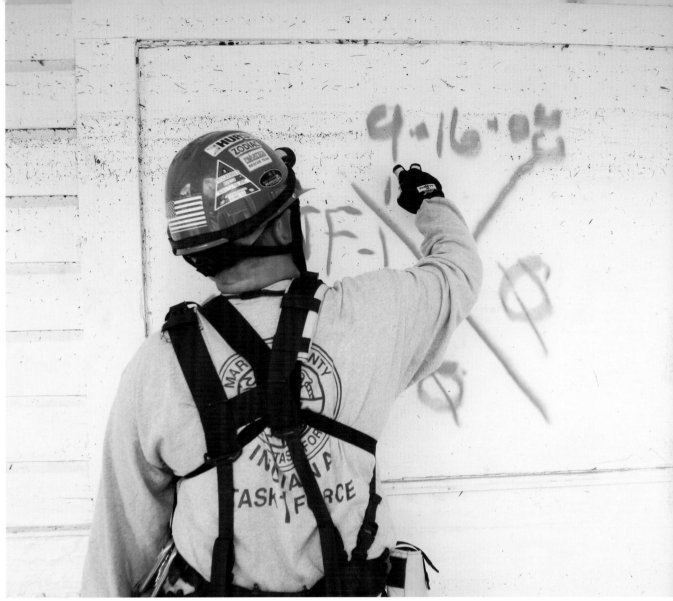

WHEN IN NEED | ABOVE | Hundreds of volunteers, rescue workers and peace officers descended on the area to help. Dan Speer of Indiana Task Force 1 tags the door of a house that needs further inspection. | SEPT. 16 | GALVESTON |
NICK de la TORRE

FALSE ALARM | OPPOSITE | Eric Frenzel of Indiana Task Force 1 kicks open the door of a house that smelled suspicious. It turned out to be rotting meat. | SEPT. 16 | GALVESTON | **NICK de la TORRE**

EXECUTIVE VISIT | PREVIOUS TOP LEFT | President George W. Bush arrives on Marine One at Ellington Field after taking a helicopter tour of the area. | SEPT. 16 | HOUSTON | **SMILEY N. POOL**

PINPOINTS | PREVIOUS BOTTOM LEFT | President Bush looks over maps of the Texas coast with Harris County Judge Ed Emmett at Ellington Field. | SEPT. 16 | HOUSTON | **SMILEY N. POOL**

BRIEFING | PREVIOUS RIGHT | Surrounded by local officials, President Bush addresses the media before touring the area. | SEPT. 16 | HOUSTON | **SMILEY N. POOL**

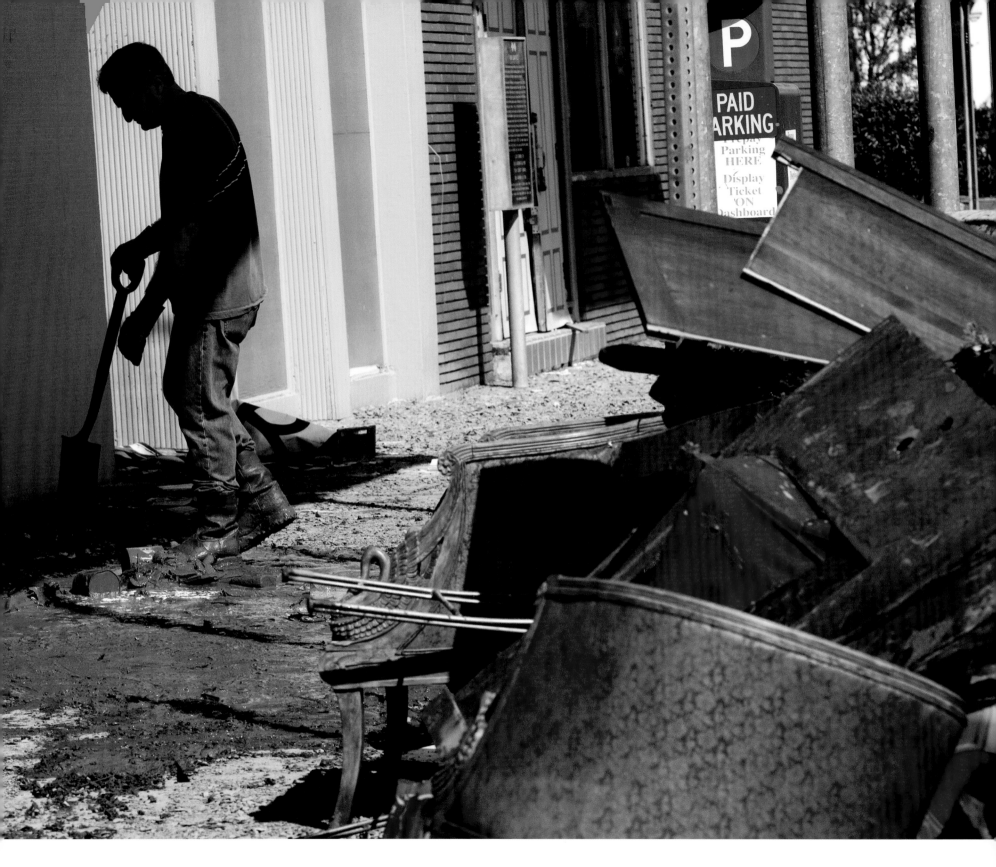

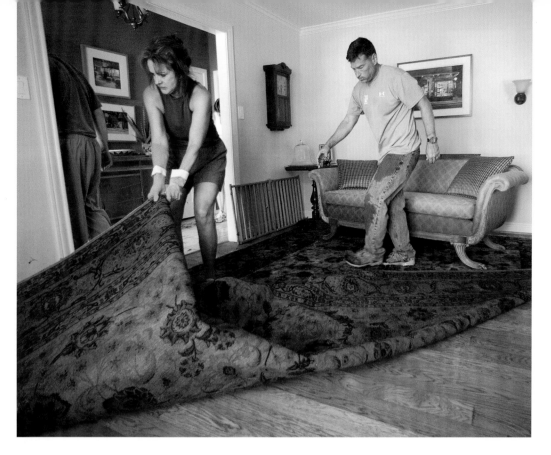

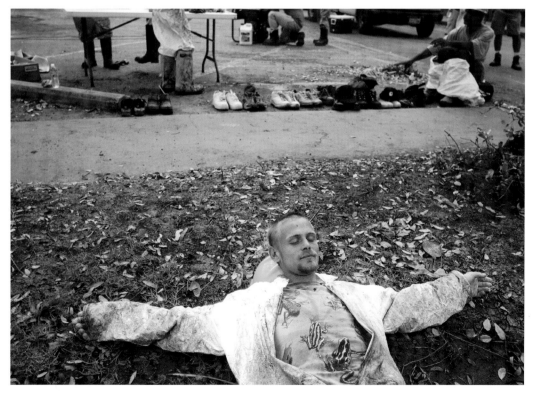

DIRTY WORK | OPPOSITE | Chip Johnson tries to clean up a loft in the city's Strand area. | SEPT. 18 | GALVESTON | **JOHNNY HANSON**

FRIENDS HELPING FRIENDS | TOP | Trudy Davis and John McKennain help pull up wet carpet in the home of Jim and Sally Galbraith. | SEPT. 17 | GALVESTON | **BRETT COOMER**

FOR THE WEARY | BOTTOM | Ryan Jarvis of Oklahoma City rests after helping to clean the First Baptist Church. | SEPT. 18 | GALVESTON | **MAYRA BELTRÁN**

MOPPED UP | FOLLOWING TOP LEFT | In the Fifth Ward, Michael Jackson and his son, Howard, 2, stand in Howard's room, which was damaged during the hurricane. | SEPT. 16 | HOUSTON | **KAREN WARREN**

PRAYER | FOLLOWING BOTTOM LEFT | Salatheia Bryant-Honors, co-pastor of Reedy Chapel A.M.E., prays after getting her first look at the extensive damage to the historic church. Reedy Chapel, the first African Methodist Episcopal Church in Texas, celebrated its 160th anniversary earlier in 2008. | SEPT. 17 | GALVESTON | **NICK de la TORRE**

DINNER IS SERVED | FOLLOWING RIGHT | Don Muniz serves soup heated on a backyard grill to his family. His wife, Vanessa, said their family is spending more time together since the power went out. "It's been an adventure," Don Muniz said. | SEPT. 17 | HOUSTON | **SMILEY N. POOL**

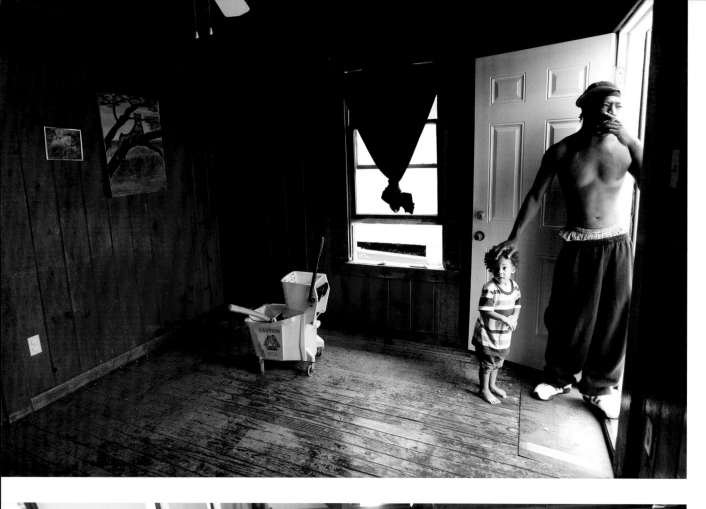
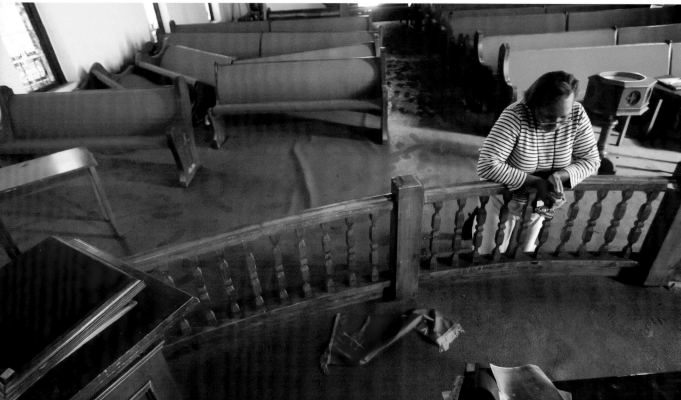

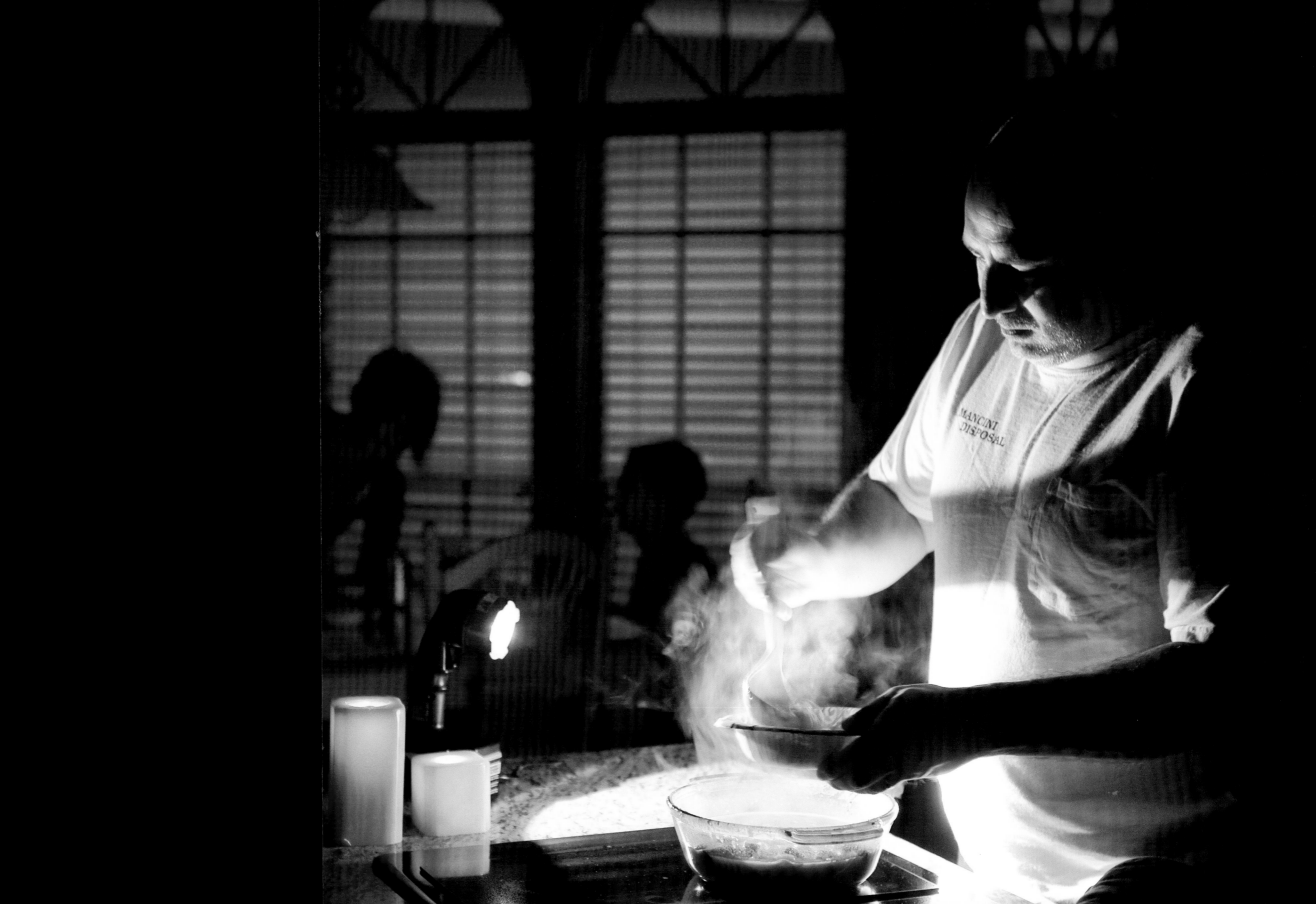

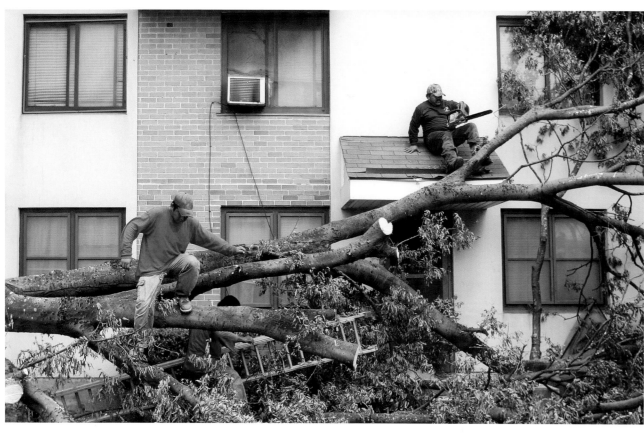

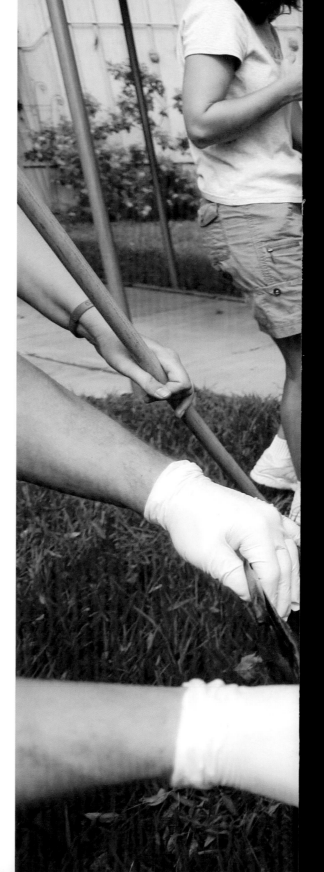

BUSY WORKERS | TOP | Alberto Ortiz and Jose Luis Rodriguez of Green Planet Landscaping remove a tree that fell in front of an apartment complex. | SEPT. 19 | HOUSTON | **MAYRA BELTRÁN**

WATER BREAK | BOTTOM | Rogelio Zarco of Green Planet Landscaping takes a break as he helps clean up debris. | SEPT. 19 | HOUSTON | **MAYRA BELTRÁN**

IN THE BAG | OPPOSITE | Some 200 volunteers, including first-grader Kiara Mena, center, and her younger sister Marley, gathered at Kolter Elementary to help clean up and get the school ready to resume classes. | SEPT. 19 | HOUSTON | **MAYRA BELTRÁN**

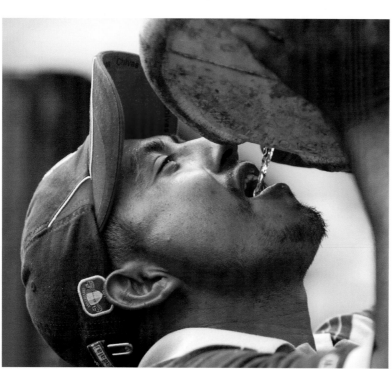

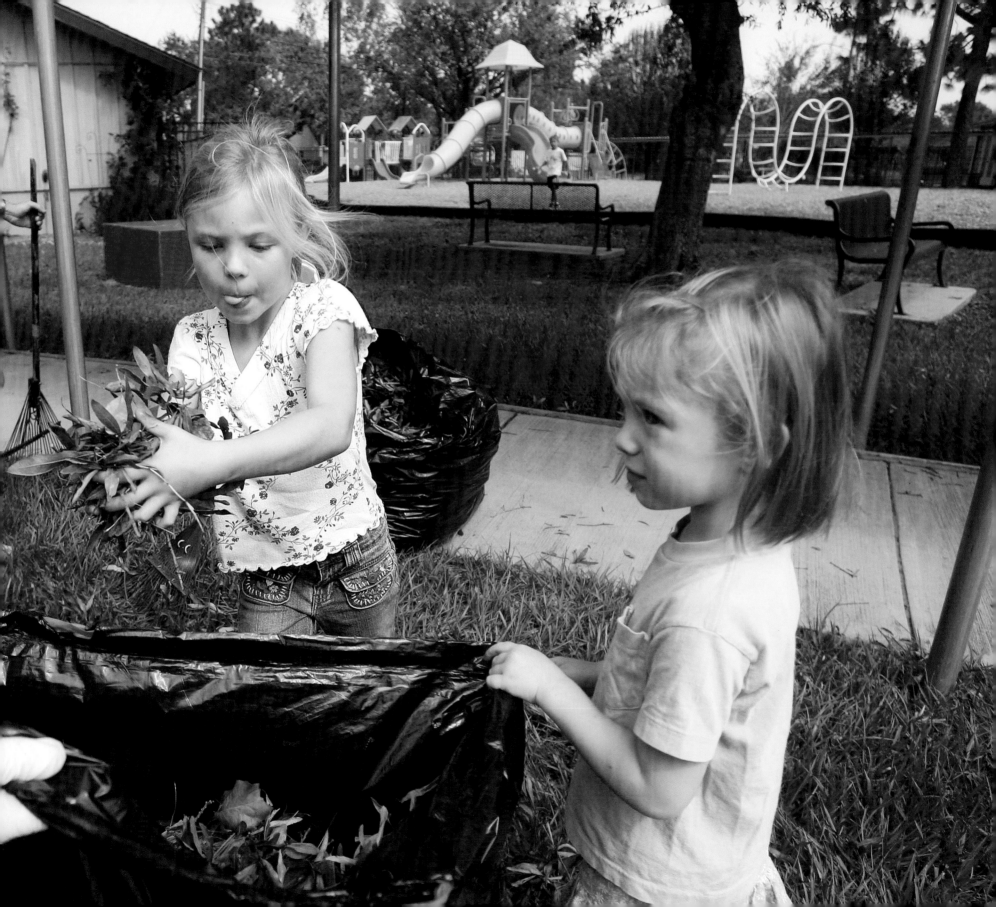

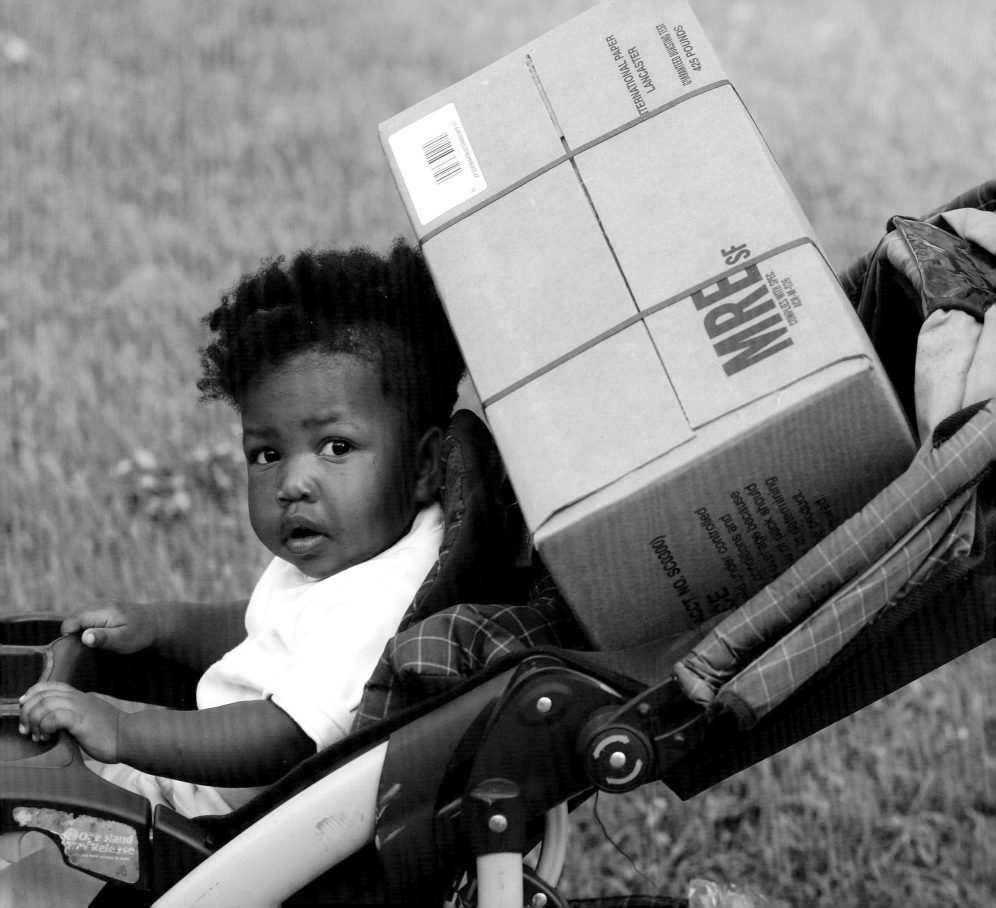

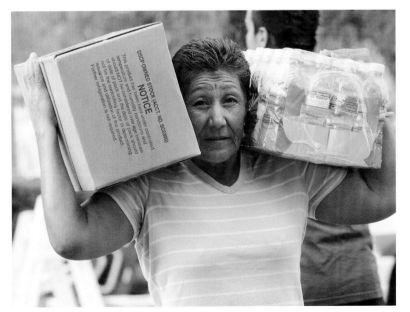

READY TO EAT | OPPOSITE | Chrishae Fennix shares a stroller with a box of MREs that her mother picked up at a distribution site at Texas Southern University. | SEPT. 16 | HOUSTON | **BILLY SMITH II**

ON QUEUE | TOP | A long line snakes around the parking lot at a FEMA distribution site. | SEPT. 15 | SEABROOK | **SMILEY N. POOL**

BULK GOODS | BOTTOM | Juanita Rojas, 54, hoists the emergency supplies she received from FEMA. | SEPT. 18 | HOUSTON | **JULIO CORTEZ**

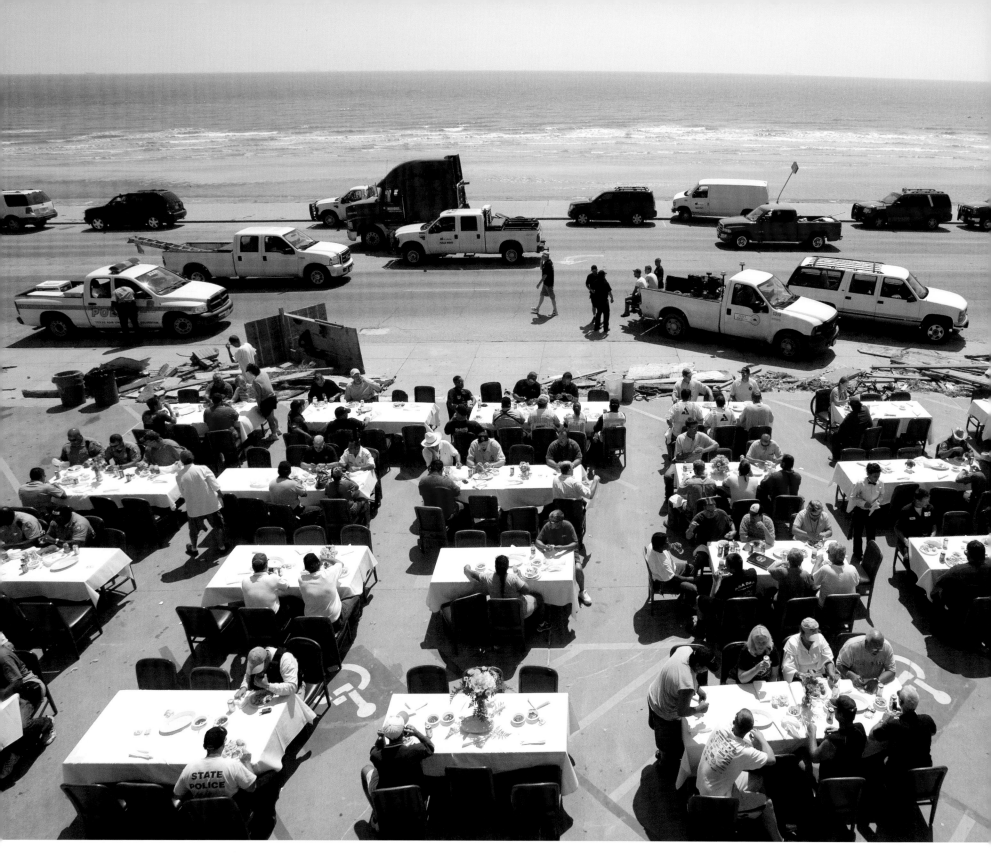

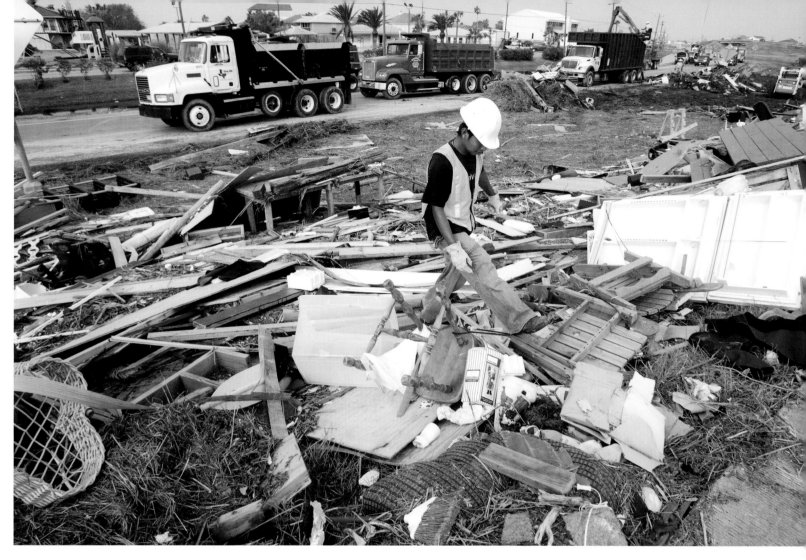

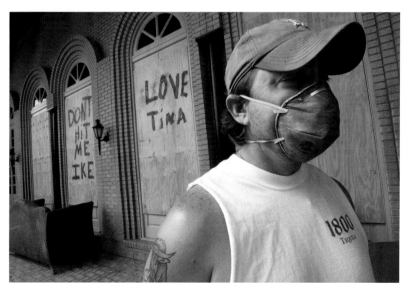

IT'S ON US | OPPOSITE | Gaido's Restaurant picked up the lunch tab for first responders and other workers helping clean up storm damage. The well-known eatery on Seawall Boulevard set up tables outside — complete with white linen tablecloths and flowers — and served a shrimp meal at no cost. The restaurant itself suffered major roof damage from the hurricane. | SEPT. 18 | GALVESTON | **JOHNNY HANSON**

LENDING A HAND | TOP | Nelson Ordanez, who's originally from Mexico, helps clear debris from an area along the Gulf Freeway. | SEPT. 18 | TIKI ISLAND | **JOHNNY HANSON**

BUSINESS TIES | BOTTOM | Andrew Vogel, a liquor representative, wears a mask as he helps clean his client's bar, Club 21. | SEPT. 18 | GALVESTON | **JOHNNY HANSON**

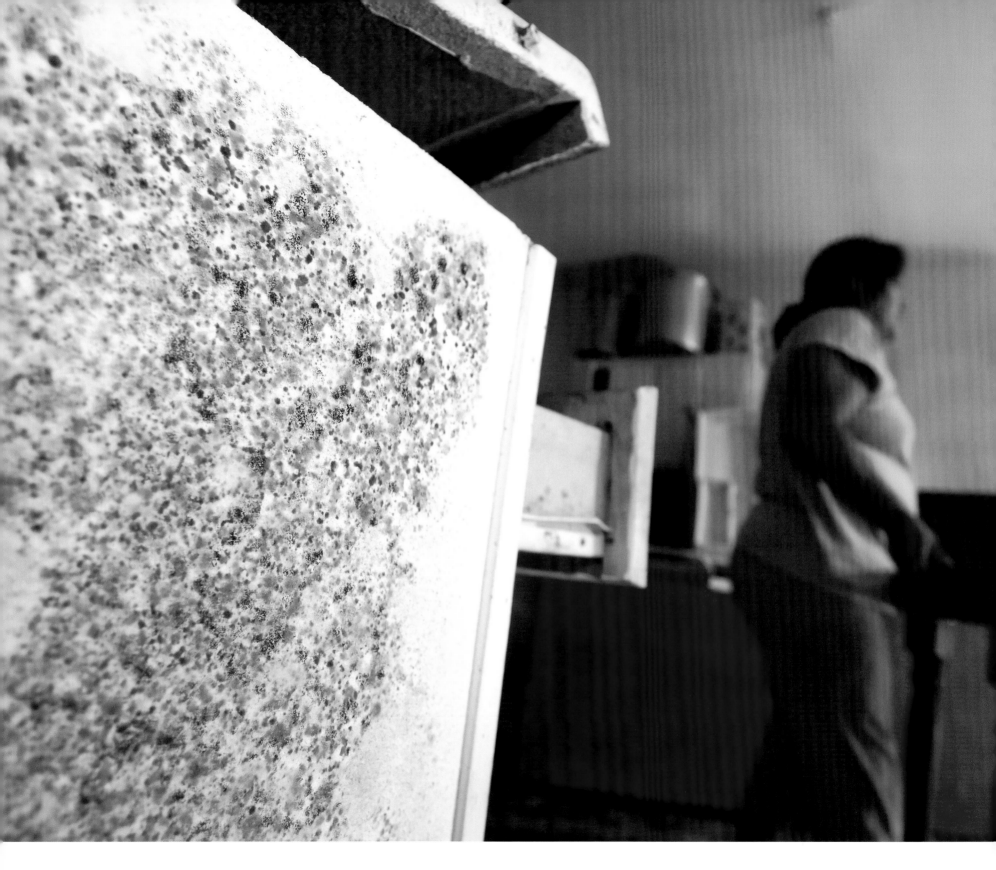

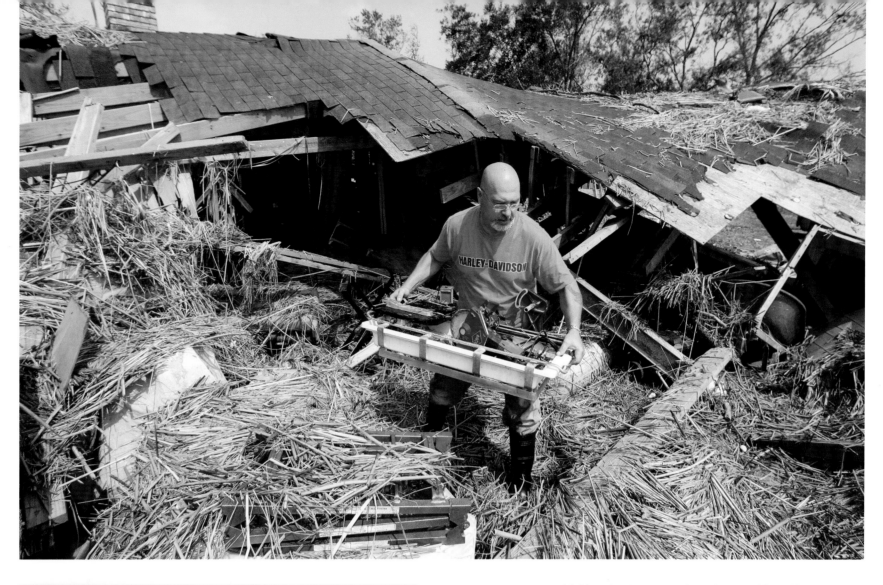

TAKEN OVER | OPPOSITE | Mold makes its way up the cabinets of Rosa Becerra's kitchen as she removes a table after floodwaters ravaged her family's home. | SEPT. 19 | GALVESTON | **JOHNNY HANSON**

WRECKAGE | TOP | David Smith salvages tools from his childhood home, which was all but destroyed by the storm surge. | SEPT. 19 | BRIDGE CITY | **BILLY SMITH II**

PRECAUTION | BOTTOM | Anthony Levine dons a protective mask as he starts cleaning up a relative's home. | SEPT. 24 | GALVESTON | **BRETT COOMER**

IMPRINT | PREVIOUS LEFT | A footprint marks the drying mud along a sidewalk on Market Street near downtown. | SEPT. 18 | GALVESTON | **MELISSA PHILLIP**

LEFT BEHIND | PREVIOUS RIGHT | A Bible is seen among the debris at a church. | SEPT. 18 | GALVESTON | **MELISSA PHILLIP**

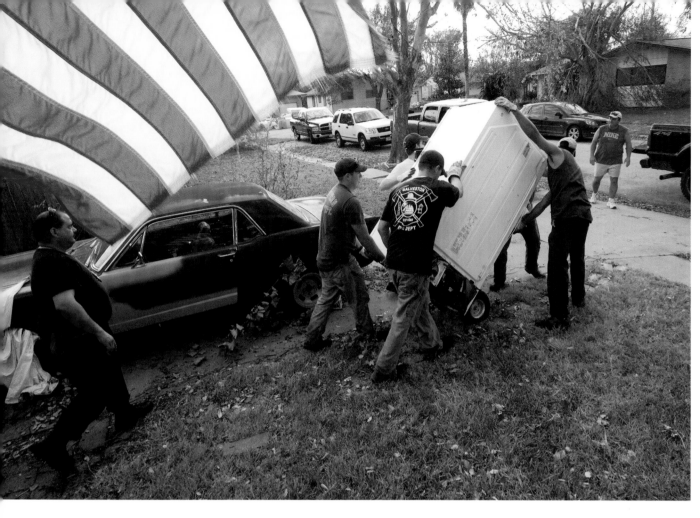

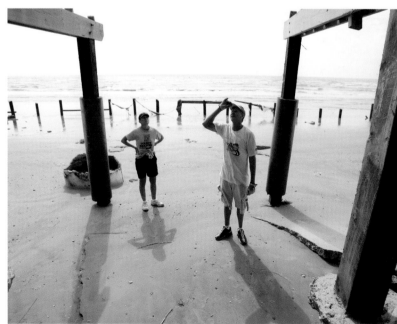

GOOD DEEDS | TOP | First responders came together to help each other out, like these firefighters helping police officer John Collins, left, move a refrigerator. "It's a bright spot in a week of dark days," Collins said. He had four feet of water in his home. The group of firefighters was able to help 11 others. | SEPT. 19 | GALVESTON | **JOHNNY HANSON**

LAMENTATION | BOTTOM | Art and Christy Picone survey damage to their beach house. "It was such a beautiful beach," said Art Picone, 50. "It had beautiful dunes, vegetation and walk-overs. Now it's all gone." | SEPT. 20 | JAMAICA BEACH | **KAREN WARREN**

MELANCHOLY | OPPOSITE | Dianne Brookshire sits in her home among her possessions, now mixed with grass and debris. | SEPT. 19 | BRIDGE CITY | **BILLY SMITH II**

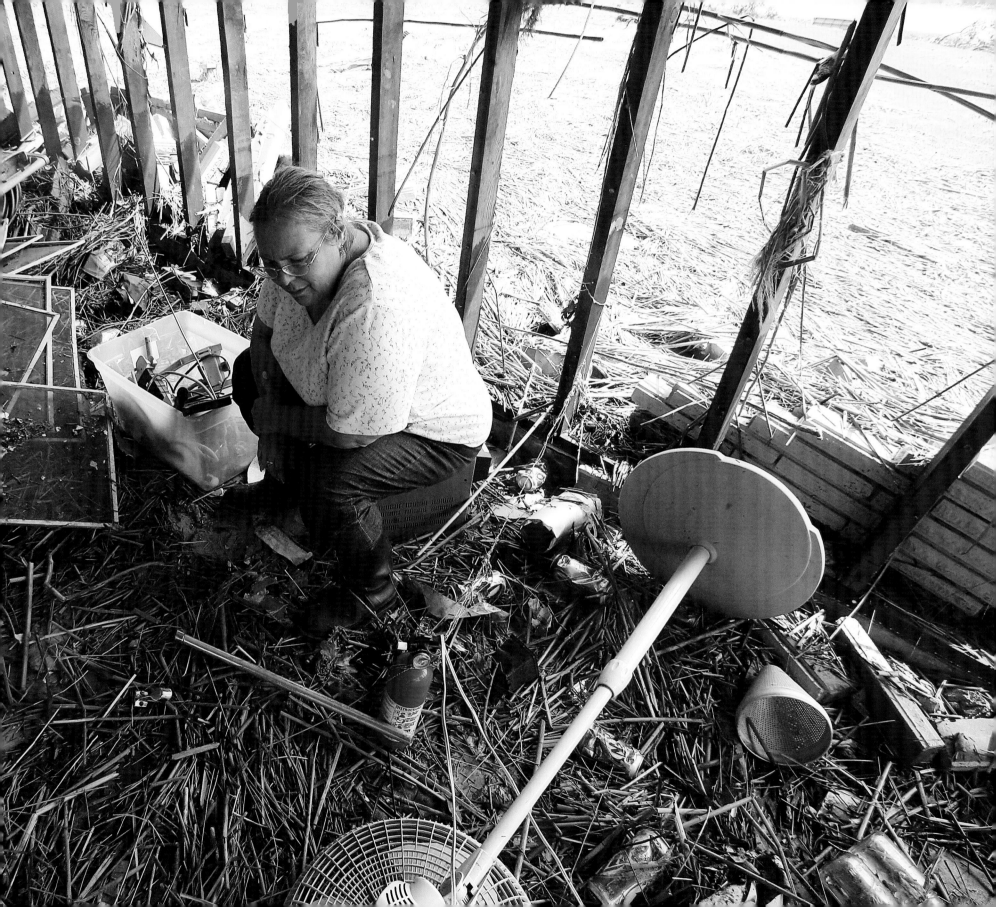

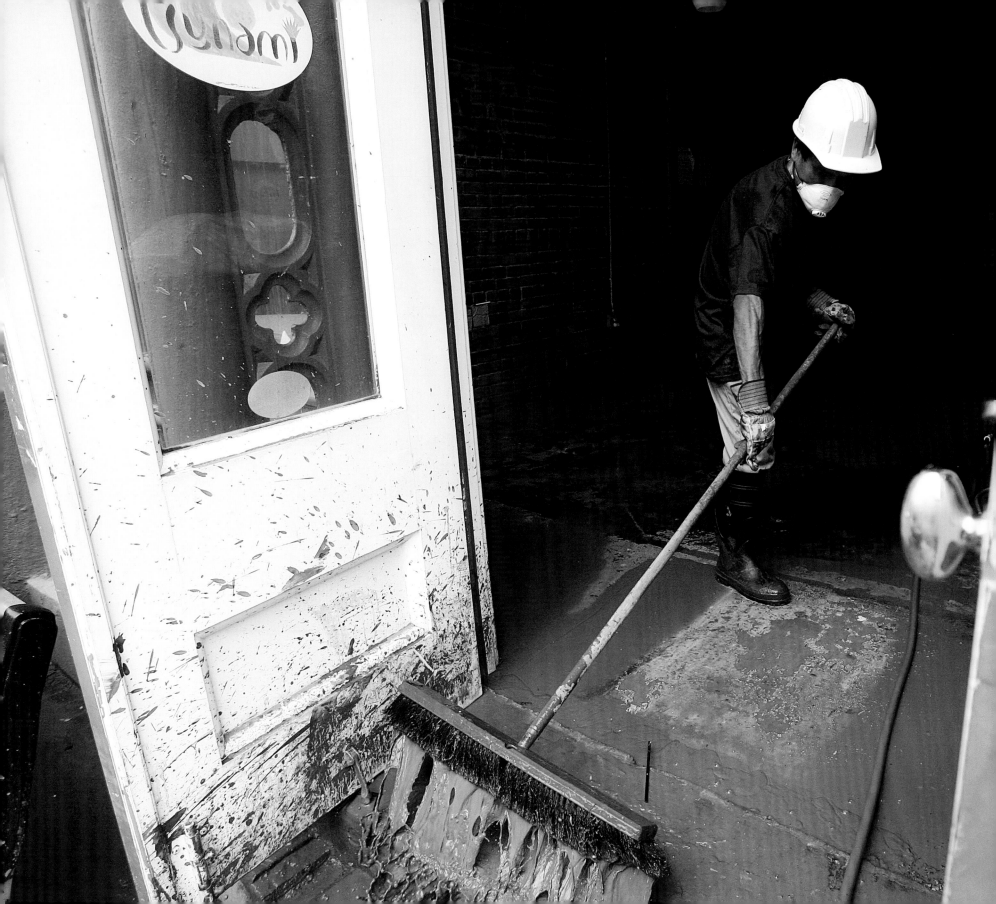

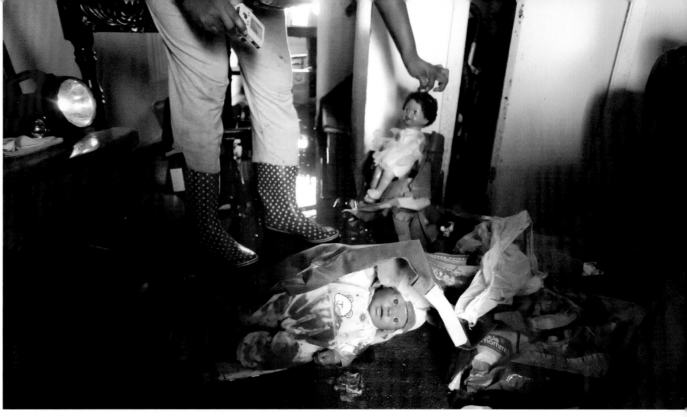
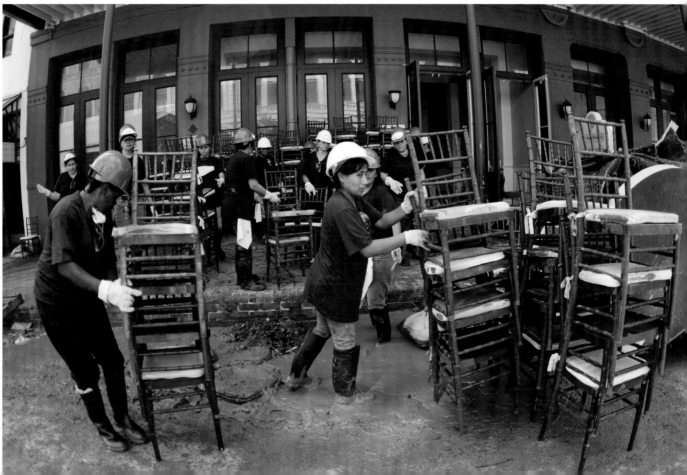

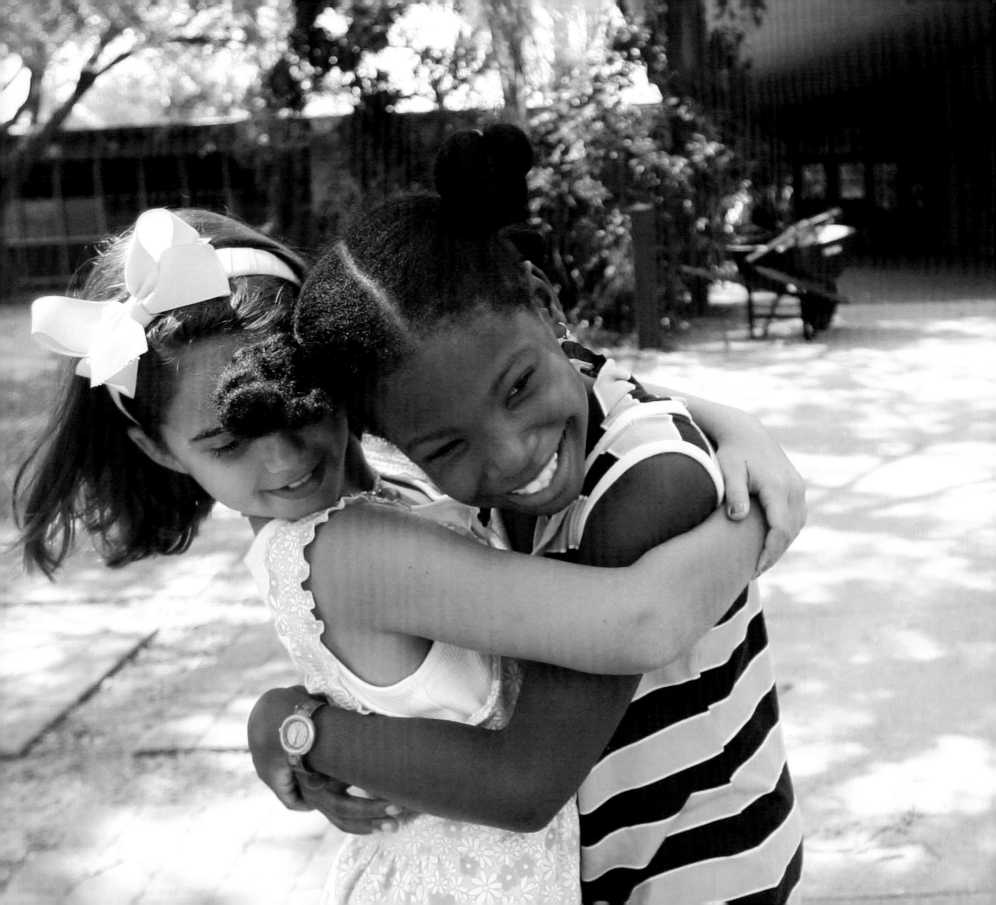

BROKEN SPIRE | ABOVE | The toppled steeple at New Life in the Word symbolizes the struggle many people felt in the aftermath of the hurricane. | SEPT. 22 | CROSBY | **JAMES NIELSEN**

ELATED | OPPOSITE | Annakatia Batoum, 7, right, hugs classmate Hanna Fradkin, 8, at Kolter Elementary School. It was the first time they had seen each other since the storm. | SEPT. 19 | HOUSTON | **MAYRA BELTRÁN**

PLENTY OF WORK LEFT | PREVIOUS LEFT | A worker sweeps out mud from inside Tsunami Restaurant. | SEPT. 20 | GALVESTON | **MAYRA BELTRÁN**

TOY STORY | PREVIOUS TOP RIGHT | Sherlonda Hampton, carefully handling one of the toys she bought her children for Christmas that was ruined during the hurricane, returns home to document the damage. | SEPT. 24 | GALVESTON | **MELISSA PHILLIP**

CLEANING CREW | PREVIOUS BOTTOM RIGHT | Workers stack chairs as they clean up debris at the Davidson House on Ships Mechanic Row. | SEPT. 22 | GALVESTON | **KAREN WARREN**

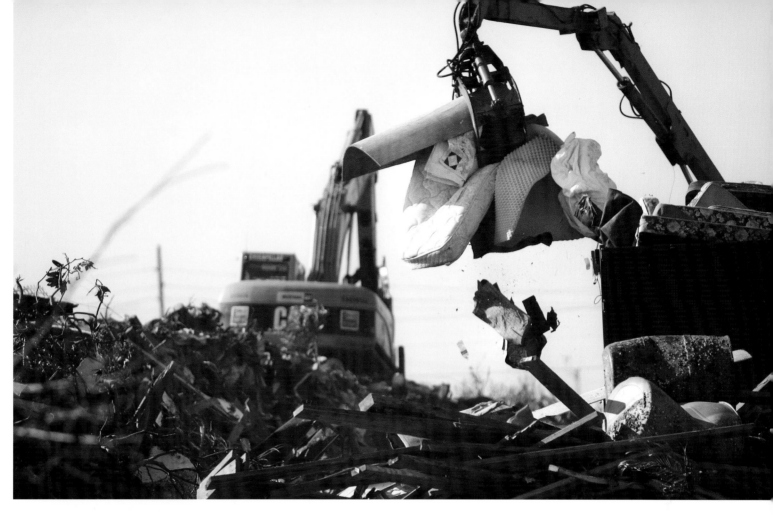

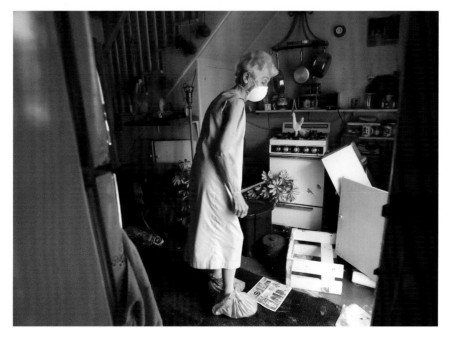

DROP OFF | OPPOSITE | Erica Penry checks the trucks as they bring hurricane debris to a land-fill. | SEPT. 21 | GALVESTON | **MAYRA BELTRÁN**

TEMPORARY SOLUTION | TOP | Mattresses and other debris are brought to a temporary landfill near the Seawall. | SEPT. 21 | GALVESTON | **MAYRA BELTRÁN**

'THINGS ARE THINGS' | BOTTOM | Margaret Dutton, 85, looks at the damage in her East End kitchen for the first time. "Things are things, but I am OK." | SEPT. 24 | GALVESTON | **MAYRA BELTRÁN**

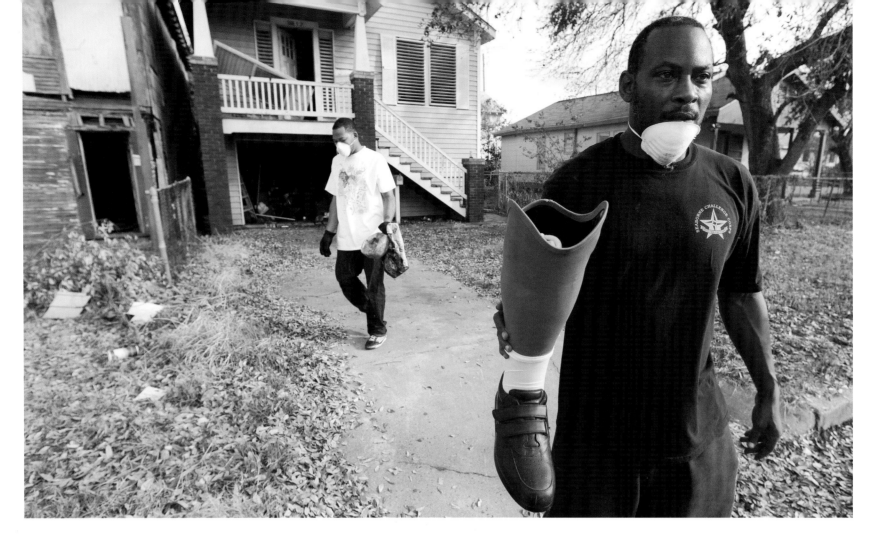

PRIORITIES | TOP | John Levine, right, carries his father's prosthetic leg as he and his nephew, Anthony Levine, begin cleaning up. "The only reason I came back here was to get my father's prosthetic leg," John Levine said. | SEPT. 24 | GALVESTON | **BRETT COOMER**

GOODBYE, IVORIES | BOTTOM | Austin Webber plays the piano in the debris-strewn yard of his family's home. He said he learned to play when he was 5, and that the piano was the one item he would miss. | SEPT. 19 | GALVESTON | **MELISSA PHILLIP**

WHAT REMAINS | OPPOSITE | Ralls Lee, center, gathers trophies from the shell of what had been the Seabrook Sailing Club. The club was established in 1934 and had been housed in this 1960s building until the hurricane. | SEPT. 20 | SEABROOK | **JAMES NIELSEN**

BEACH DUTY | FOLLOWING | Crews wheel out debris near Indian Beach in the West End. | SEPT. 23 | GALVESTON | **MAYRA BELTRÁN**

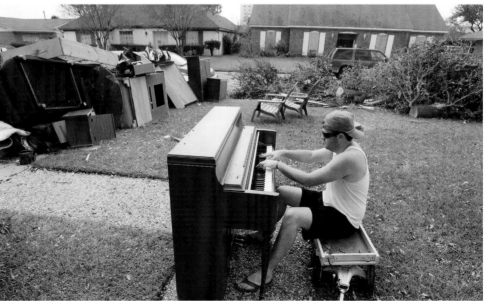

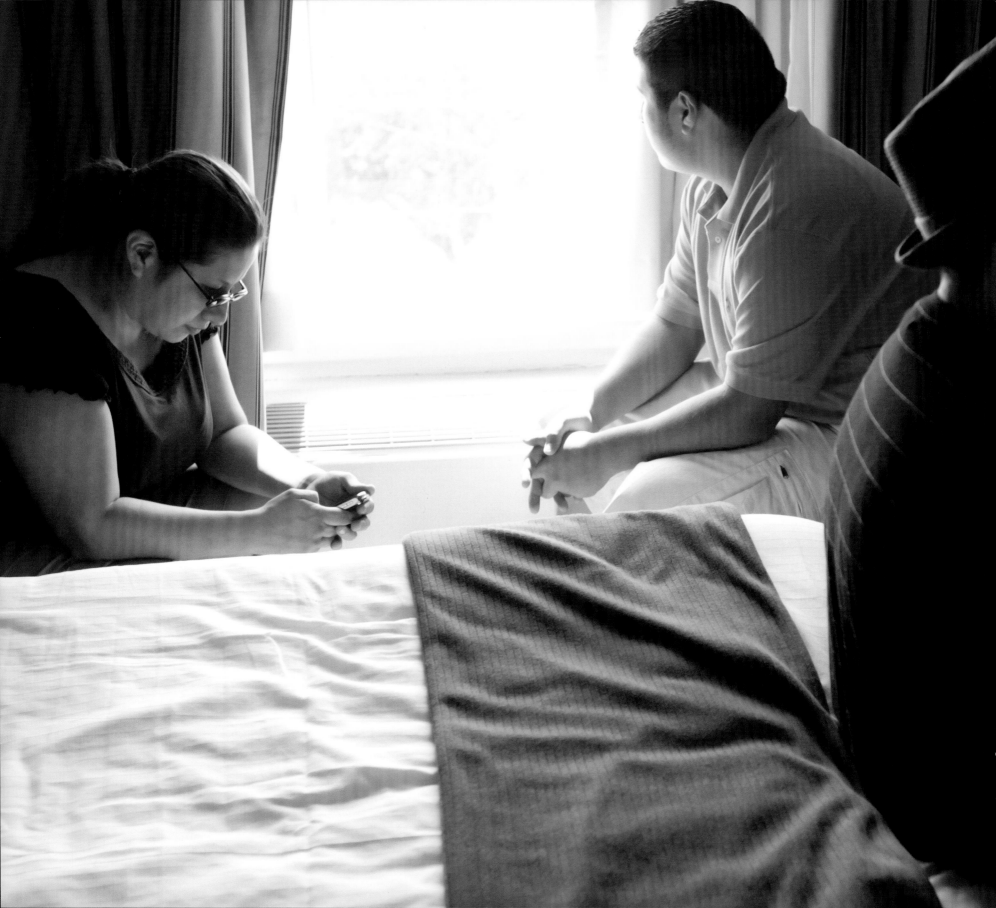

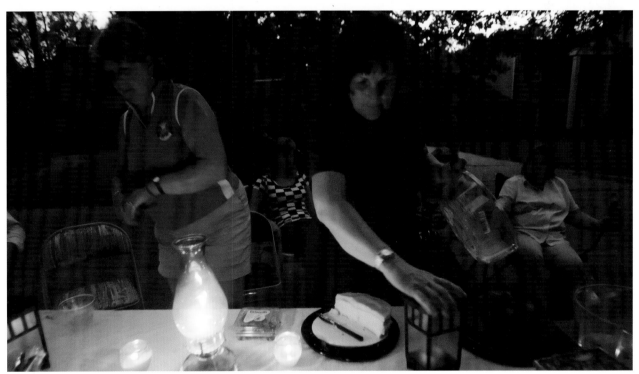

OCCUPIED | OPPOSITE | Elizabeth Galvan, left, and sons Richard and Alex pass the time in a hotel room while waiting for power to be restored to their apartment. Area hotels were full to the brim with hurricane workers and evacuees. | SEPT. 22 | HOUSTON | **ERIC KAYNE**

WORSHIP BY FLASHLIGHT | TOP | Robin Beckwith, right, attends a service at Congregation Emanu El, where power was still out. | SEPT. 21 | HOUSTON | **ERIC KAYNE**

POTLUCK SOCIAL | BOTTOM | Cindy Schulte, left, and Rita Boyer prepare the table as residents of Fawnlake Drive in the Rustling Pines neighborhood gather for a gourmet meal. The residents of the affluent neighborhood, which was among the last in the city without power, tried to survive the storm's aftermath stylishly. | SEPT. 23 | HOUSTON | **JULIO CORTEZ**

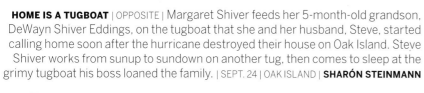

HOME IS A TUGBOAT | OPPOSITE | Margaret Shiver feeds her 5-month-old grandson, DeWayn Shiver Eddings, on the tugboat that she and her husband, Steve, started calling home soon after the hurricane destroyed their house on Oak Island. Steve Shiver works from sunup to sundown on another tug, then comes to sleep at the grimy tugboat his boss loaned the family. | SEPT. 24 | OAK ISLAND | **SHARÓN STEINMANN**

ROUGHING IT | TOP | The Shivers' two sons are living in a tent set up on the family's empty house slab. The family waited seven weeks for the Federal Emergency Management Agency to deliver a trailer. When it arrived, they still couldn't move in because the trailer must stay locked until the electricity is hooked up. | OCT. 4 | OAK ISLAND | **SHARÓN STEINMANN**

THEIR ALAMO | BOTTOM | The Shivers' daughter, Brianna, 16, sleeps on the tugboat with DeWayn, her son. Brianna usually stays on the other side of town with her boyfriend's family. Ninety percent of Oak Island's roughly 350 homes are uninhabitable, but the Shivers aren't giving up. "This is our Alamo," said Steve Shiver. | OCT. 4 | OAK ISLAND | **SHARÓN STEINMANN**

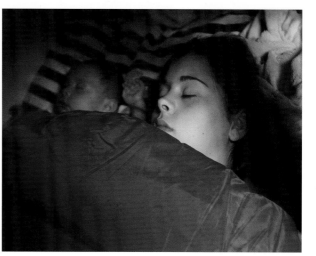

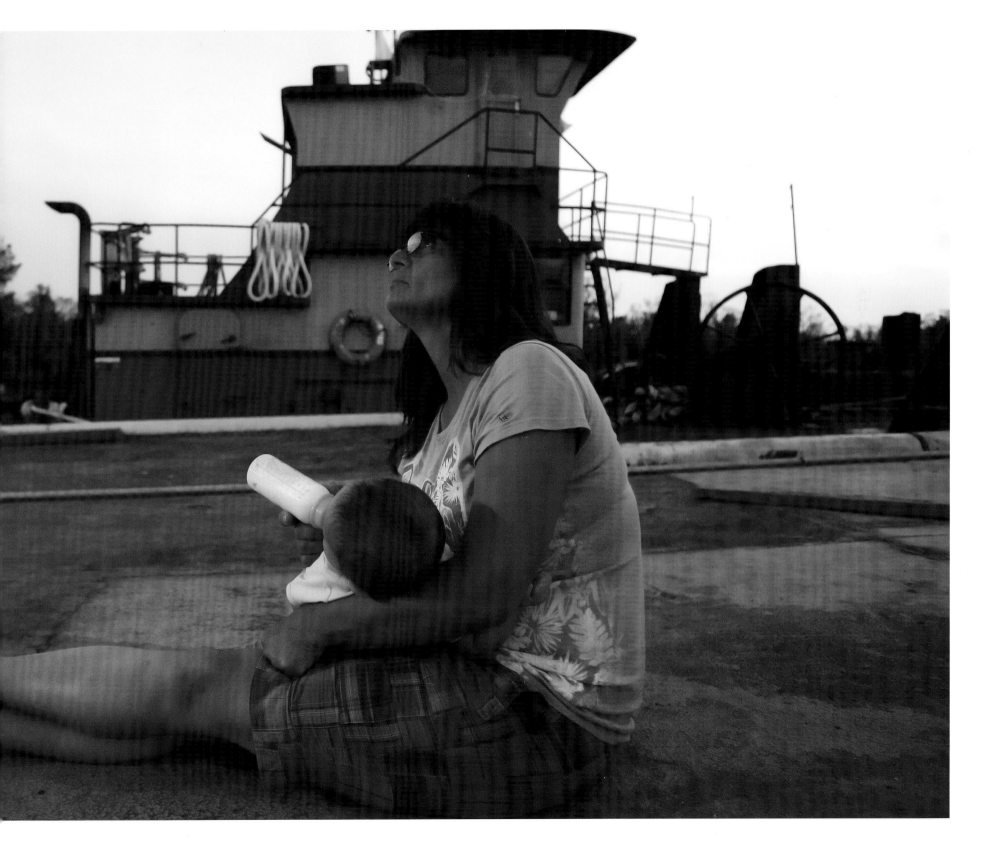

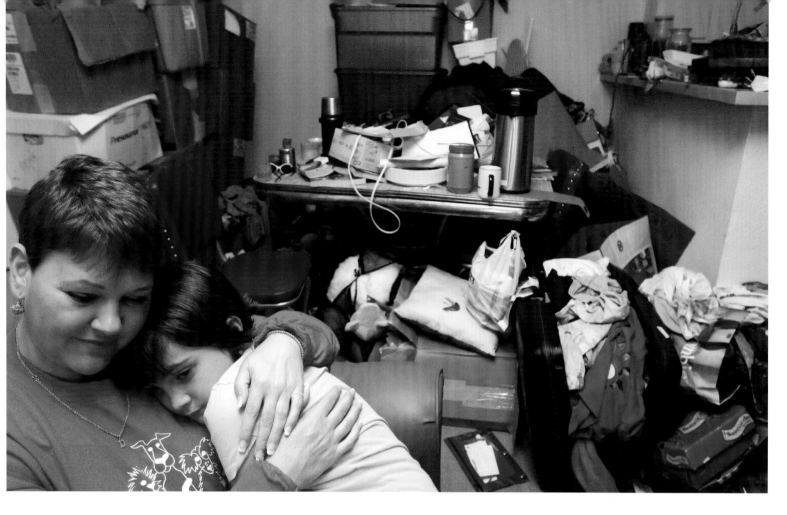
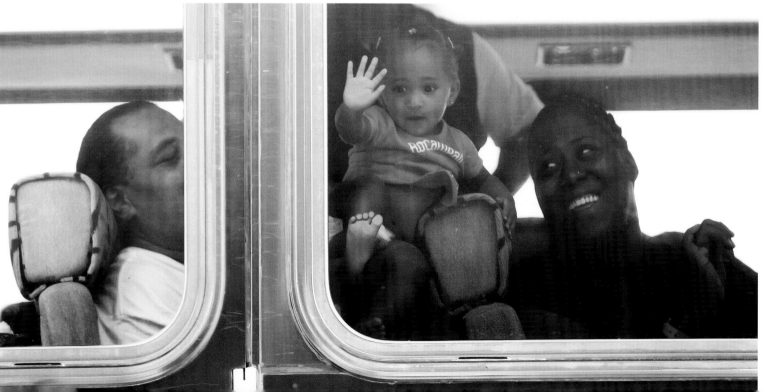

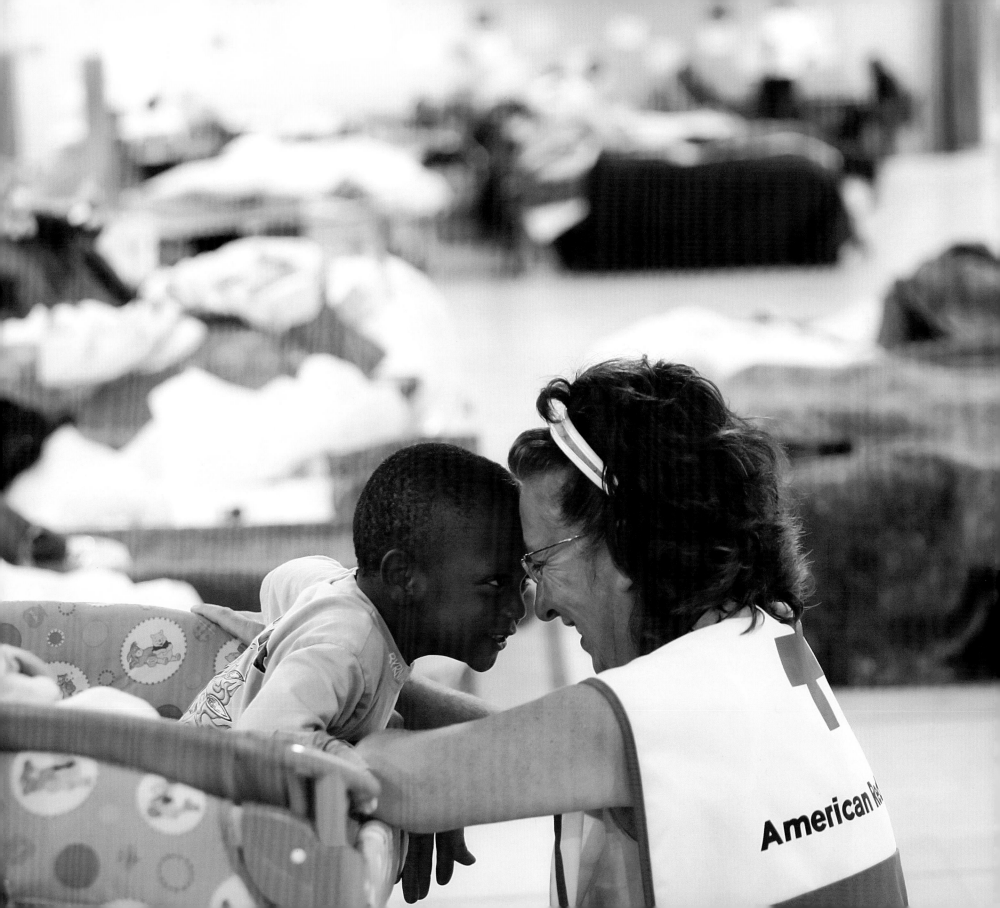

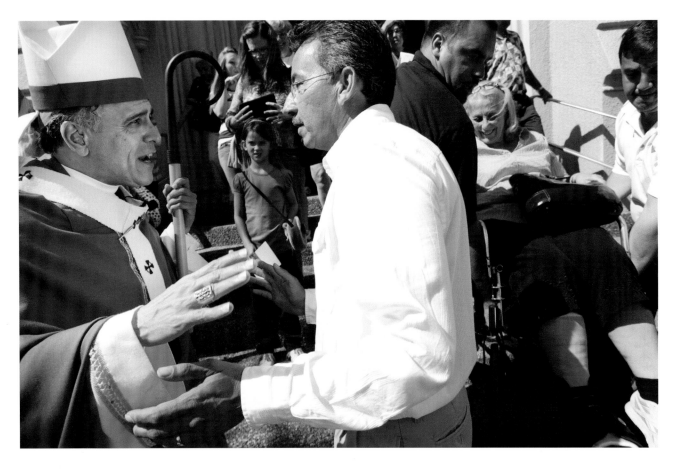

COMFORT | ABOVE | Cardinal Daniel DiNardo speaks with Juan Gonzalez after celebrating the first Mass at St. Patrick Church following Hurricane Ike. | SEPT. 28 | GALVESTON | **ERIC KAYNE**

NEW COLOR SCHEME | OPPOSITE | Blue tarps dot the damaged roofs of a subdivision on the far west side of the city. | SEPT. 24 | HOUSTON | **SMILEY N. POOL**

STUCK IN PLACE | PREVIOUS TOP LEFT | Cynthia Baker holds her daughter Bayleigh, 9, in their damaged northwest apartment. The Bakers say they can't afford to move after the ceiling collapsed in their kitchen and in two bedrooms, causing water and mold damage. | SEPT. 30 | HOUSTON | **JOHNNY HANSON**

A NEW HOME | PREVIOUS BOTTOM LEFT | Bailey Bess, 7 months old, waves from the arms of her father, Kenneth Handy, as they and her mother, Quicita Bess, settle in on the bus that will take them to their new apartment. They spent the weeks following the hurricane at a Red Cross shelter. | OCT. 19 | HOUSTON | **MAYRA BELTRÁN**

QUALITY TIME | PREVIOUS RIGHT | Alan Washington, 3, shares a moment with volunteer Brenda Ryerson at the last Red Cross shelter for Hurricane Ike victims in the city. The shelter closed a few days later. | OCT. 15 | HOUSTON | **MAYRA BELTRÁN**

RECOVERY | TOP | Paul McDowell and Ben, a cadaver dog from Special K-9 Search & Recovery, hike through a pile of debris in search of human remains. | OCT. 3 | GOAT ISLAND | **MAYRA BELTRÁN**

NO SIGNS OF LIFE | BOTTOM | Billy Flannigan, a construction worker who volunteered to help find missing people, located two vehicles that belonged to relatives of Raul "Roy" Arrambide. Arrambide's mother, Marion Violet Arrambide, 79; his sister, Magdalena Strickland; and his nephew, Shane Williams, all disappeared when they attempted to evacuate from a beach house in Port Bolivar. Both vehicles appeared to have been washed off the road. There were no signs of bodies or survivors. | OCT. 1 | CRYSTAL BEACH | **MAYRA BELTRÁN**

BACK IN THE WATER | OPPOSITE | Surfers Pat McClain, Sam Bertron and Alek Rockrisc return to the coast after a ban was lifted from swimming and surfing along the Seawall a month after Hurricane Ike. | OCT. 13 | GALVESTON | **MAYRA BELTRÁN**

FIRSTBORN | FOLLOWING LEFT | Florencio Hernandez kisses his baby daughter, Jennifer, as mother Maria Hernandez rests. Jennifer Ramirez-Hernandez was the first baby born on Galveston Island since the hurricane struck. | OCT. 13 | GALVESTON | **MAYRA BELTRÁN**

STILL MISSING | FOLLOWING RIGHT | A shrine marks the concrete slab where Glennis Dunn's house once stood. Her son found her car, with an overnight bag in the trunk, near the beach. She has not been found. | OCT. 8 | CRYSTAL BEACH | **MAYRA BELTRÁN**

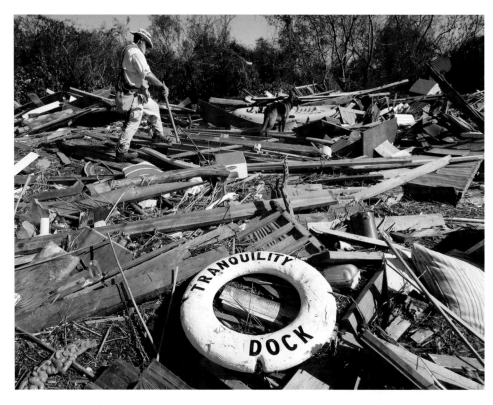

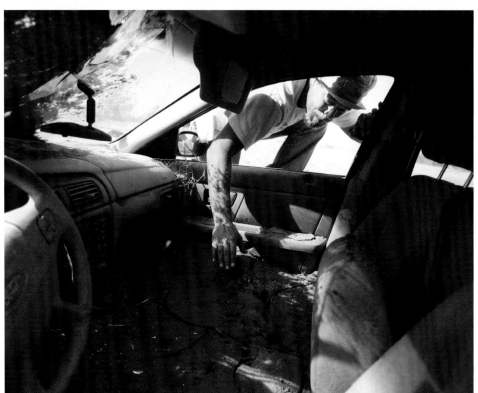

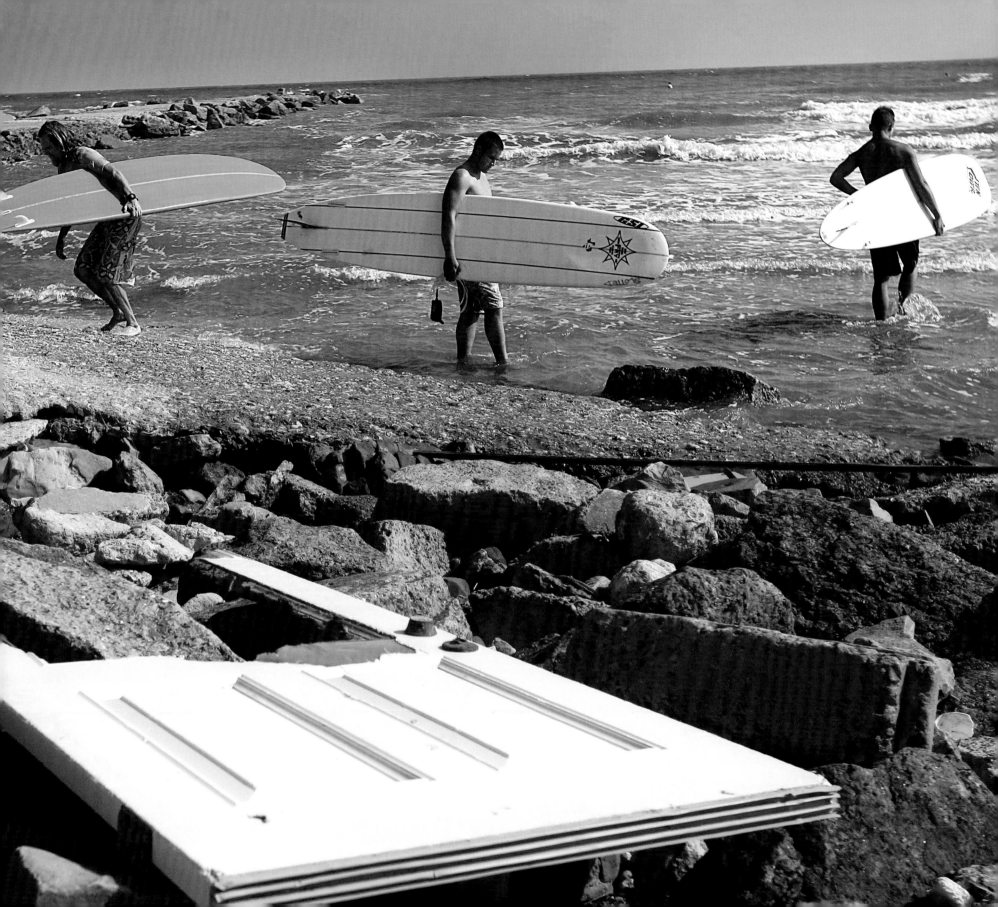

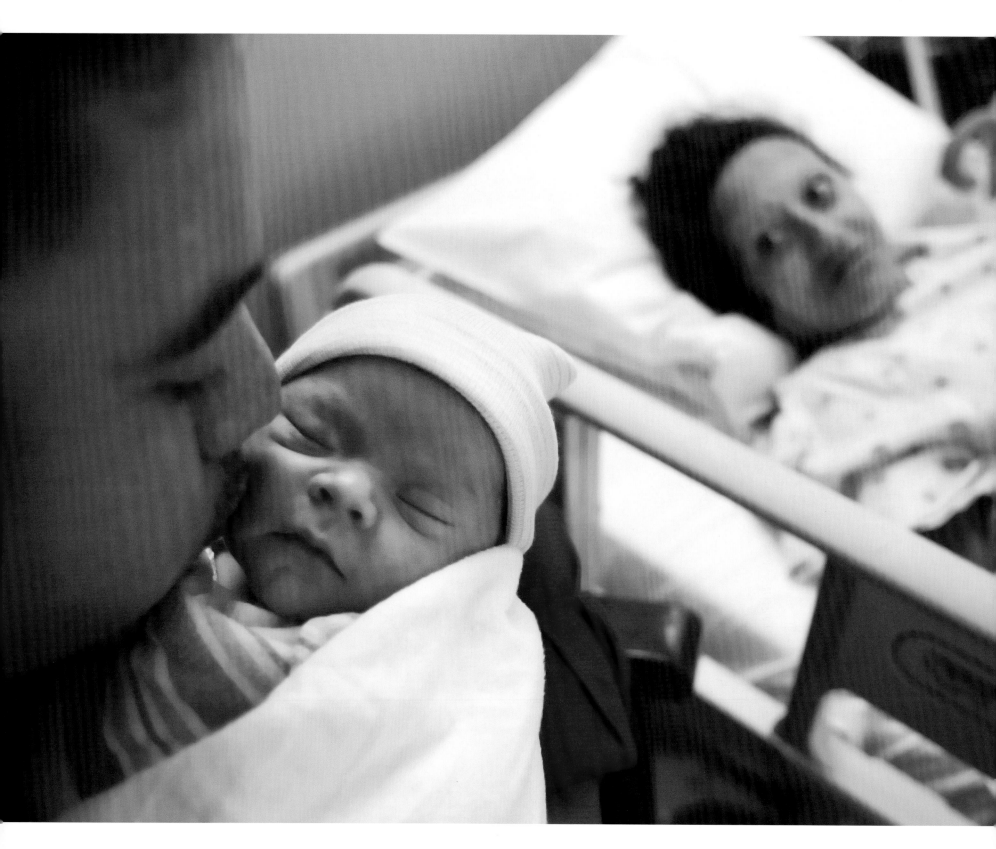

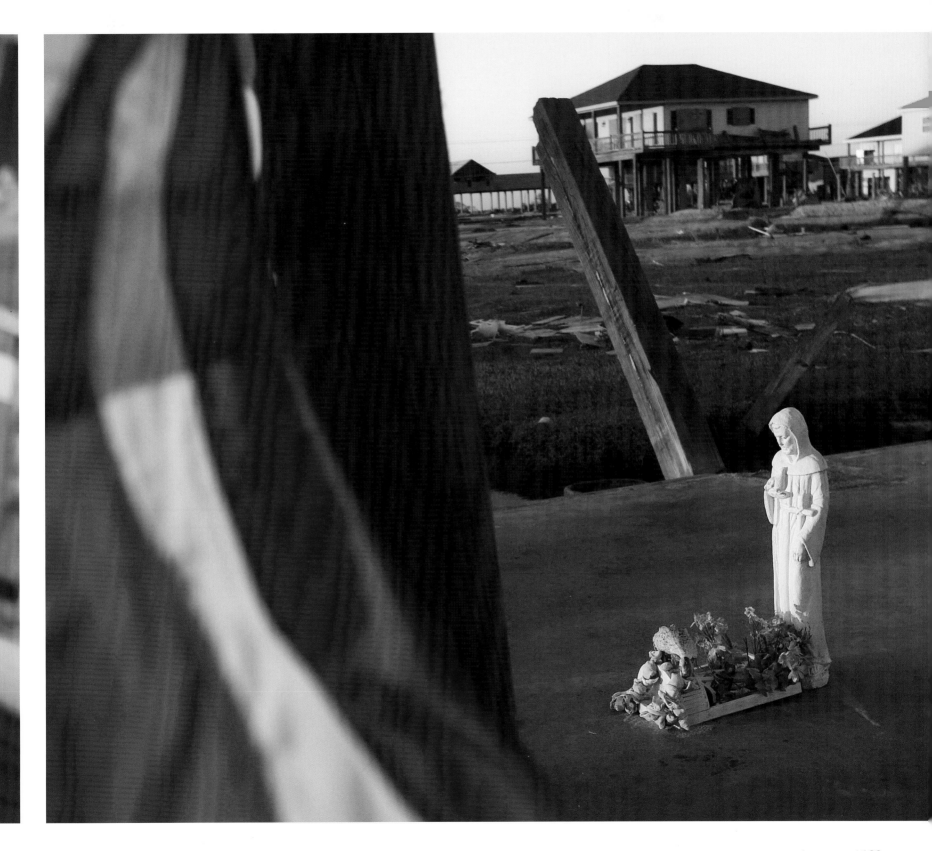

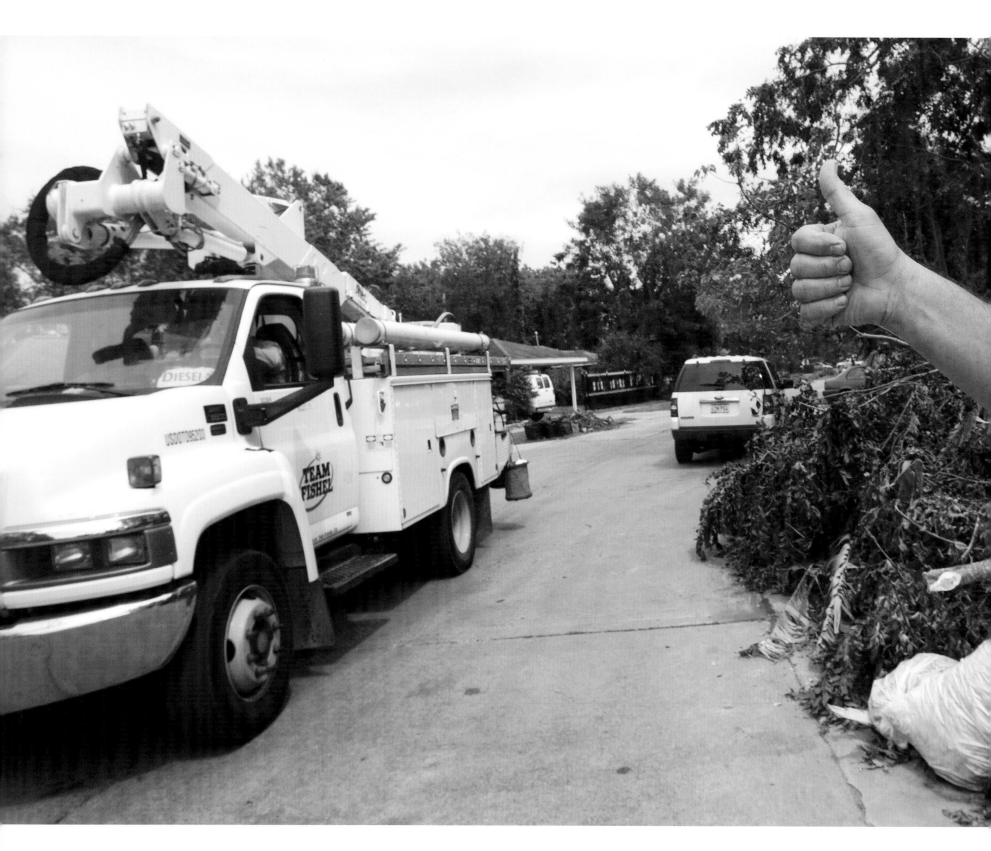

Glory, with flick of switch

By CLAUDIA FELDMAN

The other day I got lucky. I spent two shifts with CenterPoint Energy linemen, the fit, brawny guys who are shimmying up light poles and bobbing around in truck buckets in a round-the-clock effort to power up Houston.

At least for the moment, they are heroes. Women and men start to stutter and fan themselves — no joke — when they appear. Who would I most like to see in my neighborhood right this minute? No contest. Not the pope. Not Obama or McCain. I would like to see one lineman. Two dozen would be heaven.

So, who are these guys in the tan shirts, blue jeans and work boots?

They're cowboys of sorts, rough and tumble outdoorsmen patrolling power poles instead of a range.

One is Mike Goolsby. At 33, he's straight out of central casting. Muscles. Three-day stubble. Twinkle in the eye. At his house, he doesn't have power — he doesn't even have water. He's getting by on four hours of sleep. It's OK. This is his time, this is his profession's time, to shine.

"I like making people happy," he says.

Things go wrong, Goolsby says. Sometimes he and his guys work for hours, and when they flick that switch, nothing happens. Or worse.

But that's the exception. Usually, they go, they work, they focus, they wrestle with bad poles or disconnected wires or the ever-present danger of misdirected volts, and they flick that switch and make magic. Whole neighborhoods light up. Often, they hear cheers and applause. People wave and flash grateful smiles.

What kind of job satisfaction is that?

Off the chart.

Frenchie Hensley, 51, is another lineman. He wears slouchy boots and a straw cowboy hat, and in a group of linemen, he's the one who will be joking, complaining, yakking nonstop.

But who wouldn't love the guy who favors his beat-up cowboy hat over his hard hat and tends to his elderly parents' generator before and after 16-hour days?

Hensley loves his wife, his blended family.

He wouldn't tell his guys this unless he was under extreme stress, but he loves them, too. At one point, when he learned a wire he thought was dead was actually hot, he started to sweat.

"I don't want anybody hurt," he said. "These guys are family."

It takes four years of on-the-job and classroom training to become a full-fledged lineman. As a group, they seem relaxed, laid-back, unflappable.

That's not it, said Kevin Cook, who's done the job most of his adult life.

"You don't want to lose your train of thought."

The day I spent with Goolsby and his team was unusual because there was intense public and personal pressure to restore power to a city cast into the dark by Hurricane Ike. But most of the morning was spent in meetings or moving, on orders from on high, from one location to another.

The guys wanted to do the hero thing, not stand around. When they finally were able to get to work, they attacked their projects ferociously.

Their goal — the goal of several dozen linemen sent to an area off Lauder Road in north Houston — was to light up 3,000 to 4,000 homes.

About 8 p.m., when it finally was time to wrap up, Cook drove his CenterPoint truck into a small subdivision in his territory and waited. It should be just moments, he told me, until these neighbors were bathed in light.

He waited some more. Nothing happened.

He radioed fellow crew members. He drove back to Lauder and flicked one more switch. He returned to the subdivision.

He had to see the lights for himself.

Satisfied, he headed back to the Greenspoint Service Center, where he had reported for duty at 5 a.m.

WELCOME SIGN | OPPOSITE | Raul Casarez gives a group of power linemen from Florida-based Team Fishel a thumbs up as they drive down his street. At least 6,000 additional linemen and other workers were brought in from all over the United States to help restore power to the area. | SEPT. 17 | HOUSTON | **JOHNNY HANSON**

HUMOR | FOLLOWING | Debris litters the front yard of a home in the West End's Sea Isle subdivision as residents arrive to assess their homes 10 days after the hurricane. | SEPT. 23 | GALVESTON | **MAYRA BELTRÁN**

'Beautiful' day on the battered island

By LISA GRAY

"Beautiful day, innit?" said the guy in the truck. His shrug meant: Not like before.

We were in Galveston on one of those sunny, unseasonably cool days that followed Hurricane Ike. It was a beautiful day when the island was full of first responders and journalists but closed to residents hoping to return.

A beautiful day without power or running water. A beautiful day when the city manager announced that the island's sole emergency room had treated a case of flesh-eating bacteria.

I was on the Strand, taking a photo of a shrimp boat that, after washing out of the port, had crashed to a stop against a parking-lot attendant's booth. The boat — the wreckage of someone's livelihood — leaned at a jaunty angle against the booth's remains.

"They ought to make a bar out of that," said the guy. "Leave it just like it is, but make it a bar."

He waved and drove away. His truck identified him as a disaster-relief specialist, and on that beautiful day, there was plenty of disaster to relieve.

On the post-Ike island, spray paint conveys general announcements. At one house, just south of the I-45 causeway, plywood signs advised the world: OWNER IN BAD MOOD. SHOOTS TO KILL.

I wasn't sure whether that bad mood was real or a joke. Everyone else seemed oddly buoyant.

A sheet hung from a high-rise: SEND CIGS, BEER, WOMEN AND MEN IN UNIFORM

Outside the Home Depot near I-45: WE ARE OPEN!!!

On Seawall Boulevard: ANOTHER DAY AT THE BEACH.

Ike attacked Galveston mainly with rising water; Houston, mainly with wind. Galveston is obviously battered, but compared to hard-hit parts of Houston, much of the island appears surprisingly intact. Driving the streets behind the Seawall and on the island's East End, I didn't see as many downed trees, as much broken glass, as much debris as I expected. I photographed the shrimp boat because, as shocking, visible storm damage, it stood out. On Galveston, much of the damage is hidden.

Here and there, a few houses had the entirety of their soggy contents heaped by the side of the road. Those were the lucky houses: the ones with people to remove wet carpets and furniture before mold and mildew could wreak further havoc.

The other houses — the ones that looked fine from the street — were the ones that worried me.

On Seawall Boulevard, I spotted The Spot, one of the rare businesses that was open. A sign promised "gourmet hamburgers," and I hoped for lunch and a bathroom.

No food, no bathroom, and nothing nonalcoholic. I ordered a Corona.

The beefy, tattooed bartender in a Harley T-shirt said he'd kept the place open every day since Ike passed. "Doing what we can," he said.

I was the only woman at the crowded bar.

The coot next to me volunteered that the night before, he got water for his first post-hurricane sponge bath. "Better 'n sex," he exulted.

He said he'd ridden out the storm in his apartment. When water began rising inside, he put on a life preserver. His cooler floated, then tipped, and he scrambled to retrieve its contents. "Save the beer!" he shouted. "Save the beer!"

The barfly grumbled that the city ought to let citizens return, even without running water, never mind disease and sewage. The city needs to rebuild right away, he said. It needs people in it. People like him — people who defied the evacuation order — were heroes just for staying.

Proud and full of purpose, he ordered another beer. On the Strand, the 1861 Custom House looked OK from the street. But inside, a crew from the Galveston Historical Foundation was assessing the effects of 4 ½ feet of water.

Rust was already starting to creep up the iron stairwell, and the place smelled foul.

The foundation's IT manager was manning a broom, pushing out the brown slurry that covered the floor. I asked Dwayne Jones, the group's executive director, what the stuff was.

"A combo," he said. "Sewage. Dirt. Petroleum. Who knows what else."

Standing in hip boots in the toxic mess, he too was upbeat. The damage could've been far worse. The historic foundation's buildings were trashed, but all had survived. There was work to do, and today, after days of worrying, he and his crew were glad to start.

Walking toward the back of the Custom House, Jones winced.

I looked at him questioningly, worried that the beautiful day, and its beautiful mood, were giving way to something more seasonable.

"The smell," Jones explained. "The longer we're in here, the harder it is to stand it."

I felt suddenly protective of him, and of everyone on the island.

They were riding a collective mania, I thought — high on having survived, on having a purpose. They seemed like their buildings: Fine on the outside.

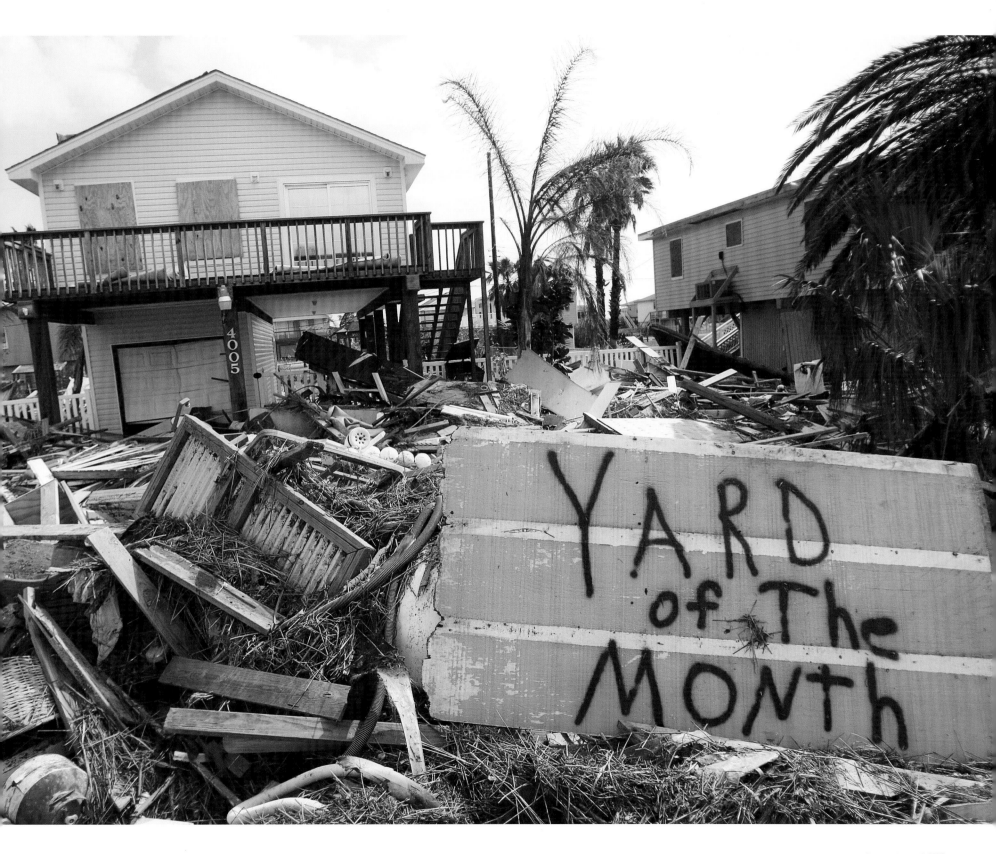

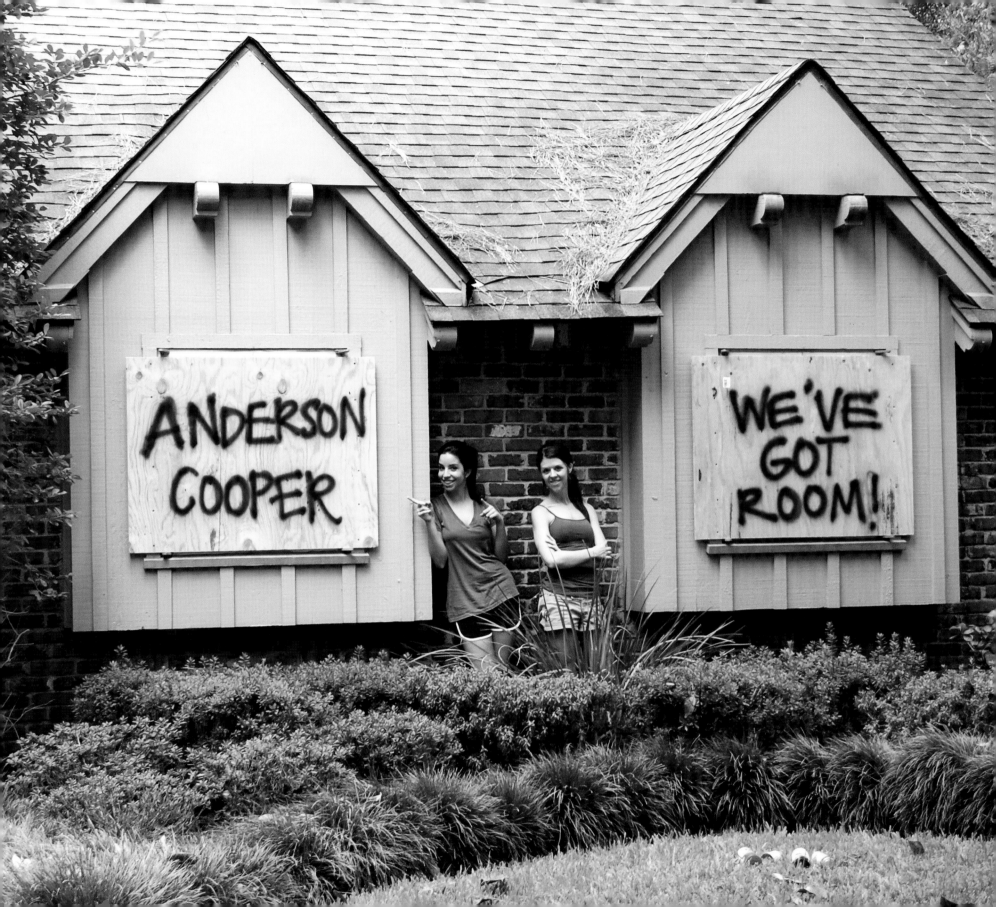

CHAPTER *Five*

through your eyes

Hurricane Ike was not just the Chronicle's story. It was a story that engaged the entire region, and many of our neighbors contributed to our reporting efforts. On chron.com, we invited readers to help their neighbors by telling them where to find ice, gasoline and groceries — and which streets had electricity and which were still dark. And readers sent us dozens of photographs, some of which are reprinted here. Some contributors gave us their full names, others a screen name or no name at all. But the reader photos helped bear witness to the devastation and recovery efforts that we all endured together.

OPPOSITE | SEPT. 12 | **NATALIE BOGAN AND ELYSE WEIDNER**

TOP | SEPT. 12 | **LYNN POPKOWSKI**

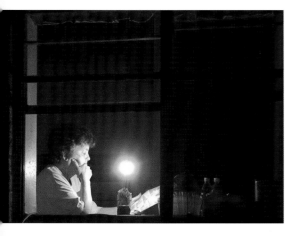

TOP LEFT | SEPT. 12 | **CHADWICK**

BOTTOM LEFT | SEPT. 22 | **THOMASM**

RIGHT | UNKNOWN | **UNKNOWN**

OPPOSITE | SEPT. 15 | **GEORGE BORDOVSKY**

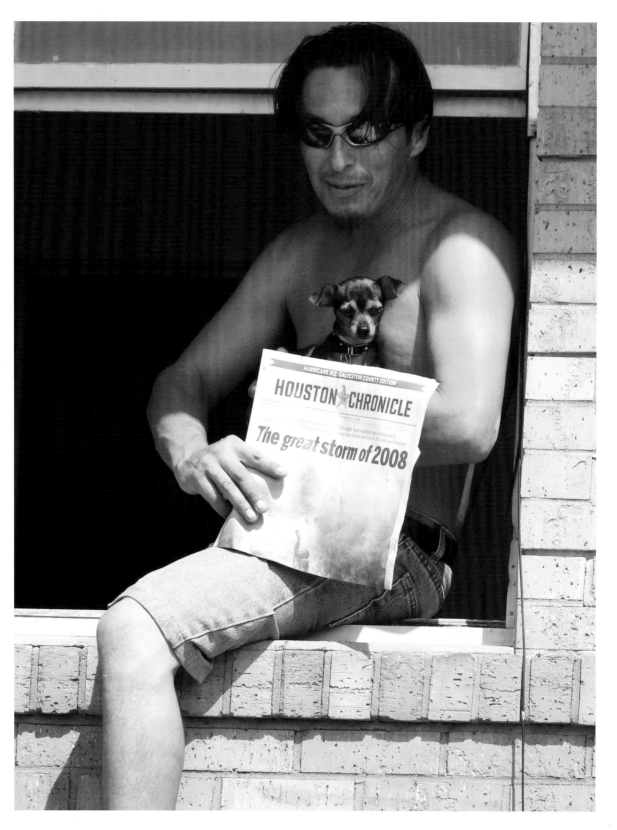

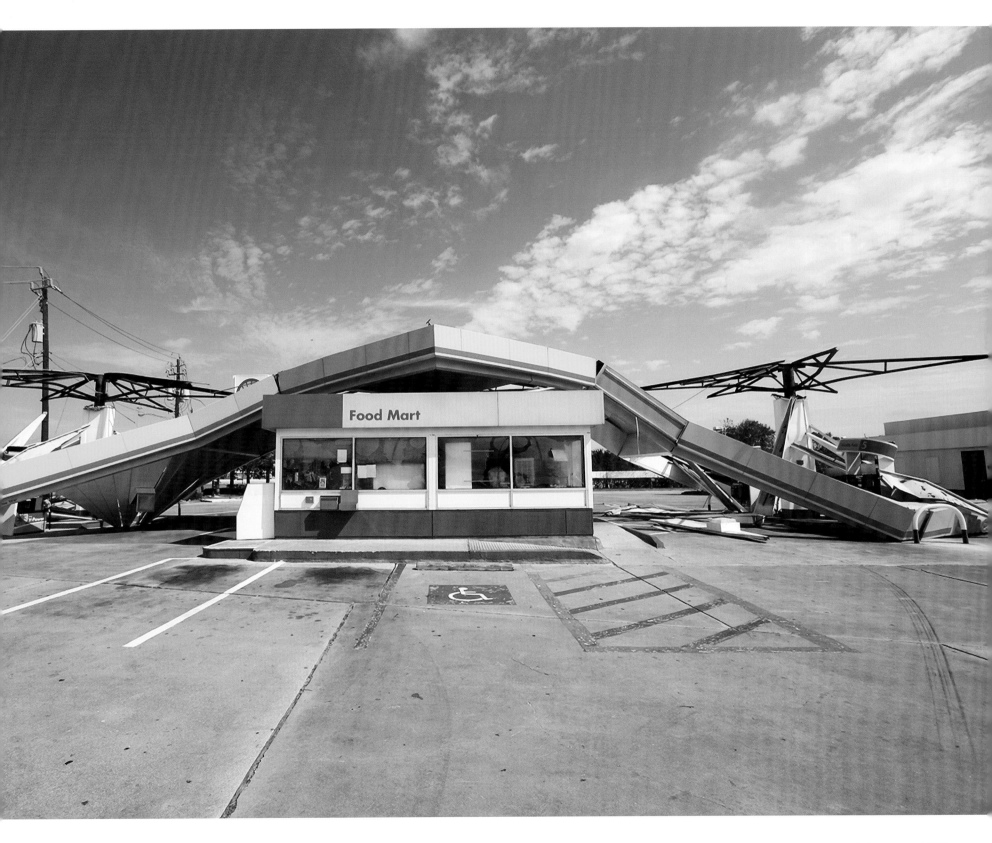

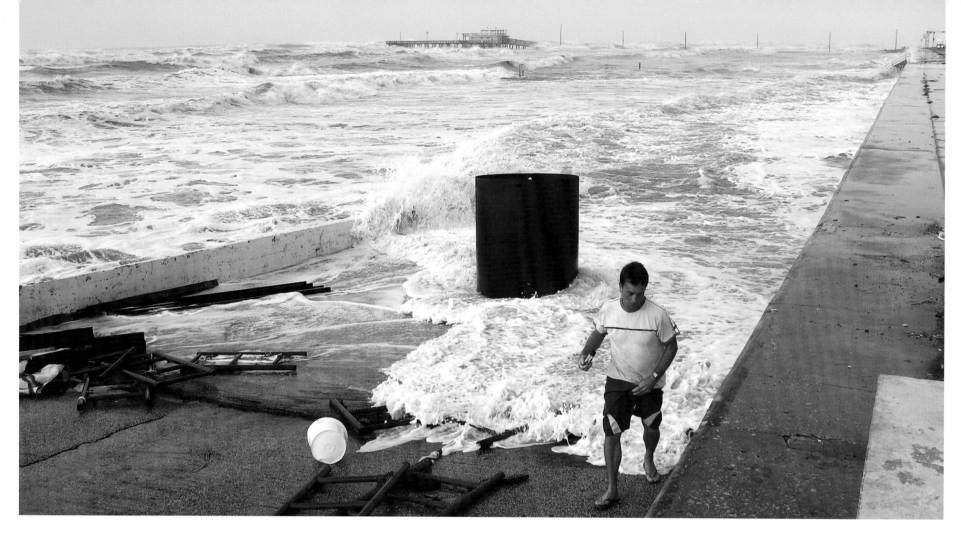

TOP | SEPT. 12 | **BEAUTIFULANDLIGHTPHOTOGRAPHY**

BOTTOM LEFT | SEPT. 12 | **ERASMO MARTINEZ**

BOTTOM MIDDLE | SEPT. 20 | **UNKNOWN**

BOTTOM RIGHT | SEPT. 19 | **VICKY PRATT**

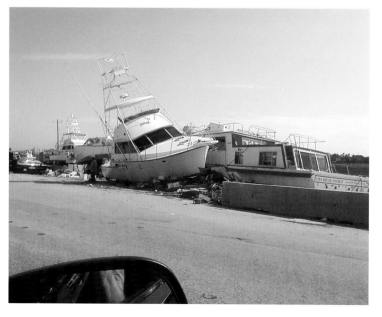

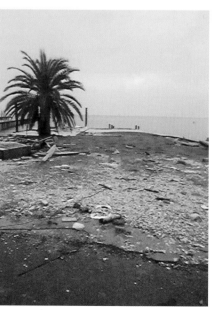

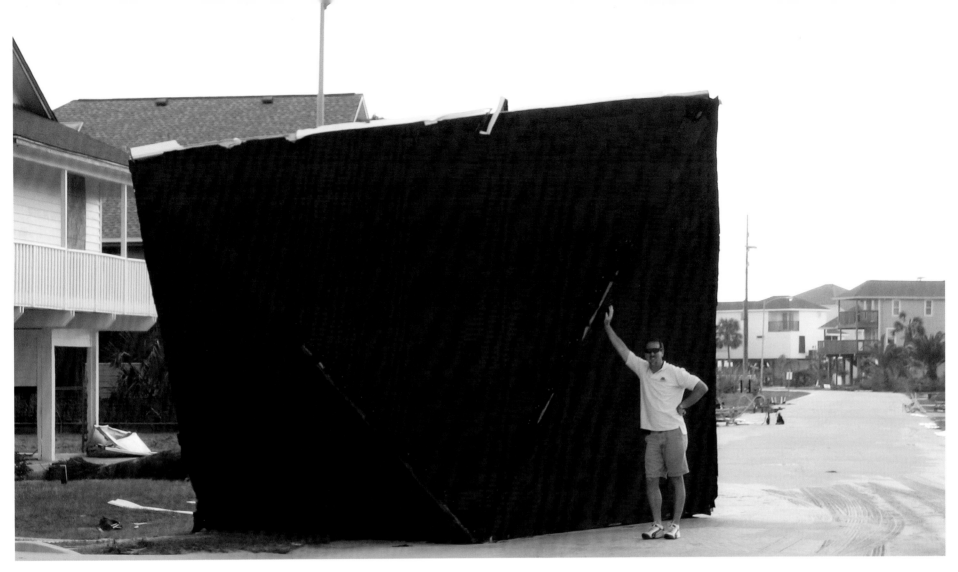

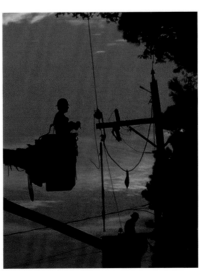

TOP | SEPT. 20 | **DAVE WILSON**

BOTTOM LEFT | SEPT. 12 | **KKOGDEN**

BOTTOM RIGHT | SEPT. 22 | **THOMASM**

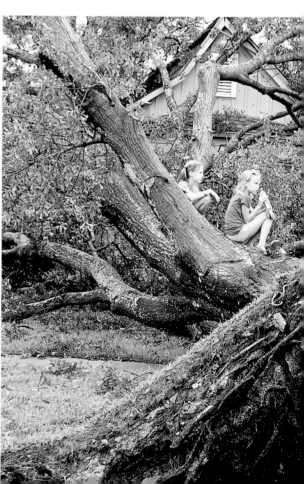

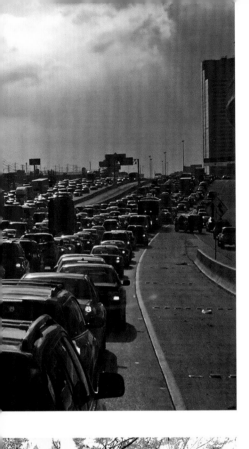

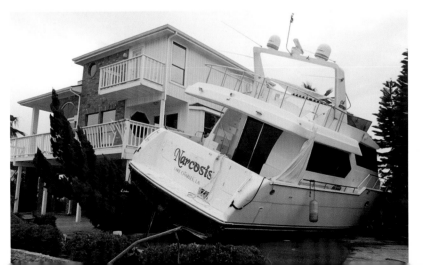

OPPOSITE | SEPT. 15 | **LESLIE THORNHILL**

TOP MIDDLE | SEPT. 23 | **MANUEL BARRERA, JR.**

BOTTOM MIDDLE | SEPT. 13 | **DANNY KAMIN**

TOP | SEPT. 23 | **MANUEL BARRERA, JR.**

BOTTOM | SEPT. 14 | **JIM TACL**

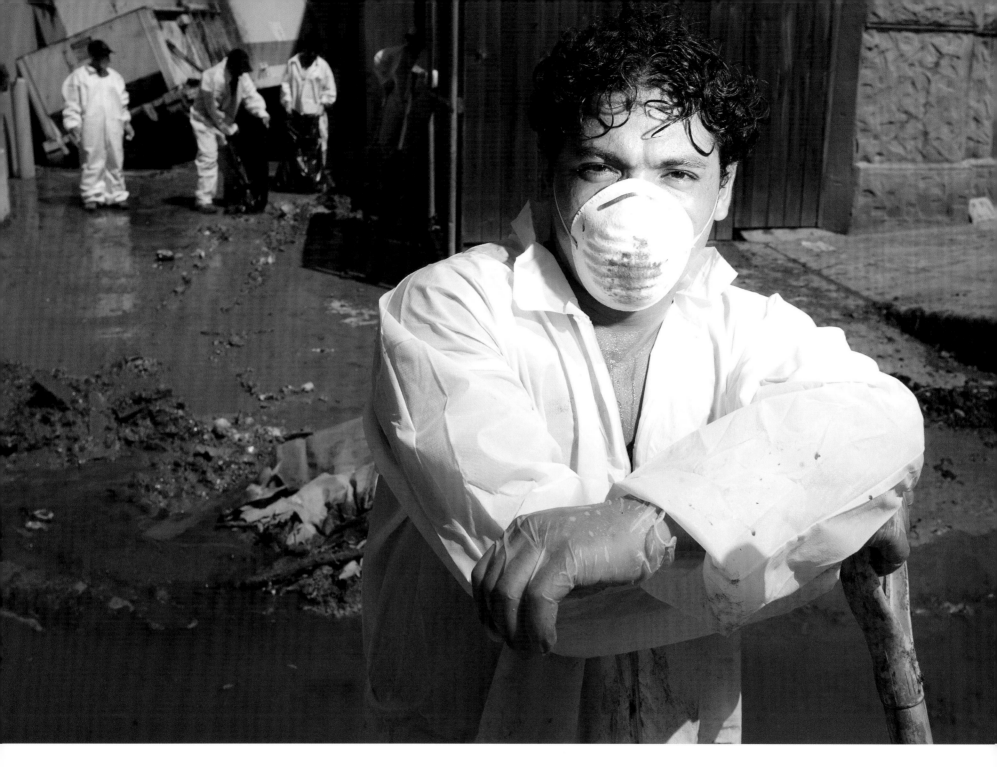

Luis Monterrosa

| A WORKER WITH A DIRTY TASK | Monterrosa is a native of El Salvador who lives in New Orleans. He arrived in Galveston to help with the cleanup. His tasks included shoveling rancid mud from a building on the Strand.

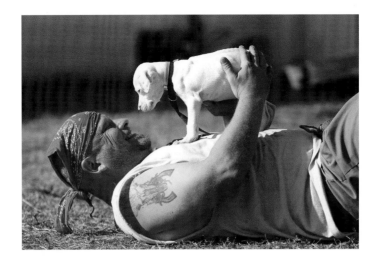

heroes

As Hurricane Ike blasted through the area, flooding homes, uprooting trees and unplugging electricity, many residents reached out for at least a little comfort. In the aftermath, hundreds of thousands of Gulf Coast citizens called out for help. A multitude responded to save lives and soothe souls. Firefighters cooked meals, soldiers gave away food, executives rolled up their sleeves. Strangers became friends. Workers from distant states arrived to fell trees and restore power lines. Some flew in on the wings of helicopters to pull the desperate from the water or to nurse the sick. Others simply offered a bag of ice to a neighbor who had none or provided a shoulder for tears. By the end, these people were our heroes of Ike. We are in their debt.

TEXT BY TARA DOOLEY

PHOTOGRAPHY BY NICK de la TORRE

Bryce Lange

| SPCA VOLUNTEER | Bryce Lange of Denver tries to ease a displaced puppy's tension at the SPCA's temporary headquarters in Galveston.

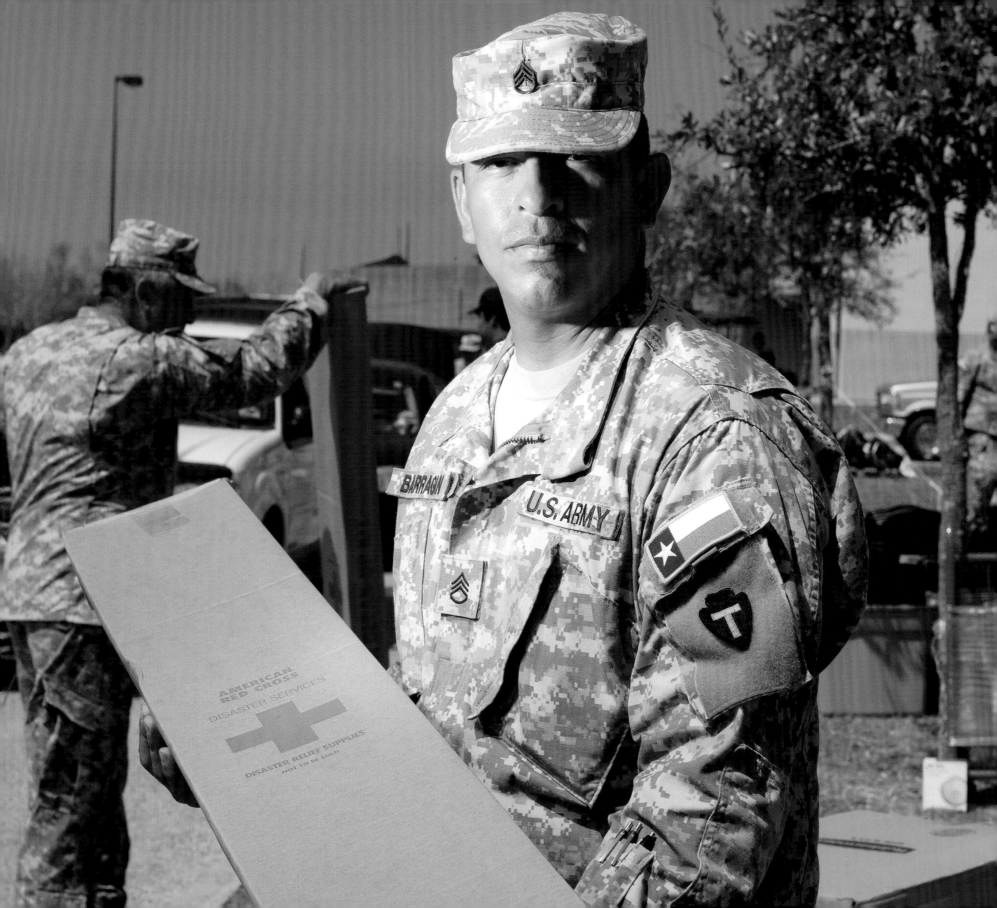

James Bagwell

| A VOLUNTEER | Bagwell evacuated Anahuac for the storm. When he returned days later, the 71-year-old set to work at the Mid-Chambers Christian Caring Center, giving out items such as baby formula and cleaning supplies to Chambers County residents.

As a rule, the center offers used clothing for sale. But there are certain items that must be new for a person to feel right, Bagwell said. So he made at least two runs to Wal-Mart in his pickup for necessities.

"People have lost everything and they can get by with old clothes," he said. "But they have to feel like they are part of society by having new underwear."

Staff Sgt. Juan Barragan

| A SOLDIER | | LEFT PAGE | As part of the Texas National Guard, Barragan, of Laredo, said his mission was to help Galveston residents get back on their feet after Ike. At a federal distribution point on Broadway, Barragan spent his days handing out mops, water, food and other basic supplies.

David Cangelosi

| FIREFIGHTER | The Jamaica Beach volunteer firefighter was part of a corps of city personnel who hit the ground early after the storm to help revive the area. Cangelosi cooked late into the night to feed hungry workers.

Though he wasn't born in Jamaica Beach, Cangelosi has memories of the area that extend back to his childhood.

"To see it get destroyed and everything, you kinda want to rebuild it to where your kids, later on in life, can come down here and have the same fun and still be able to go down here and fish and go surfing," he said.

Curtis Strother

| A CLEANER | | RIGHT PAGE | Strother, an excavation company employee, used a front-end loader to clear lumber, insulation, uprooted trees and other storm debris from the Offatt's Bayou area of Galveston. The goal was to make room for personnel from CenterPoint Energy to fix all the downed and damaged power lines.

"It is rough because you have to pick up people's belongings and it is people's lives," he said.

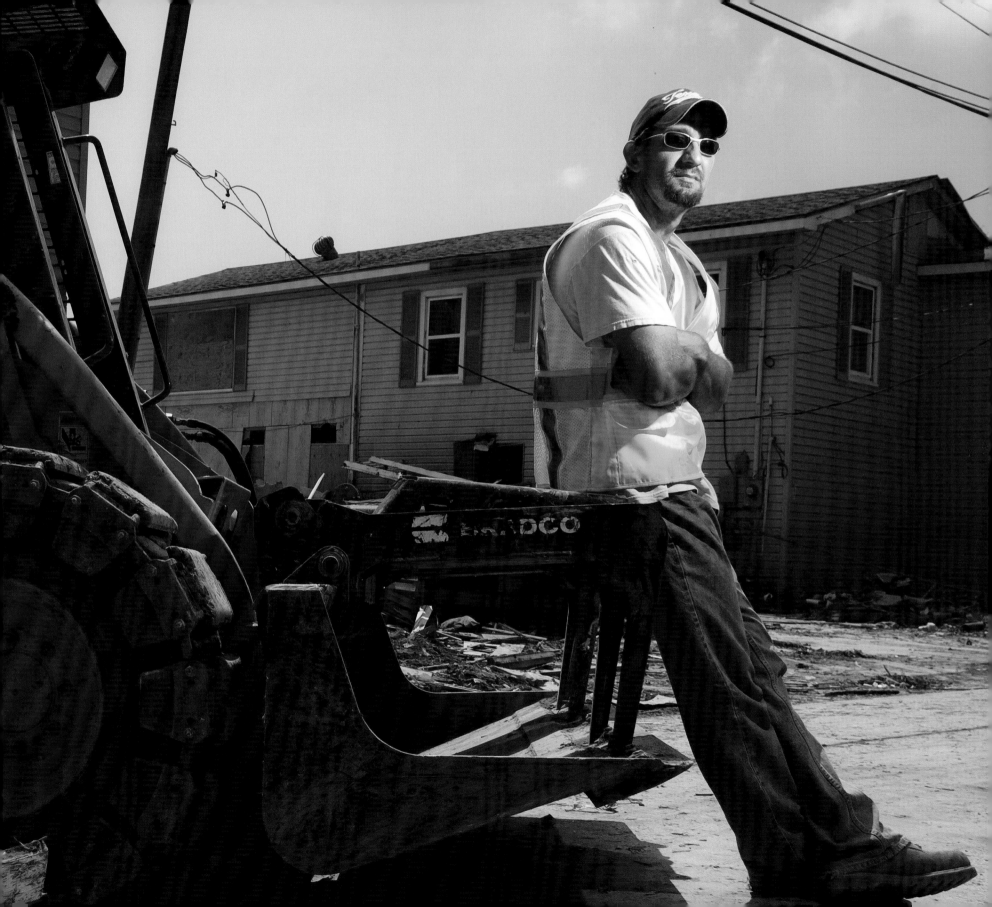

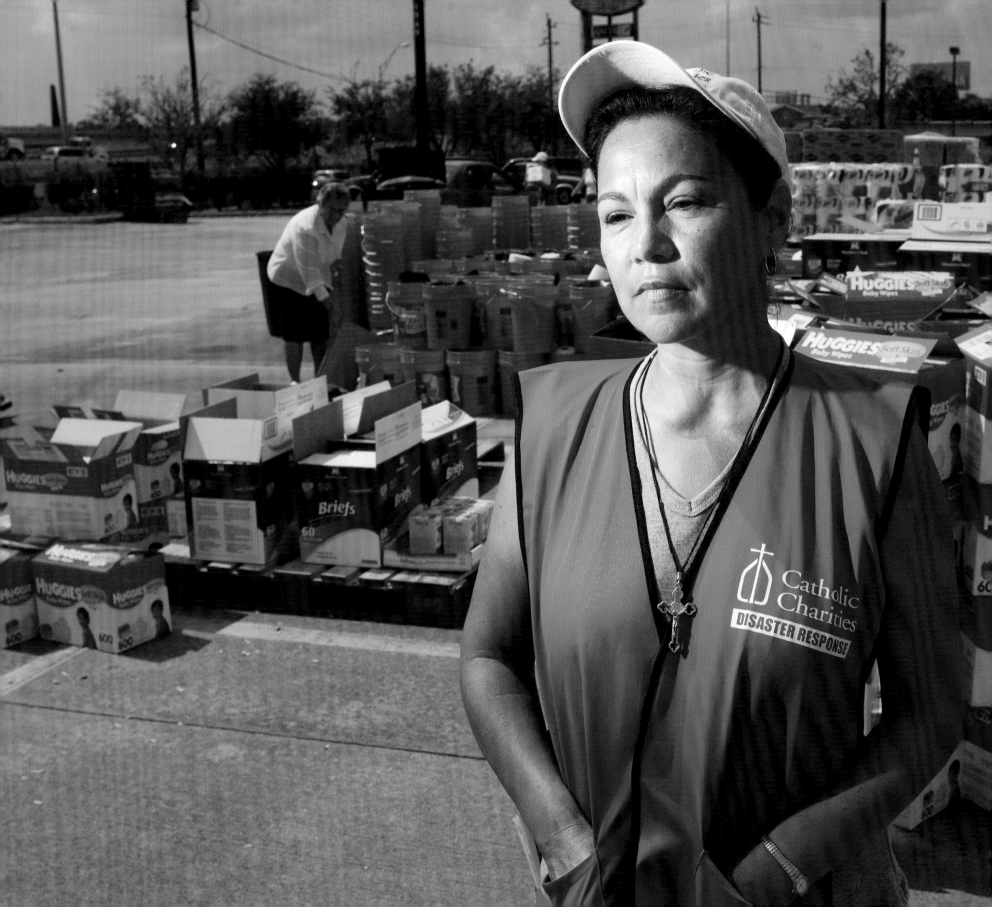

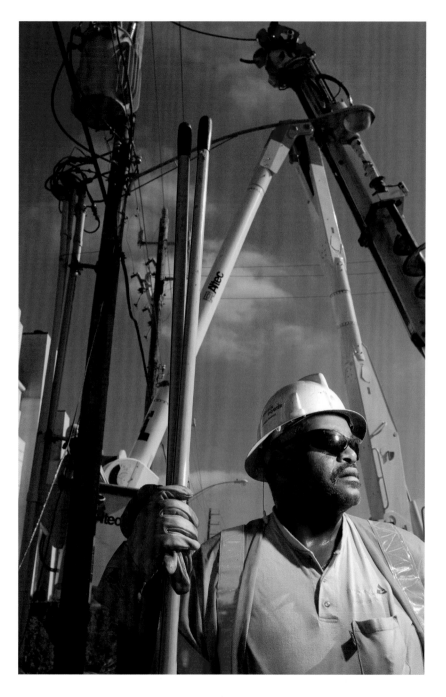

Doug Mahaffey

| A MAN WITH POWER | Mahaffey was part of an army of linemen who came from around the country to help return electricity to the area. Mahaffey, a crew leader for Georgia Power, was met with smiling faces wherever he went in Galveston.

"People were very happy to see us when we were rolling in to help out down here," he said. "It is always a good job to be able to come down and help out."

Rosie Saldana

| A CATHOLIC CHARITIES VOLUNTEER |
| LEFT PAGE | For at least three days, Saldana was among the Catholic Charismatic Center volunteers who spent hot, sweaty hours in the church's parking lot handing out ice, food and other supplies for Catholic Charities of the Archdiocese of Galveston-Houston.

Saldana worked on an assembly line of volunteers who handed out food and talked through car windows to those who had come for help.

For Saldana, 51, the work was a chance to put her faith in action, she said.

"It looks like it is a lot of hard work, but at the same time it's a blessing for us," she said. "It makes us feel good."

Mitzy Moaddab

| EMERGENCY ROOM NURSE | Moaddab rode out the storm in Houston, sleeping on the floor of The Methodist Hospital.

Once the winds died down and ambulances were able to make their first runs through the city, Moaddab tended a flood of traumatized patients in a packed ER.

After the first rush, Moaddab, 25, was able to go home and sleep. But she arrived day after long day to care for elderly patients with deep wounds and dialysis patients stranded without care during the storm.

"The hardest part was hearing people's stories," she said. "People ran out of electricity. I mean, they were just crying, telling you what they had lost."

Jennifer Mefford

| FLIGHT NURSE | | RIGHT PAGE | Mefford left her family in Glasgow, Ky., to help sick storm survivors at the University of Texas Medical Branch at Galveston.

"It is very rewarding to know you can help these people in need even though you do have to leave your family for a period of time," she said.

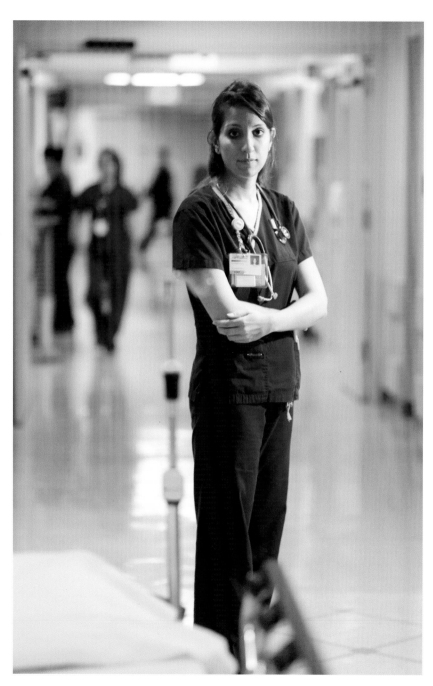

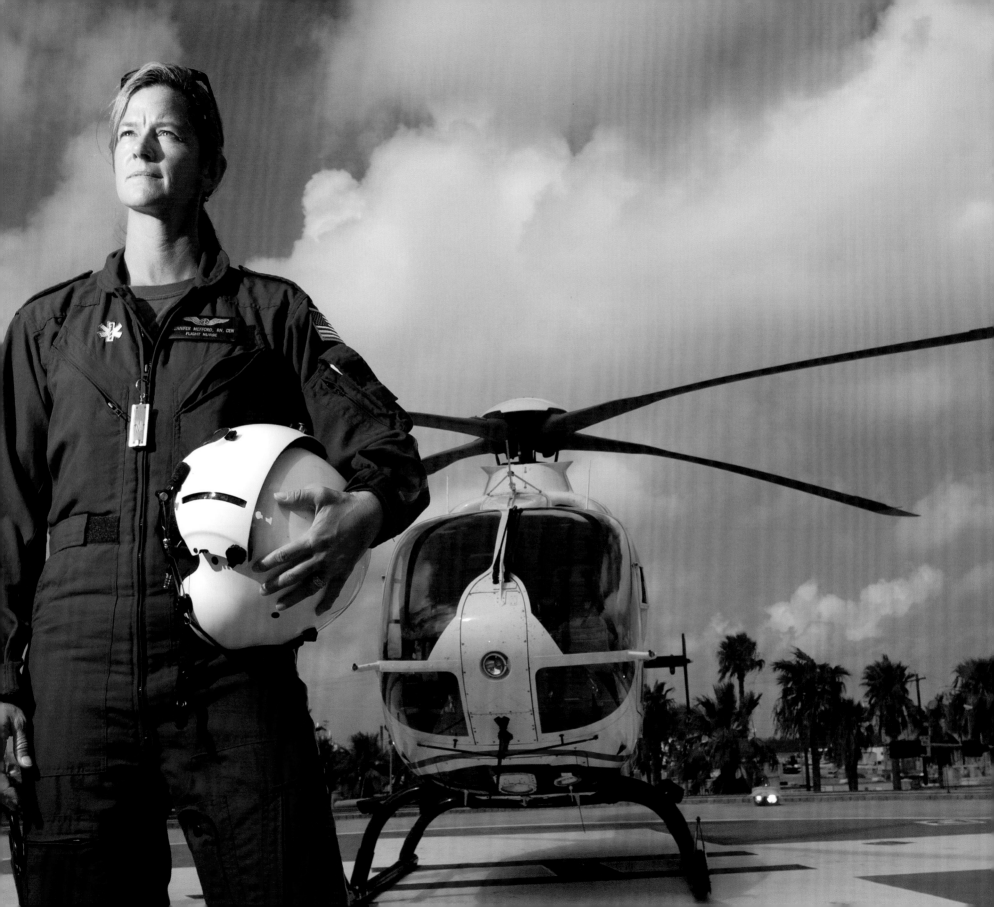

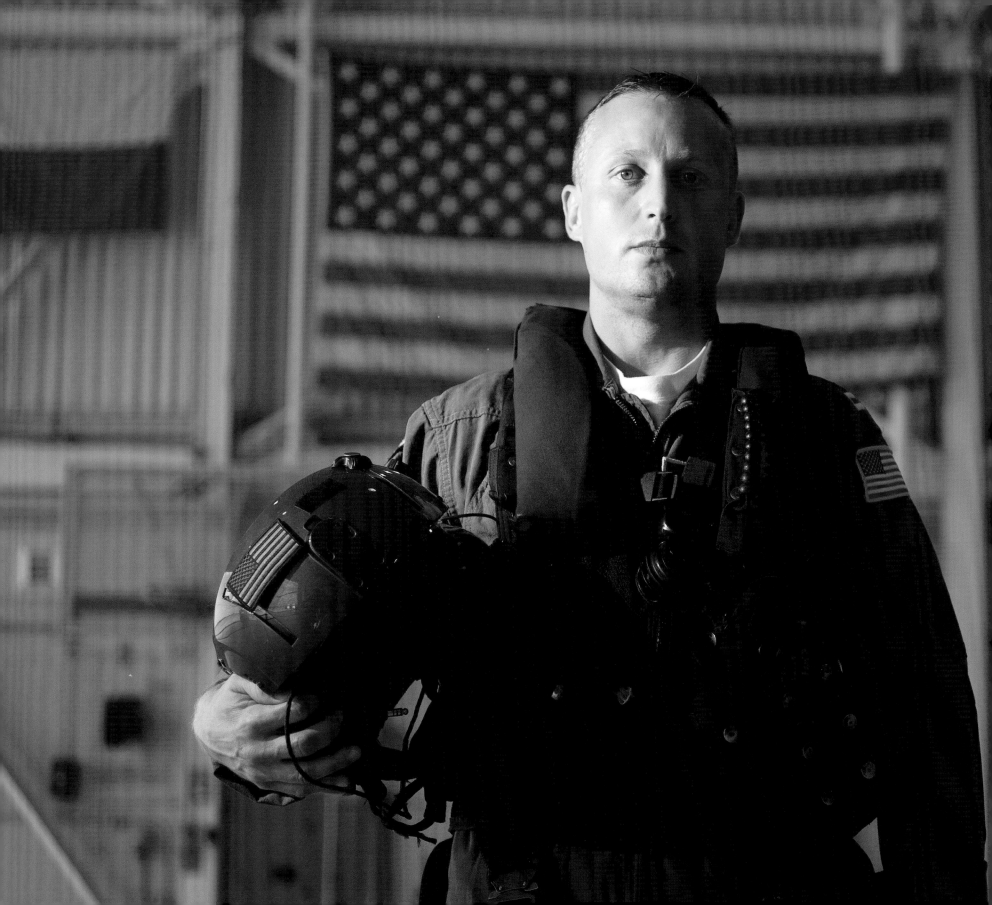

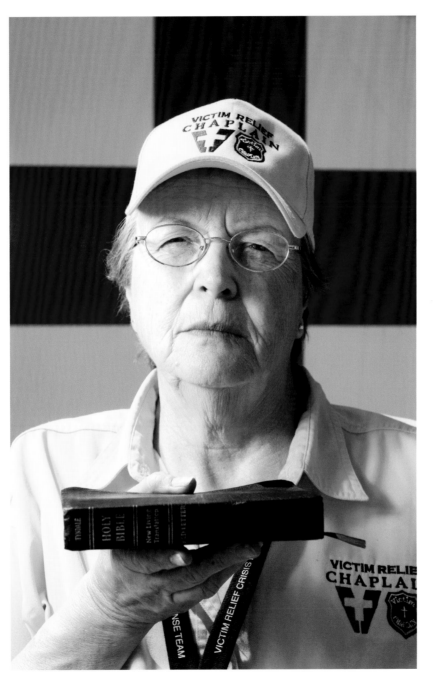

Cheryl Bohl

| SPIRITUAL GUIDE | Victim Relief Ministries of Richardson deployed more than 150 chaplains to the Galveston area before and after Hurricane Ike. These spiritual guides, clad in yellow shirts, became a small army of comfort to storm survivors. At an official food and supplies distribution center on Broadway, Bohl was able to offer distressed residents some spiritual compassion to go with bundles of food, water and ice.

John Moran

| RESCUE HELICOPTER PILOT | | LEFT PAGE | Before the storm, the U.S. Coast Guard lieutenant and his crew of four rescued 20 people from the surging waters on the Bolivar Peninsula. Among those saved were three children and four adults who were in the back of a pickup that was being dragged out to sea.

By the end of the rescue, the helicopter was running on its reserve fuel supply as the team pulled the final man from the back of the truck.

"There was no one left to come for him," Moran said. "So we had to use our remaining fuel to get him. That was a big relief when we got him on board."

Kristen Smith

| A NURSE | Smith arrived from Fort Lauderdale, Fla., with the Disaster Medical Assistance Team to work at the University of Texas Medical Branch at Galveston. The Galveston hospital suffered significant damage during the storm and health care was scarce in the immediate aftermath.

"It is nice to help and it's nice we can make a difference doing small things and providing medical support," she said. "It is a privilege."

Larry Carwell

| HOUSTON POLICE OFFICER |
| RIGHT PAGE | Average intersections in Houston became danger zones with traffic lights on the fritz after Hurricane Ike. But the complicated four-way intersection at Kirby and Shepherd would have been its own disaster during rush hour without Carwell and four other HPD personnel to coax traffic along its way.

Even with a badge, standing in the middle of traffic had its scary moments. "You have to stand right there in front of them and pray they go around you," Carwell said.

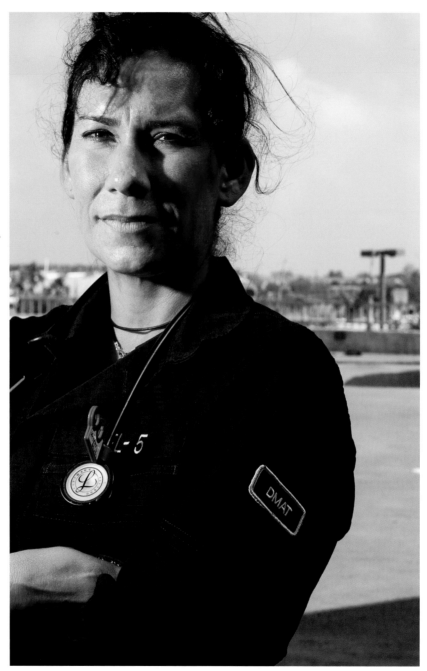

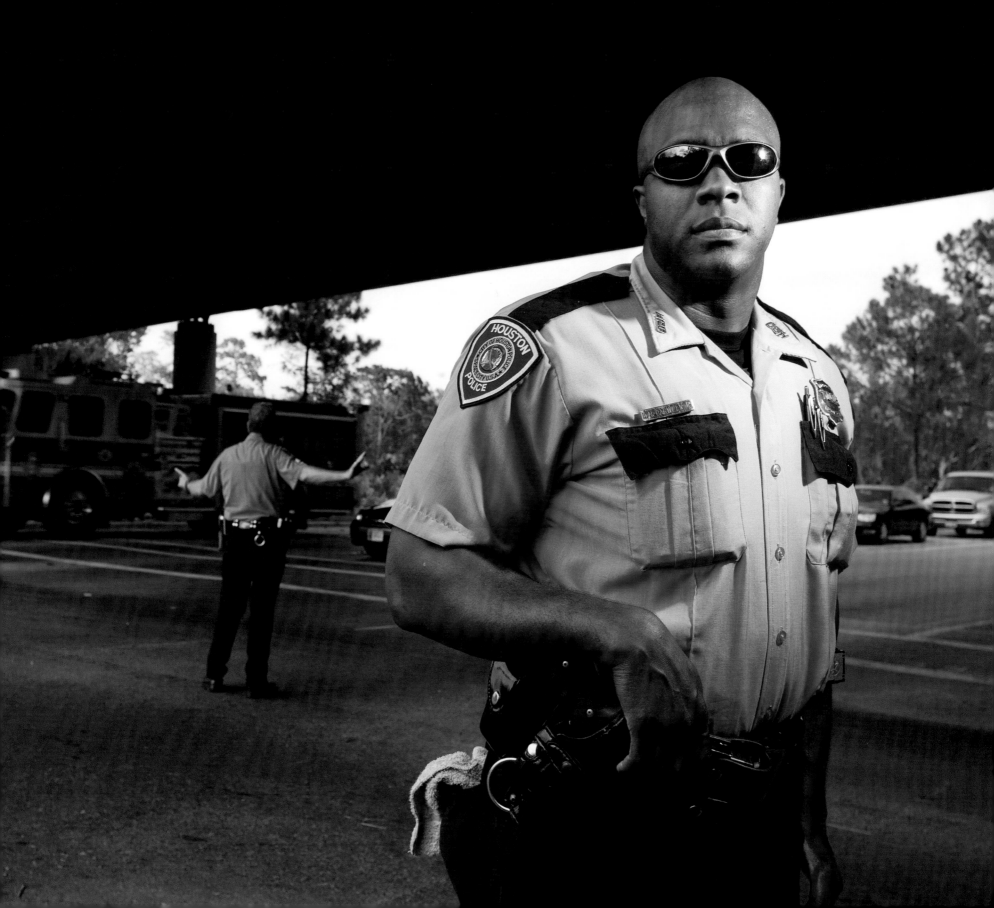

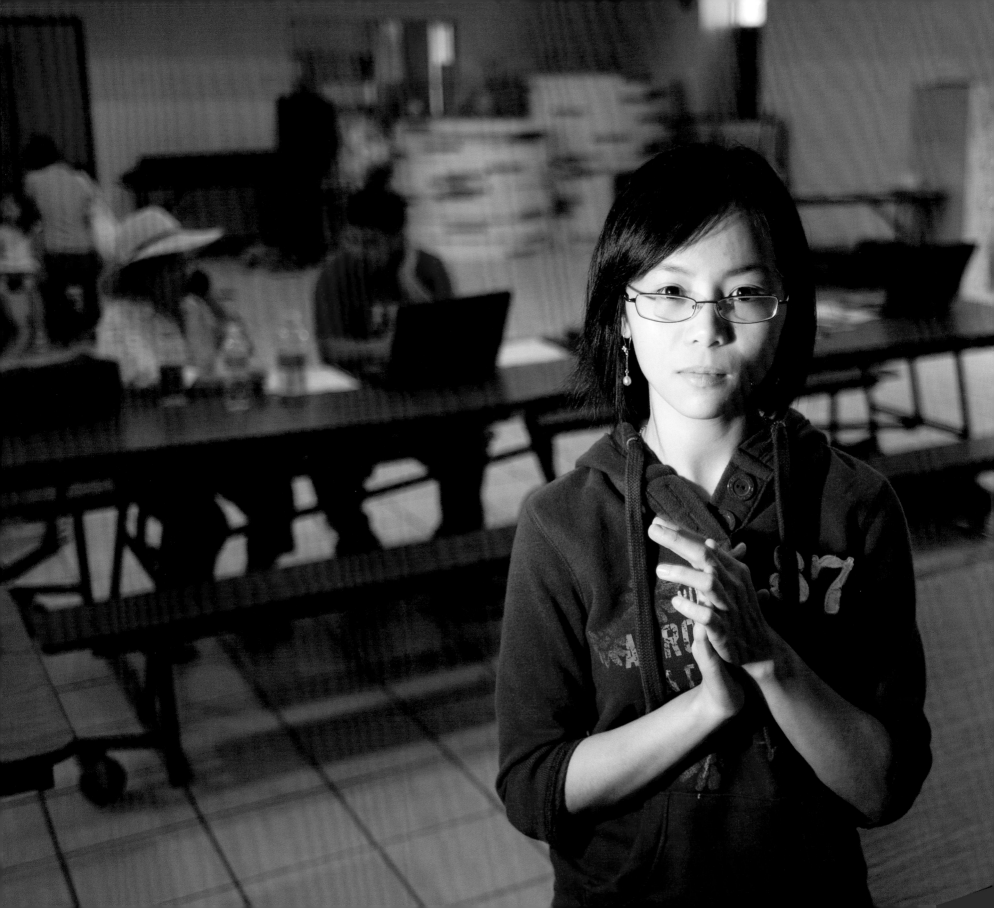

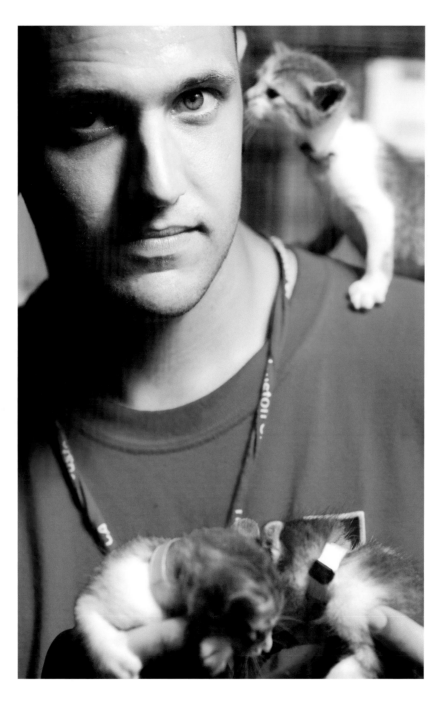

Chris Woehrle

| ANIMAL LOVER | A Denver resident with a love of animals, Woehrle arrived in Galveston to help Ike's furry, four-legged victims find a meal and a home. He worked out of a makeshift shelter in Galveston, helping as many animals as he could. But many never received any care, he said.

"The catastrophe for me is just seeing all the loose animals running around and realizing how many animals are still out there that I can't help," Woehrle said.

Ngoc Nguyen

| TRANSLATOR | | LEFT PAGE | Hurricane Ike put a temporary stop to Nguyen's classes at San Jacinto College. With the free time, the 19-year-old hunkered down with a laptop and a telephone at Vietnamese Martyrs Catholic Church to help 30 Vietnamese speakers a day with FEMA aid forms.

"First of all, they don't have a computer and second of all they don't understand English," Nguyen said. "I feel really rewarded because you are actually helping people who are really in need."

Dave Downtain

| PARAMEDIC | In the first days after Ike, Downtain administered more than 1,000 vaccine shots at a Galveston clinic. Often he had to restock supplies to meet the need.

"Your hands get pretty tired from it, wore out from it," he said.

Vicki Anders

| A HOSTESS | | RIGHT PAGE | Anders and her husband, Raymond, were a port in the storm for friends and neighbors.

The couple took in about 15 people, some into their Anahuac home. Others set up campers on their property. The result was a refuge for friends, including Jimbo and Ernestine Watson, whose Oak Island home and restaurant were destroyed in the storm.

At night, the couple served dinner to 25 to 30 people. Vicki Anders said the mood was mostly cheerful, despite the days without electricity.

"We have our moments," she said. "We have our little cry-baby spells. But it's OK. We've gotten along real good. Everyone just knows you got to do what you got to do."

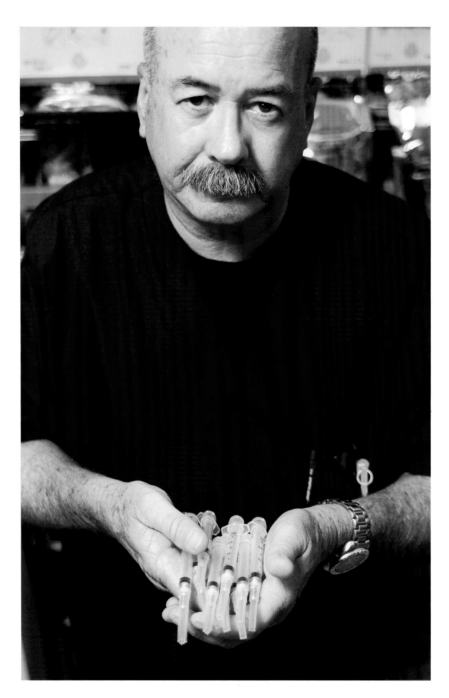

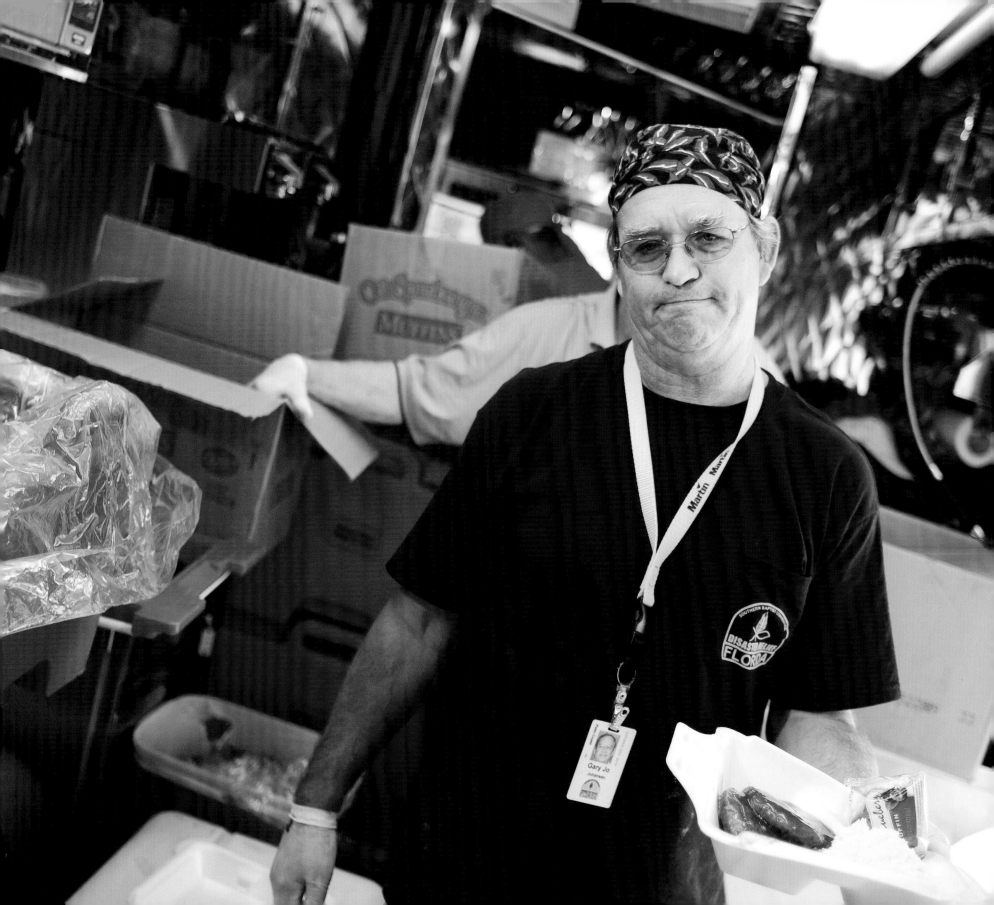

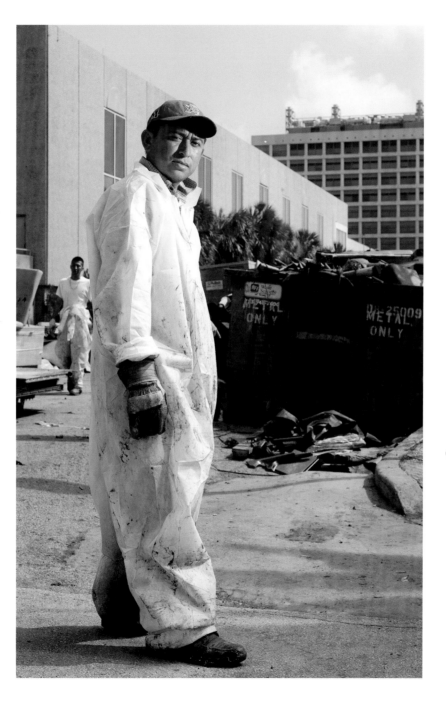

Alfredo Torres

| DAY LABORER | Torres, a Houston resident and laborer, helped remove trash from buildings at the University of Texas Medical Branch at Galveston.

Gary Johansen

| SALVATION ARMY VOLUNTEER |
| LEFT PAGE | Johansen traveled to Galveston from his home in Florida to feed hungry residents and relief workers. Among those he served were a group of men who, judging by their appetites, had not eaten in a while, Johansen said.

"We filled their plates twice, so full that any normal human being wouldn't have been able to eat it all," Johansen said. "They were so grateful. They couldn't stop thanking us. It touched my soul."

Tameka Horton

| NURSE | Even in the best of times, Horton has the toughest of duties. She is the nurse who cares for terminally ill patients and their families at The Methodist Hospital in Houston.

The night of Ike, Horton, 28, spent the night in the hospital so she could be there the next day to help patients and their families, some of whom were making life and death decisions.

"That was rough," Horton said. "That is probably one of the things I will remember about Ike, just being deprived of sleep and worried about our families and worried about what is going on with our homes and still having to provide exceptional care for the patients who needed it here."

David Griffith

| COOK | | RIGHT PAGE | When news of the damage made it to his home in Llano, Griffith, a Chambers County native and retired schoolteacher, decided to help. He packed up his trailer and headed to Anahuac to prepare food for county emergency workers.

For about a week, he served lunch to 80 to 100 people, some of them former pupils. His menu included gumbo, red beans and rice, sausage and cowboy stew.

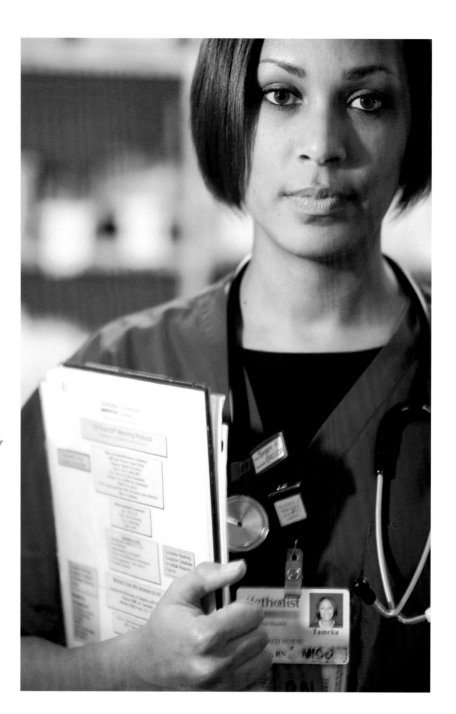

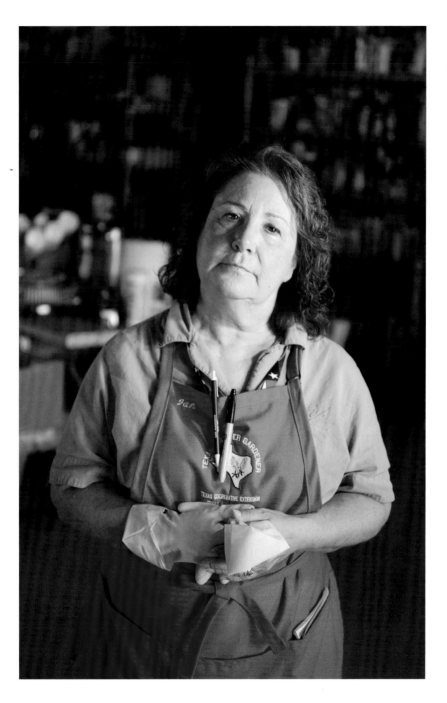

Jan Brick

| DEN MOTHER OF SORTS | Brick provided support to city fire, police and other personnel of Jamaica Beach who worked from "dawn to dark" to help with recovery efforts after the storm.

Brick, a city employee, said she was proud of the response from the workers and city residents.

"This has been a very moving experience for us and brought us much closer together," she said.

Bill White

| HOUSTON MAYOR | | LEFT PAGE | With Hurricane Ike bearing down on America's fourth-largest city, White was in charge of keeping city workers focused on the future.

"We knew it was going to be bad," White said. "You can't control what happens to you in life so much of the time. You can control how you respond."

White responded by pulling long nights sleeping in the emergency center before the storm. After Ike trundled through the area, he prodded relief providers with an insistent sense of urgency.

the photography team

Mayra Beltrán

Beltrán has covered four hurricanes, but Ike was the first storm to hit her own hometown. She was struck by the scope of the devastation: "Houston residents in the coastal areas had evacuated, but not Houston residents in the north. They were without power, running out of basic survival supplies two days after the storm, which created a different need than in the devastated areas in the south."

Steve Campbell

A 29-year veteran of the Chronicle photo staff, Campbell has spent his entire career in Texas. "I've lost track of the number and names of the hurricanes that I have covered, but have shot hurricanes and hurricane-related stories from Monterrey, Mexico, to the Florida Keys. It's always different when the storm hits your own hometown."

Brett Coomer

Just a couple of weeks before Ike roared ashore in Galveston, Coomer was in Louisiana covering Hurricane Gustav. Ike hit closer to home. "I have to thank my family for their support during Hurricane Ike. If it weren't for their strength and support, I would never have been able to put as much as I did into covering this storm."

Julio Cortez

Cortez, the first in his family to graduate from college, has covered four hurricanes — Ike, Katrina, Rita and Wilma. During Ike, he covered the small community of Surfside Beach as the police and volunteer fire department evacuated all but two people, demonstrating the beauty of residents of small communities working together.

Buster Dean

Buster Dean is a 30-year veteran of the Chronicle photo staff who hunkered down in the Chronicle building during Ike. He knows storms are a part of life on the Gulf Coast. "This is where we live and this is what we have to deal with. There is another big one coming someday."

Johnny Hanson

Hurricane Ike was the first storm for Hanson, who joined the Chronicle in 2006. The storm left an impact on the young photographer. "I was scared, frustrated to see some people taking the storm lightly, saddened by the stories of those who did stay and for everyone's losses, and uplifted by the work of first responders and utility crews for their concern and passion to help."

Jill Karnicki

Hurricane Ike was personal for Karnicki, whose family had a home in Crystal Beach when she was a child. "About three weeks after the hurricane, I went with my parents to look for myself. It wasn't until I was standing where the old house once stood, barely recognizable except for the mangled posts that once held it up, that the severity of Ike really hit home."

Eric Kayne

Hurricane Ike was Kayne's first hurricane, both as a citizen and a journalist. He lost power for 12 days, but considers himself lucky after covering families who were living in Galveston public housing. "Those with the least are usually the ones who have lost the most."

Catherine McIntosh

As assignments photo editor, McIntosh plans staff photo coverage of the region. She was ready when Hurricane Ike hit. "After careful planning and preparation for Hurricane Gustav in August, we were ready to take on Ike. The whole staff pushed hard for a full two weeks, producing some of our best images of the year."

James Nielsen

A native of Galveston, Nielsen enjoys working at the newspaper he grew up reading. Ike left his home without power, but his Galveston relatives were not as lucky. "My mother's home suffered floodwaters of over 2 feet and caused heavy damage. My aunt's home had floodwaters of over 5 feet and she and her special-needs daughter lost everything."

Thế Ngọc Phạm

Phạm, who fled Vietnam with his family in 1975 as South Vietnam fell, has spent the past 18 years as a photo editor and helped edit both Katrina and Ike photos. "During Katrina, we were the ones sheltering and caring for the victims. During Ike, we were the victims. We comforted each other after Sunday Mass. It was real pain and sorrow that we shared during this hurricane."

Melissa Phillip

Phillip has covered seven hurricanes and took some of the most striking photos of Hurricane Katrina's devastating impact on New Orleans. "My most memorable photos over the years have been of these disasters and of the people I met. They are unforgettable. Seeing people struggle amid chaos is very difficult, but documenting that struggle and their will to live is a privilege."

Smiley N. Pool

Pool, who shared in the Pulitzer Prize for photography at the Dallas Morning News for his work during Hurricane Katrina, shot aerial photos of Ike's damage. "My grandmother lost her home at Bolivar during Hurricane Carla in 1961. All that remained was the foundation and the bathtub. That was before I was born, but I can vividly remember the stories she would tell when I was little."

Billy Smith II

Hurricane Ike helped Smith understand what a community goes through after a storm. "My wife and I were without power for nearly a week, but others in our neighborhood had it worse. I met a grandmother standing in line at a hurricane aid center waiting for MREs, ice and water because she had nothing at home to feed her grandchildren."

Sharón Steinmann

Steinmann has intimately covered Ike's damage to the small fishing community of Oak Island. "They have pitched tents on their slabs and are living in boats in an effort to stay in the town they love. Their church is in a tent and every Sunday the tent is packed with congregation members, some driving miles to reconnect with their community."

Nick de la Torre

De la Torre photographed the police officers, linemen and volunteers who were heroes of the storm. "I would approach a subject while they were working or while they were doing whatever it is that they were doing and I would ask for about 90 seconds of their time. I would take the pictures, get their names, try to get their stories and I was off."

Steve Ueckert

Ueckert's first hurricane experience came in 1960 when Hurricane Donna passed near his Florida home. His memories of Ike: "While my neighbors and I were without municipal electrical service for nearly six days, a benevolent neighbor with an industrial generator supplied power to five houses, including mine. I already miss the block parties we had where neighbors turned out to enjoy each other's company."

Karen Warren

Warren, who has spent most of her career in Texas and covered many disasters, said Ike showed the best side of the community. "The first few days were brutal. But I was really glad that Houstonians reacted the way they did during that period of time. The theme 'neighbors helping neighbors' was what I saw everywhere I drove."

I spent most of my life living in the Midwest — Kansas and Missouri. We had our share of storms, but they came in the form of powerful tornadoes, thunderstorms, flooding, ice and snow. Hurricanes were foreign to me.

Three years ago, I relocated to Houston. I gained new respect for the strength of Mother Nature after Hurricane Ike. When tornadoes would hit Kansas, the refrain was familiar: "It sounded like a freight train," the locals would say. The twister would strike and move on. Ike, on the other hand, was a freight train mixed with a pack of howling wolves attacking my home for 12 long hours.

In the pages of this book you will see images produced by the Houston Chronicle's photojournalism team before, during and after the storm. Their photos took the readers to places they could not reach themselves. Many readers were dependent on the daily edition of the Chronicle because their homes remained without power and they had no other way to stay informed about Ike.

Steve Gonzales

Steve Gonzales is the director of photography at the Houston Chronicle. Before moving to Houston, Gonzales was the assistant managing editor of photography at The Kansas City Star. He worked in Kansas City for 18 years as a staff photographer, night photo editor and photo editor for features and sports. Before Kansas City, he was a staff photographer at The Topeka (Kansas) Capital-Journal. He began his seven-year stint in Topeka as a photo lab technician.

Gonzales is a past president of the Associated Press Photo Managers and an active member of the National Association of Hispanic Journalists. He was a 2003 Poynter Institute Ethics Fellow. He served as a judge for the National Press Photographers Association 2006 Best of Photojournalism Contest and the 2006 American Society of Newspaper Editors Community Service Photojournalism Award.

In big events like this, photojournalists usually go in and stay awhile, then return to the comfort of their homes. But during Hurricane Ike, we lived and worked in a disaster zone. What you will not see in this book is the pain, frustration, tears, fear and exhaustion the Chronicle team experienced as we returned to our own damaged, dark homes. All of the photographers and editors had to deal with covering a disaster in their own city. And Ike was a 24/7 story for weeks.

I am proud of the dedication demonstrated by our photojournalists. They worked as a team and their hard work and professionalism show in the images and stories they produced.

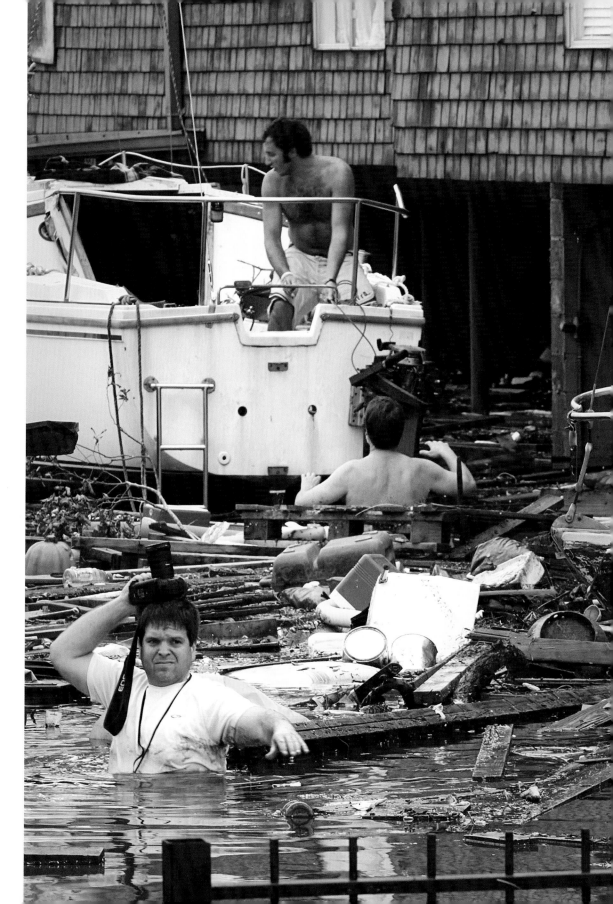

HOUSTON CHRONICLE | CHRON.COM

JACK SWEENEY | PUBLISHER AND PRESIDENT

JEFF COHEN | EDITOR

HURRICANE IKE
BOOK CREDITS

SUSAN BARBER | DESIGN DIRECTOR

JAY CARR | GRAPHICS DIRECTOR

ROBERT DIBRELL | GRAPHIC ARTIST

TARA DOOLEY | WRITER

STEVE GONZALES | DIRECTOR OF PHOTOGRAPHY

GEORGE HAJ | EDITOR

KIM KOVAR | COPY EDITOR

SMILEY N. POOL | PHOTO EDITOR

KIMBERLY TABOR | COPY EDITOR

MIKE TOLSON | WRITER

PEDIMENT PUBLISHING | DESIGN AND PRODUCTION

ALL IN A HARD DAY'S WORK | RIGHT | Houston Chronicle photographer Eric Kayne wades into the muck to capture a shot. | SEPT. 13 | EL LAGO | **COURTESY OF WILLIAM FARRINGTON**